William Carter

William Carter

Causes and Spirits

Photographs from Five Decades

Steidl

for Weston Naef

who inspires by seeing

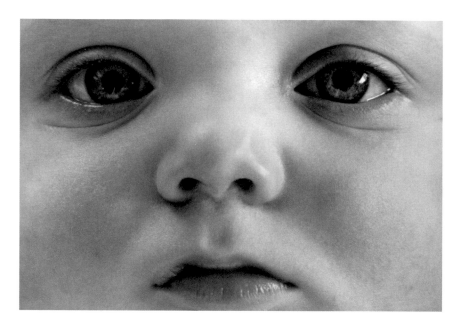

Alexandria, Virginia · 1996

To See is to Connect

"Want to see—to see!" gasped the fourteen-year-old Eugene Gant *in Thomas Wolfe's autobiographical novel,* Look Homeward, Angel.

To see—to comprehend—to take in, experience and explore: the extended meanings of our most vivid sense impression—"ineluctable modality of the visible," James Joyce called it—are everywhere. Even the U.S. national anthem opens by asking, "Oh, say, can you see?"

Photography reproduces what we see, including all the overtones and metaphors, incoming and outgoing. Once thought of as a mere copy machine, the camera has come to be understood as both receptor and projector of our values as individuals and societies.

When I was a boy, textbooks spoke of the "Age of Exploration," centuries peopled with swash-buckling seafarers like Columbus and Magellan, discovering "new" lands whose newborn societies would be imbued with the value of newness itself.

Later, the camera became a way for me to discover, at once, the world and myself. To discover means to uncover. Which includes dropping our own protective boundaries. The camera has been in the vanguard of globalization—our awakenings from isolation.

Lens, films, sensors become extensions of one's optic nerves. Or, like some spongy mangrove environment, mediators between the tamed land we familiarly walk on and the vast moody seas that once separated and now connect us.

I grew up sheltered in the Los Angeles of the 1950's. My father protected us from the poverty he had known coming of age in the Depression, and which had energized him to climb the success ladder. We lived in a Tudor house on a leafy, secure street in 1950s L.A., a city itself then making up its mind to ascend the rungs of high culture. Like many another teen, I felt half-trapped in a half-impermeable cage of half-understood feelings and half-repressed utterances.

I valued what I had received, but felt there was much beyond it, beyond myself, much I couldn't yet see. I gravitated toward permeable membranes promising wider vistas—basketball, music, books. My prep school friends summered at the beach, behind the stiff walls of private clubs, making contacts that would serve them well in their later careers. Those social arenas were open to me, but their unwritten codes sometimes made me feel like a stranger in a strange land.

I was drawn more to places like the Hollywood YMCA. I took a secret pride in taking the Rossmore Street bus to the Y; no one else in our immediate family ever took any bus anywhere. Had one

of the great city basketball players at the Y spotted me sliding out of my mother's shiny black sedan, I would have died of embarrassment. By contrast, my mother's mother, Grandma Dailey, never even learned to drive, and in her later years took buses all over L.A. I spent a lot of time in Grandma and Grandpa Dailey's house. I felt close to them. They were small-town midwesterners: Grandpa had run a general store in Ohio. At thirteen, I was alone with him the morning he had a stroke and would die that afternoon.

Later, I would see that finding ways to go beyond that sense of a divided self—the exclusive black sedan versus the y'all-come yellow bus—was a strong, if often unconscious, motivator for me. It would play out in my zeal for two twentieth-century art forms, both of which link middlebrow and high-brow culture—jazz and photography.

College opened doors to everywhere, across time and space. Four formative years in a humanities program left me deeply inspired by the legacies of major civilizations. Yet it gave me no clear sense of how I would fit into all that—what I would do, or who I was. I plunged into the writings of Kafka. Like his rudderless seafarer in "The Hunter Gracchus"—and like Jung's *Modern Man in Search of a Soul*—I seemed destined to wander in intermediate zones, forever questioning and incomplete—touched by all, held by none, coming of age in a time of transition, the world poised between fragmentation and what might lie beyond.

I developed an intense craving for meaning and form. Los Angeles seemed a city without form or meaning. It seemed to have no physical or cultural boundaries (great for developers I guess). No river or coastline seemed to define the city, or me. Dad and other town fathers were working to import culture in the way of museums and symphonies, but all that pointed toward a distant, unknown future—nothing I could plant myself in. I needed a deeper soil than that below the projected freeways and shopping centers. I sensed no substance beyond the facades—the chrome surfaces of bumpers, the surfboards, the carhops and hopped-up cars, fifties TV, the air-conditioned savings and loans, the forlorn bus-stop seats featuring ads for funeral parlors.

One person who seemed to embody an alternative vision lived just across the street from us. A gregarious family friend, Marion Pike was a talented and dedicated painter. Home from college, I would stop in to see her and watch her work. The rich smell of oil paints wafted through the large house, blending with opera recordings and luxuriant flowers. Marion kept an apartment in Paris, where she cultivated the old world overtones and connections implicit in her paintings. She knew all kinds of rich and famous people, many of whose portraits she had painted. Her less conventional portraits were huge heads with large eyes staring straight at the viewer: windows on the soul, reminiscent of early Christian icons. I stared back at them and at Marion's own disarming eyes. Watching the progress of her magical brushwork, I was filled with confusion and wonder—with longing, uncertainty, unbearable suspense. Who was I?

I knew I was no painter. I thought of becoming a psychoanalyst. I needed to go beyond and below surfaces, to find a rationale in the secret realms of the mind and heart. Those were presumably no secret from a worldly-wise artist like Marion, but they were certainly concealed from me, half her age, and with a tenth of her culture and experience.

I needed to enter life from the bottom up. My father had begun collecting seventeenth-century Dutch landscape and still-life paintings. Every time I came home from college, it seemed, a new one would have been acquired, or was under consideration. I enjoyed looking at them, and my admiration for those artists, their special milieu and their values would deepen over the years—an admiration inseparable from my admiration for all my father was doing for culture and education in California. All of which, including his rags-to-riches story, was some part of me. But for now, at least, the more active strands of my DNA seemed to have come from my grandfather—my mother's father. Whereas my father operated most comfortably in buttoned-up board rooms, laughing and deal-making with other movers and shakers, the memories of Grandpa I would cherish were the opposite. He and I shared countless hours out in the San Fernando Valley, which in those years was still rural. We would spend all morning hammering away on the window frames of some decrepit house, fixing it up to sell. Or all afternoon chatting with a gruff old real estate guy named Jesson in his sweltering office under the slowly turning ceiling fan, Jesson's gravely voice and bluish cigar smoke curling up through the yellowish afternoon light, his foot with its gartered socks stuck in an empty bottom file drawer, while I crawled around, feeling indulged to be allowed to inspect every nook and cranny. Or lunchtime, sitting on the earth with our backs resting against an avocado tree: how good the fresh-picked tomatoes tasted, still hot from the fields, either eaten whole or else sliced by Grandpa's precious pocket knife, and placed in the thick, brown-bread sandwiches Grandma had packed into our lunch bags that morning at five a.m.

That kind of bottom-up humanity needed somehow to be fused, in me and in my work, with the inspiration of a living artist like Marion Pike, and with that overarching sense of form and spirit on view in Dad's Saenredams and van Ruisdaels, and implicit in classic civilizations. "Bill has an overdose of independence," Dad said of me. I was far from being a revolutionary, but I had indeed taken to heart Emerson's line, "He who wouldst be a man must be a non-conformist."

These various parts of me would take their own good time to eventuate into a life direction. Slowly, an inner compass would show itself, not at any particular moment, nor as a top-down strategy, but as a long summation of individual acts and impulses: revealed not in words but as a journey whose unwritten itinerary became: "Go East, Young Man." My search for comprehensive meaning eventually carried me from the westernmost edge of the West, across America to New York, thence to London and across the heartland of Europe, on to the Middle East, and eventually to India and Tibet. Finally, I found myself back in California. Photography had become a kind of connective tissue linking me to an endlessly unfolding union, or re-union, with the outer world, and with the different parts of myself. Half a century of search-and-discover would diagram itself into the plan of the present book.

* * *

In the late fifties and early sixties, I lived within the jazz and arts-intellectual netherworlds of Berkeley and San Francisco. I was in these worlds but not of them—was that becoming a pattern? Some radicals I encountered were not merely protesting, but actively working to tear down civilization. I

could sympathize with ideals like reaching across barriers of class, race, and gender, or scrutinizing texts for buried assumptions, or personal loosening-up to enable the flow of love. But I could not see enshrining anger per se, or willingly destroying beauty, or sponsoring chaos, or enlisting in some "ism" or another. I was turned off by the kinds of oppositional arts and politics that tried to oppose the power structure by creating their own power structure.

Within a few years, many of these diverse strands were woven into what was loosely termed called the counterculture. I was affected by it but not part of it. I was, and would remain, part of no generation: neither straight nor hip, hot nor cool, conservative nor radical, revolutionary nor counter-revolutionary. Developing an interest in photography, I became neither an Ansel Adams groupie nor its Pop Art-derived opposite, the "Pictures Generation" that tried to portray its own victimization by ironically mingling icons of high culture and the mass media. Rather than arising from surfaces or trends or movements, my instinct has always been to try to go through them or around them—in spite of them—into the richer realms of experience and emotion that are always there for the taking—beyond and below the surface.

* * *

Worldwide photo assignments provided richly varied perspectives. I learned how contradictory life can be: that core human values need to be earned and tested by tough experience—not pledged as truisms—and that most societies' cumulative memories and long perspectives are quite different from one another's, and from our own.

Causes and Spirits is not "on" anything or "about" anything, unless that be, simply, humankind. Taken over half a century, these are the pictures that I kept as favorites "for me". Perhaps they were not only for me and by me, but of me. A historic Zen master, Tozan, was quoted by a later one, Suzuki: "Wherever I go, I meet myself."

Attitude is everything. Photographic prints become objects. Their contents, however, are subjects. That, at least, is the attitude I try to have when working with people. "Subject" implies an underlying respect between the photographer and the person or thing being photographed—neither party to the transaction being used merely as a means (commercial, dehumanizing, or "objectifying"). No greeting is better than the Indian *namaste*: "The God within me greets the God within you."

* * *

This book is populated by human beings. But it is less about them as individuals than it is about certain split-second (or slower) interfaces and reactions one has in encountering people. Conditioned by acculturation, inspired by our received ways of seeing, the act of placing the frame and releasing the shutter is fed by an underground stream of influences that make each of us who we are—an inheritance I have no interest in trying to disrupt or subvert. One feels infinitely grateful not to have

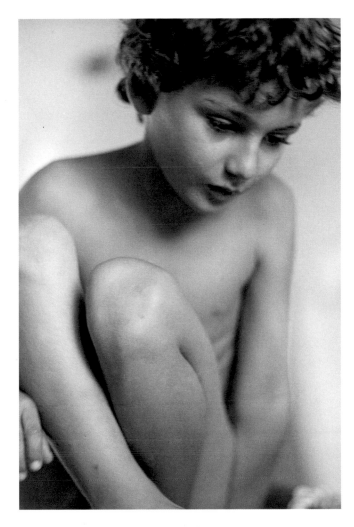

Los Altos Hills, California · 1998

been born in an isolated village or in some lost century. The received world culture of today feeds us with a trove of visual nuances, cues, and implications no less rich and varied than the poetries of speech. Why should anyone wish to "deconstruct" such a heritage?

Photography is a relationship: a modern sort of relationship—like jazz: often at its most intense when it is most fleeting. This is the mystery of this medium. We live in a time-space continuum. Between its cracks lurk hidden implications, eye-blink compositions, odd ironies, and happy accidents. Sometimes our shutters can catch them.

Photographers are privy to different sorts of revelations, styles, time-meanings, and power implications from those embedded in the arts of, say, the pharaohs or Maoris or medieval Christians or

abstract expressionists. Yet where would we be, aesthetically, without such ancestors? Without our museums and libraries to preserve and transmit their achievements and mythologies into our own visual DNA? And without the long string of scientific breakthroughs making possible, for instance, our cameras? Who would wish to subvert the long, precious march of civilizations underlying such structures of our minds and hearts?

The idea that photographs should be "made, not found" seems a false dichotomy: photographs have always been made in the finding, and found in the making. At least that is my experience, not only out in public, but also in the studio, working with the nude. To place a frame in time and space, on the infinity of passing realities that is the world, is simultaneously to impose and extract form. Our brain, and the camera, register, in a fraction of a second, a certain organization of visual elements that we—and perhaps others of similar cultural conditioning—find meaningful.

To see, and successfully register, these split-second relationships requires enrollment in classrooms without walls. Every photographer develops ways of working consonant with his or her own temperament. Technique and vision are fused. Composing with light and shadow, learning to see the world as an arrangement of tonalities, imbibing hard lessons about what can and can't be adjusted later, experiencing how form and content merge in an instant, sensing how and when the concrete and the particular point to the general and universal—all those come together, with people's expressions, in a single click. Our visual recording machine becomes a seamless extension of eye-mind-heart. No one can teach this course. But by taking it, one eventually meets oneself, everywhere.

Life supplies the meanings, which emerge from within the picture and draw the viewer in. That source—life—is inexhaustible and ever-fresh. Some would call the ultimate source God—the formless—manifesting temporarily as form. Some would say that to see and represent the forms clearly is to see, by means of them, through them and beyond them—pointing us back to the source. For the artist, drawing the viewer into the picture's feeling or aura is key. This is analogous to the importance of tone in writing. Or to tone's importance in music: the photographer's role as interpreter may be as important as his role as composer.

One particular formulation, grounded in traditional Hinduism, strikes me at several levels, including the making of photographs: "One sees the world as one is."

People often ask me what I think about digital photography. Which is a little like that question of half a century ago: "What do you think of 'available light' photography?" I picked up a friend's reply: that he always used whatever light was available. Technologies change, and we use whatever tools suit our purposes. I like digital cameras and computers, especially for color. But I love the black-and-white darkroom. I count myself fortunate to have been seeded in the warm loam of classic photographic practice. Equally, I'm glad to make use of whatever new developments prove useful.

Yet I remain hopelessly wedded to outmoded ideals like beauty and truth. Real work springs from an artist's inner energy and vision, not from trends. I'm attracted to classic philosophies that emphasize going beyond the pairs of opposites to attain oneness. Jazz musician Duke Ellington spoke of going "beyond category." Recently, I scribbled a list of "go beyond" categories. Here is an excerpt (the reader can devise his own list):

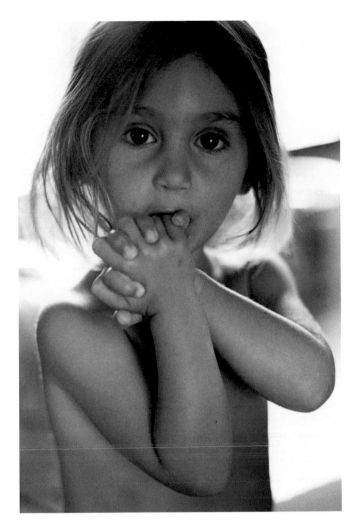

Los Altos Hills, California · 2003

Go beyond immediate and timeless
Go beyond disruptive and cozy
Go beyond passion and dispassion
Go beyond surface and depth
Go beyond pretty and ugly
Go beyond illusion and disillusion
Go beyond chaos and pattern
Go beyond the knower and the known

Both Aquinas and Joyce believed that art can be a bridge to wholeness, harmony, and radiance. One sees those qualities in works from all times and places. Someone compared one of my nudes to a small sculpture, the Venus of Willendorf, part of a group from Austria and southern Germany dating back some thirty thousand years.

In 1857, less than twenty years after the invention of photography, Lady Eastlake wrote, "Every form which is traced by light is the impress of one moment, or one hour, or one age in the great passage of time."

In 2009, I saw a major exhibition of Robert Frank's classic photographs, *The Americans*, at the National Gallery in Washington. The show was called "Looking In." I said, "Yes, that's it": the outsider, looking in—a stranger in a strange land, imposing meaning from without, seeing our civilization in a certain way, reflecting it in a very particular mirror, adding that fresh twist to its ever-expanding definition of itself. A Swiss visitor looking in on this ever-diversifying, never-definable society, inclusive and permeable: his name now emblazoned on a huge banner of acceptance draped down the front of an American monument. He altered the civilization he saw by the act of seeing it, and was now officially a part of it. The process is not unlike that described by Heisenberg's uncertainty principle: in order to specify where a particle is, one must add energy (light) to the system, thereby changing the position of that which one is observing. No longer a stranger in a strange land, Frank stopped being the outsider (and the photographer) he had been.

Around 1900, historian Arnold Toynbee recognized what he called "the destruction of time and space": travel, communications, and the wide dissemination of knowledge now meant that separate civilizations, historical or modern, would never again develop in isolation from one another.

In the early twenty-first century, a new, post-romantic spirit, beyond illusion and disillusion—a new realism—appears to be dawning in our globalizing society. There seems to be a gathering awareness that while the clash of opposites may never end, the mature way forward is not to be caught in the clash, but rather to go beyond it, into that permeable membrane of interrelatedness.

Watch any mother kneeling beside her toddler, pointing and explaining what they are looking at. Our urge to see, to comprehend and connect, starts there.

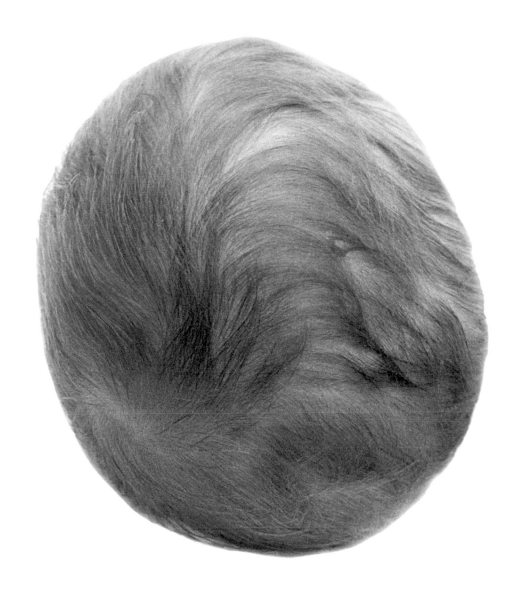

Stanford, California · 1998

To a more earnest vision,
outlines and surfaces
become transparent:
causes and spirits
are seen through them.
The wise silence,
the universal beauty,
to which every part and particle
is equally related,
is the tide of being which floats us
into the secret of nature;
and we stand before
the secret of the world.

EMERSON

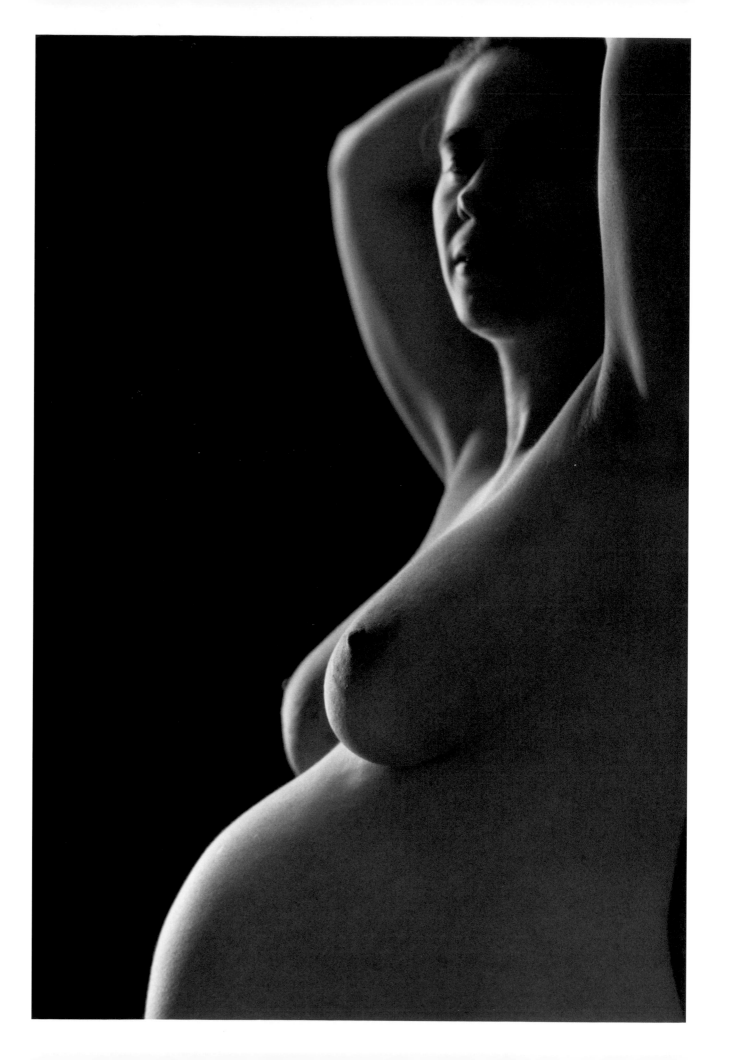

Genesis

The most constant thread of my life has been photography.

In 1958, when I was twenty-three, my mother brought me a precious gift from Japan: a medium-format camera.

The timing was fortuitous. I was in a transitional period, of the sort others may remember in their own ways. Having finished my formal studies, a wonderfully inspiring liberal arts education, I now found I had no way to address the "real" world, personally or professionally.

Unintentionally, Mom's gift linked to something she had sometimes said earlier when my purist attitudes seemed to isolate me: "You live in a world of people." Little by little, as photography took over much of my life, the camera became a window to the world, and to myself.

The first challenge was to learn how to use that rather klunky two-eyed object with its interchangeable lenses. I read the English translation of the Japanese instruction manual. I bugged photo store salesmen until they gave up all their secrets. I began reading Ansel Adams' technical books, and studying his work and that of his colleagues.

I tried taking some pictures of children in a schoolyard near where I was living in Berkeley. When I put up contact sheets on the bulletin board, some parents wanted to order prints. So I had to learn to print.

I immersed myself in the mysterious yellow dimness of a big public photo lab in San Francisco. It opened at three p.m. Toward midnight I would totter home, exhausted but inspired. Advertising my services, I visited people's homes to take informal pictures of their kids, sometimes the whole family.

I dug into the photo books of people like Henri Cartier-Bresson, Edward Weston, Robert Frank, and Dorothea Lange. I became aware of the long, proud tradition of California photography, many of its greatest practitioners still living in the Bay Area. It never even occurred to me to try to meet them—in truth, I didn't yet feel qualified.

I branched out to other subjects. Jazz and blues musicians, and the glorious Pacific seacoast would remain central to my interests. But for spontaneity and expressiveness, and sheer beauty, nothing compared with children. Those fresh faces were perfect for the camera—my newfound medium of exchange with the world.

* * *

Forty years later, the neo-natal department at Stanford University invited me to photograph newborn babies, plus some births. As I donned my green gown and scrubbed my forearms, the project seemed to echo my memories of coming of age as a photographer.

In 1960 I had emerged, blinking, from the womb of great past cultures, to find myself blinking in the light of a medium that was (like jazz) very much here, and now, and living in America.

Children's Hospital, Stanford University, California · 2000

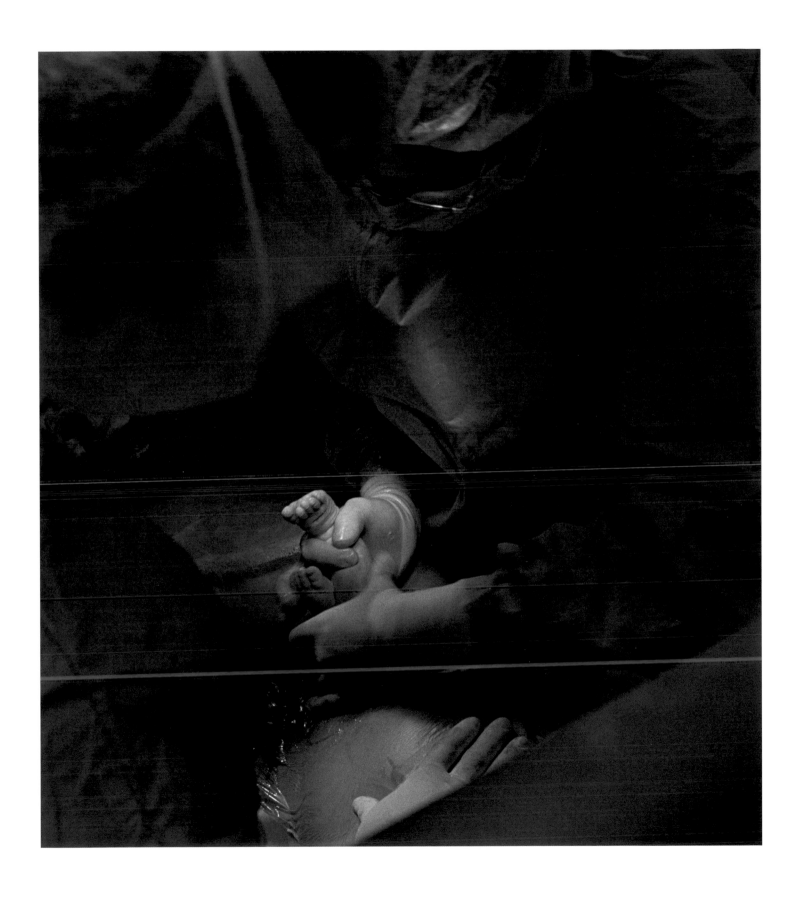

Children's Hospital, Stanford University, California · 1998

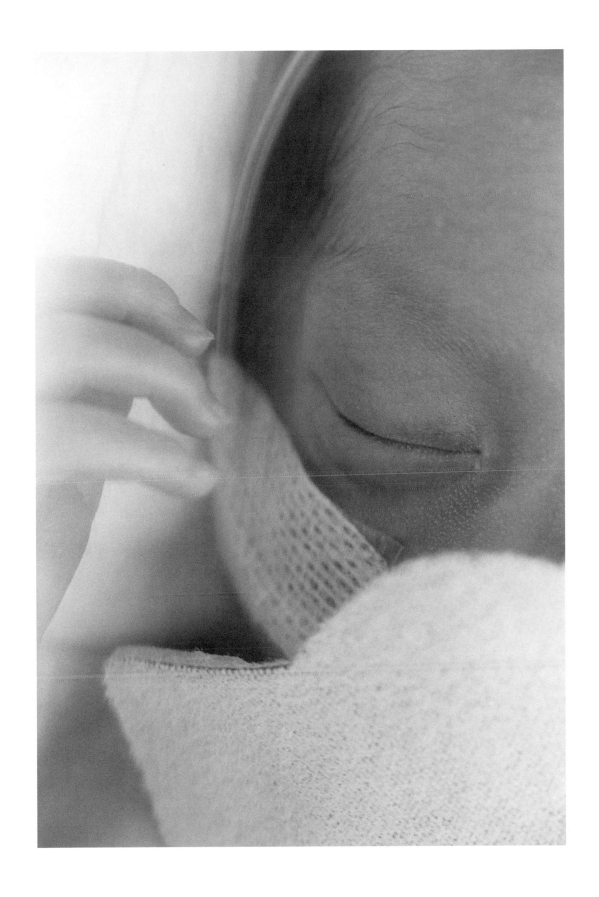

Oakland, California · 1995

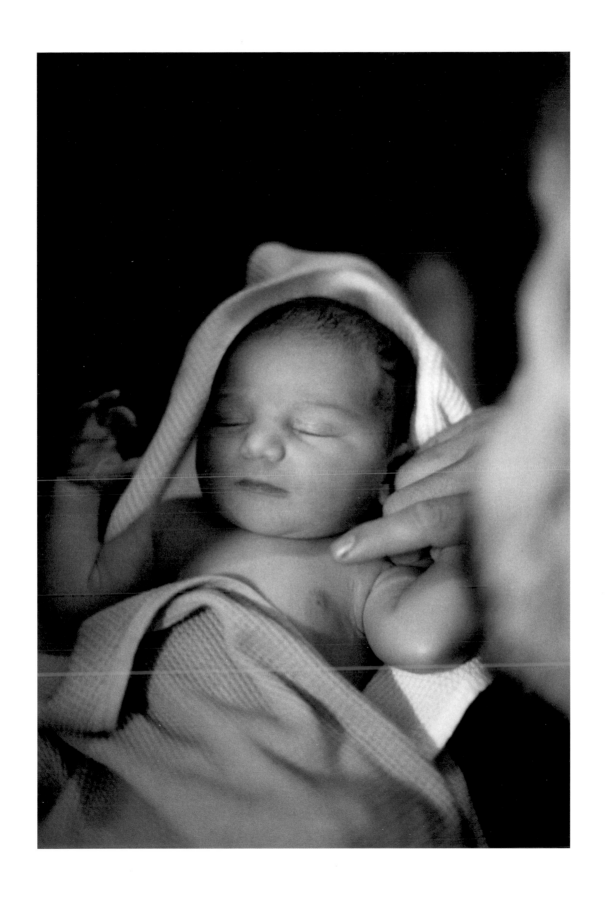

Alexandria, Viriginia · 1997

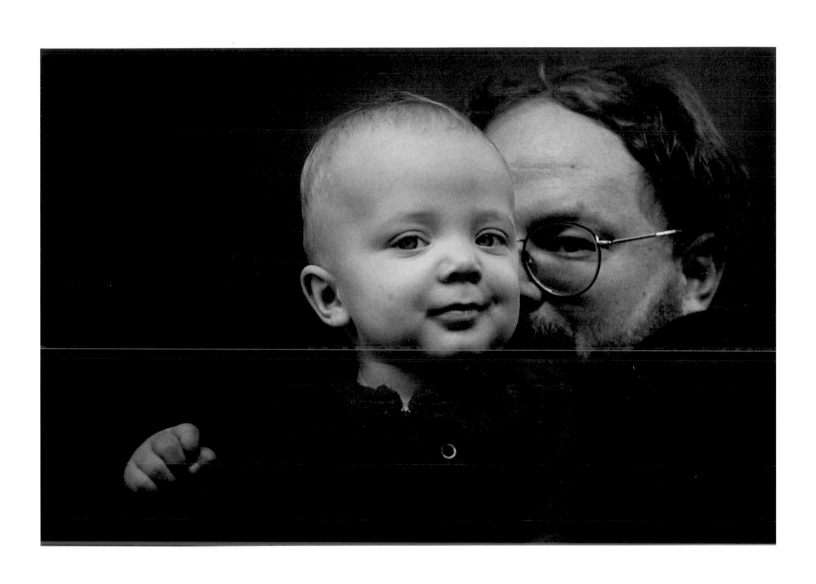

Staten Island, New York · 1962

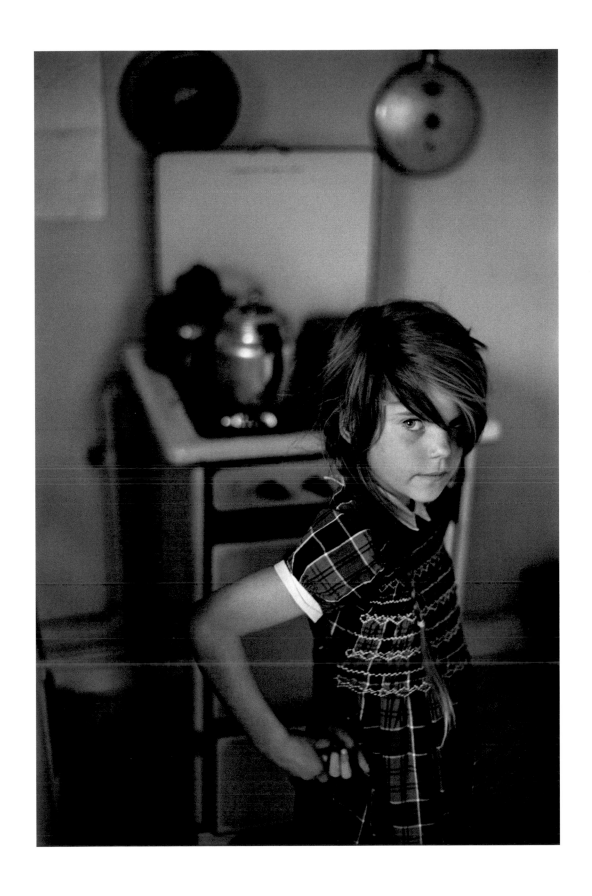

Lower East Side, New York City · 1963

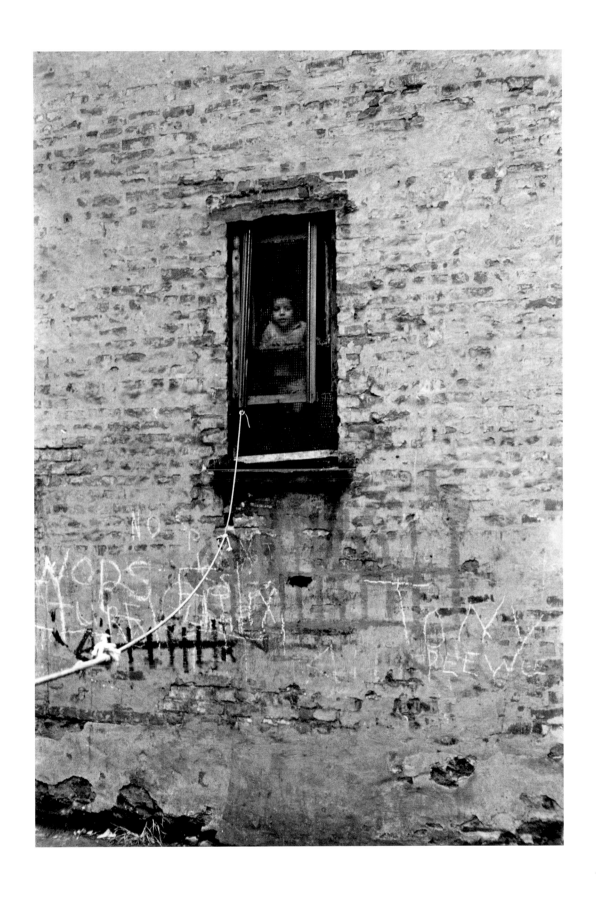

Lower East Side, New York City · 1963

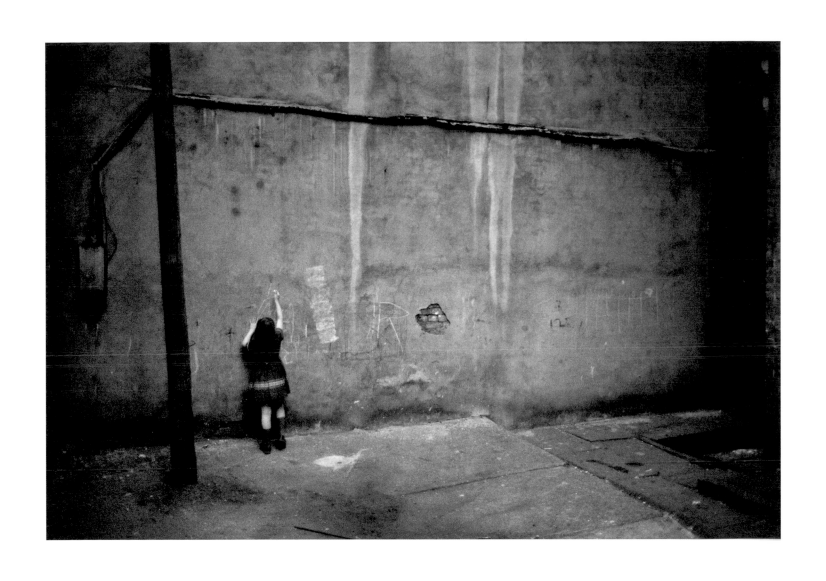

Western Montana · 1970

Oakland, California · 1959

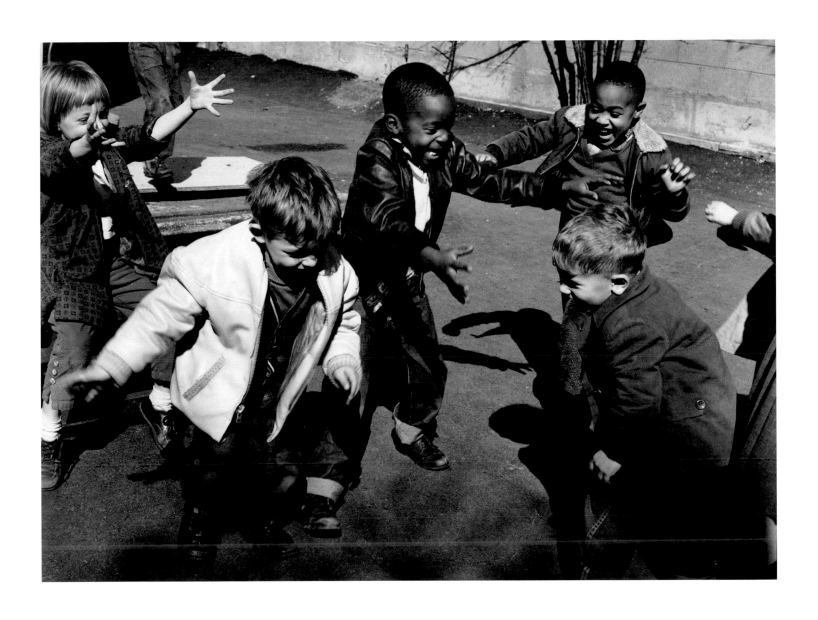

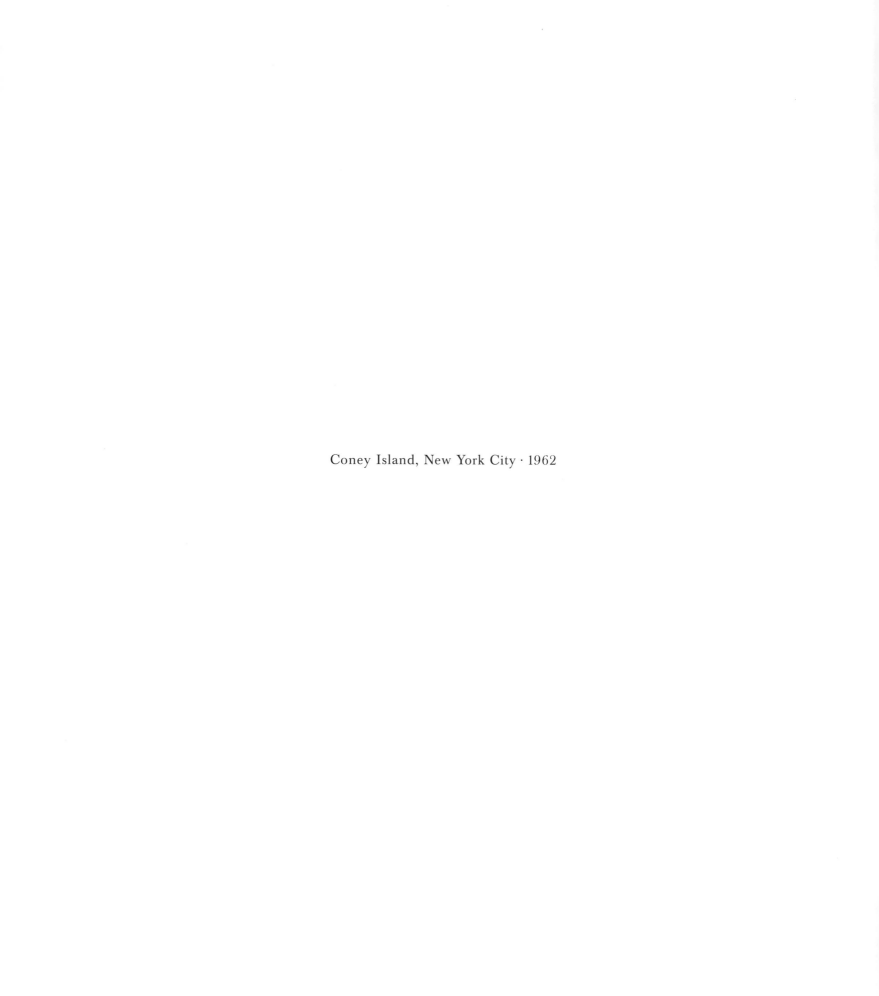

Coney Island, New York City · 1962

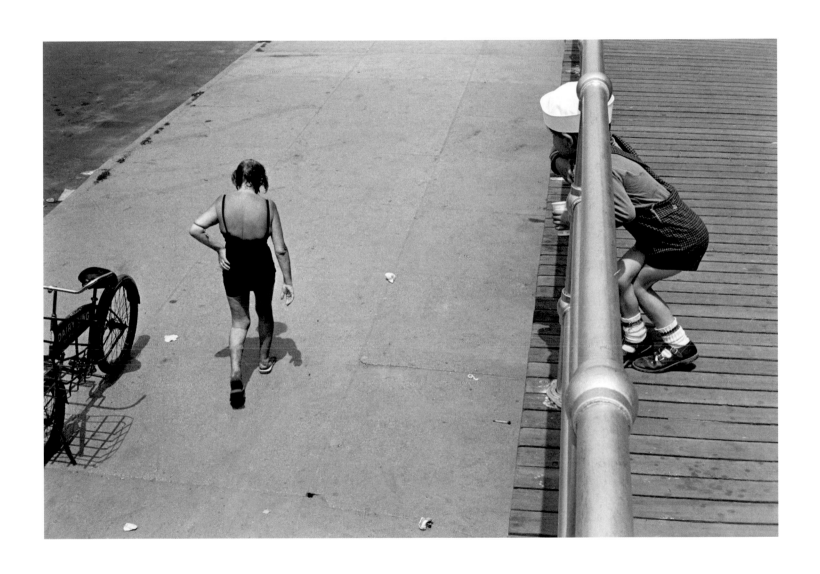

be

still

and

still

moving

T. S. ELIOT

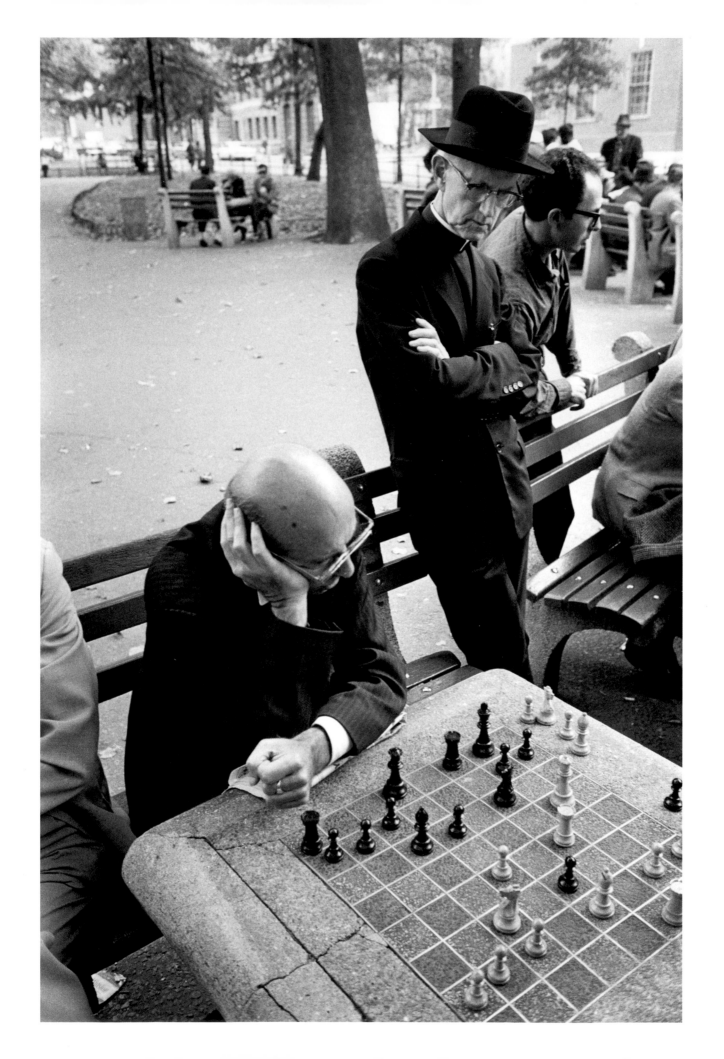

Gigs & Inspirations

By late 1961 I had learned a lot about cameras, darkrooms, and life in the Bay Area on the cusp of several social revolutions. It was time to move on. I went to New York and found a job as a junior editor at a major book publisher. In the rich ethnicity of the Lower East Side I found a great, cheap, walk-up, floor-through apartment with a side room I converted into a darkroom by running hoses through a bathroom wall and down a hallway.

I roamed Manhattan with two Leicas hanging around my neck. The quick-paced sidewalks and leisurely parks offered endless possibilities to place my bright-line frame—pictures I still consider my most important body of work from that period.

I met people of many stripes, including one that I had long idolized—Louis Armstrong—whom I photographed on and off stage at a concert at Cornell University. I nearly met another idol, the great photographer Henri Cartier-Bresson. My boss knew him and once let slip that Henri was in town, staying at the Chelsea Hotel. With trembling fingers I dialed the number and asked for his room. A kindly French voice said, "Allo." "Hello. Is this Mr. Cartier-Bresson?" "Yes." Suddenly my throat contracted. I was too terrified to speak. All I could do was hang up. It was one of those what-if moments that has tortured me ever since; I never did meet Henri. Sometimes we seem to need to let our distant gods remain distant—so we can keep growing in our own way.

I snagged some assignments around town. For Rand McNally I did a picture book on ice skating, and another one on horse shows. For my regular employer, Harper & Row, I photographed the Catholic Worker, a relief shelter for the homeless on the Bowery, not far from my flat.

Often my wanderings took me through Washington Square, at the edge of Greenwich Village. There, I never tired of photographing people so engrossed in playing chess that they didn't seem to notice me. Only later would I learn that another distant god, photographer Andre Kertesz, was living in an upper-floor apartment of a tall building at the foot of Fifth Avenue at Washington Square, right above my head.

At exhibitions I pored over prints studying how photography's elder statesmen composed in blacks, whites, and grays to express their personal vision. A classicist at heart, I was indifferent to current rages. At museums I felt lucky to spend an hour staring at one picture, then leave—exhausted.

On the Lower East Side, I'd come a long way from the emotionally restrained, velveteen surrounds of upper-middle-class L.A. When my dressed-up, Ohio-born mother came to visit my apartment on teeming East Sixth Street, I wondered what she thought of the newspapers blowing along broken curbs past old men in suspenders sitting on stoops in front of tenements crowded with blacks and Puerto Ricans on the verge of a brawl. Did she have second thoughts about having brought me that first camera? She never said; I never asked.

left: Midtown, New York City · 1963

43

East Sixth Street, New York City · 1962

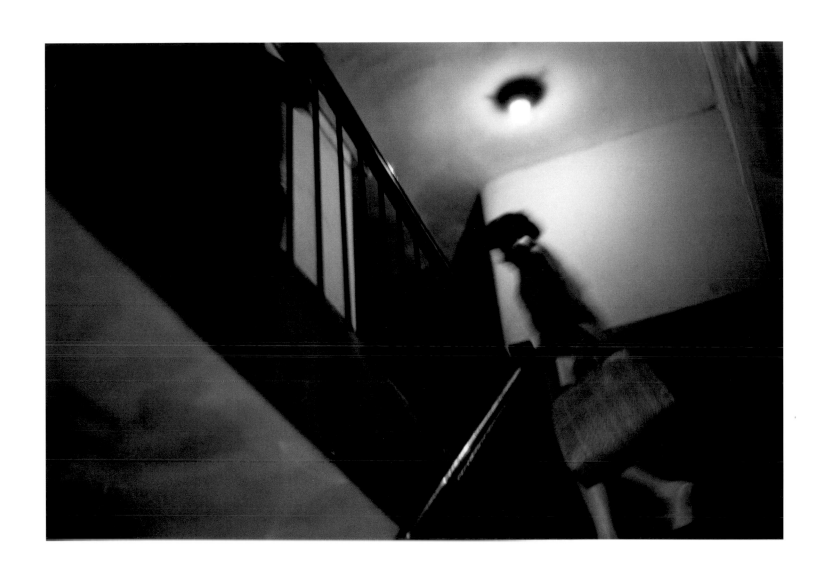

East Side, New York City · 1963

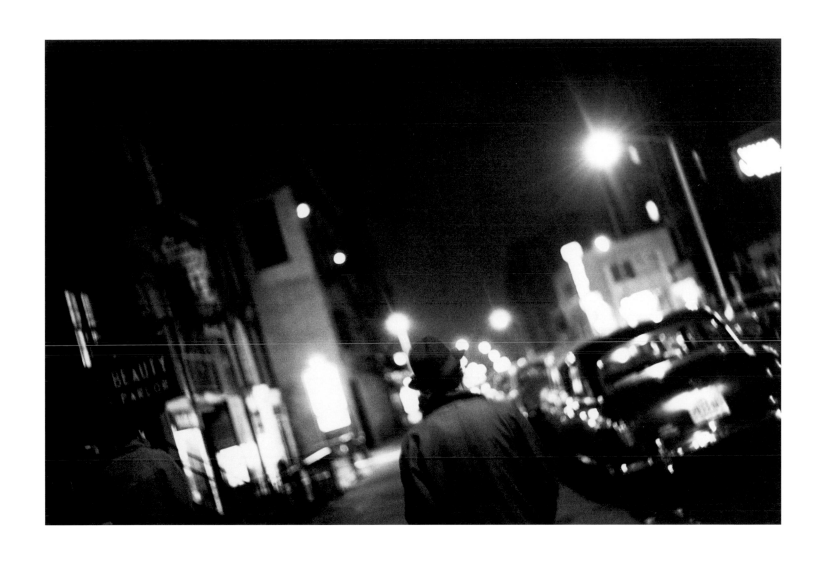

Lower East Side, New York City · 1963

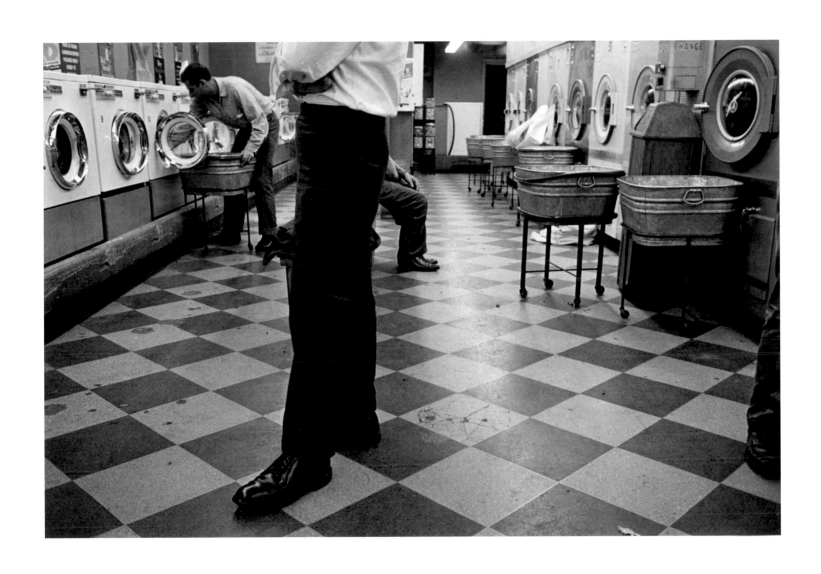

Midtown, New York City · 1963

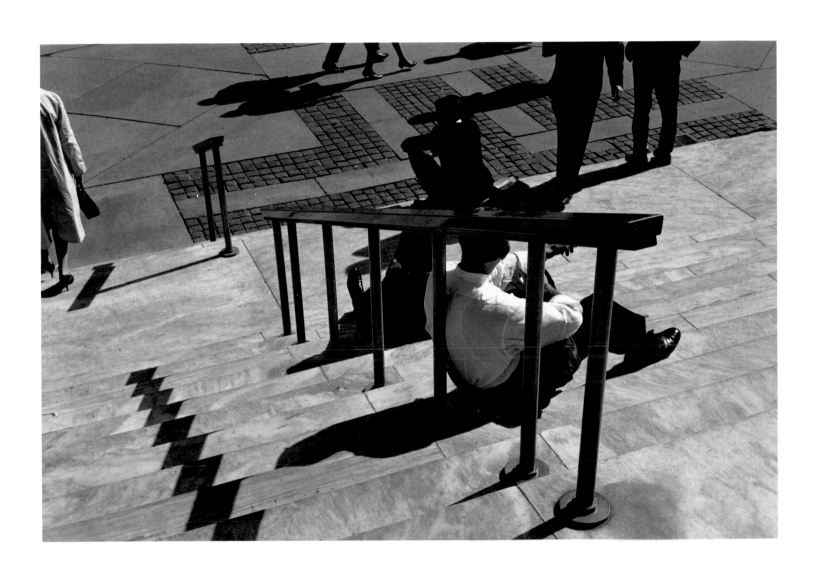

Midtown, New York City · 1963

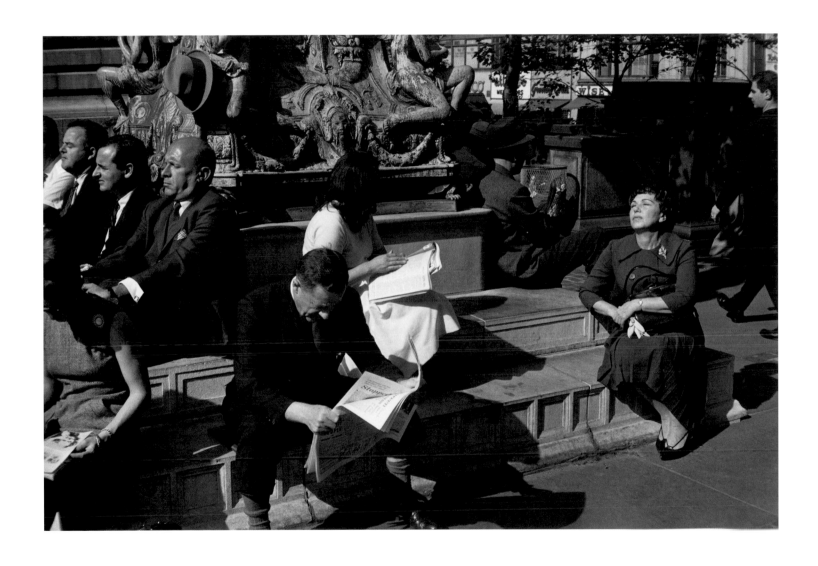

The Bowery, New York City · 1963

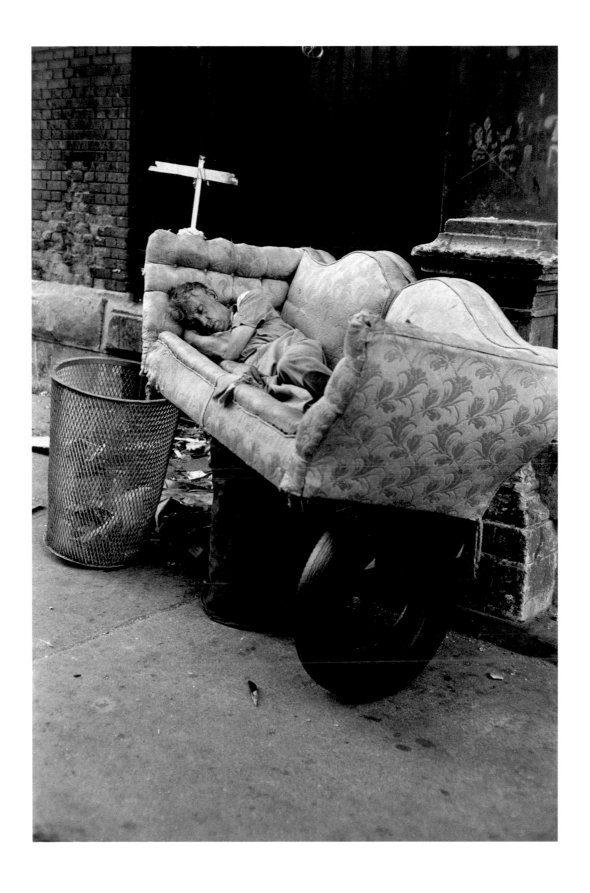

The Bowery, New York City · 1962

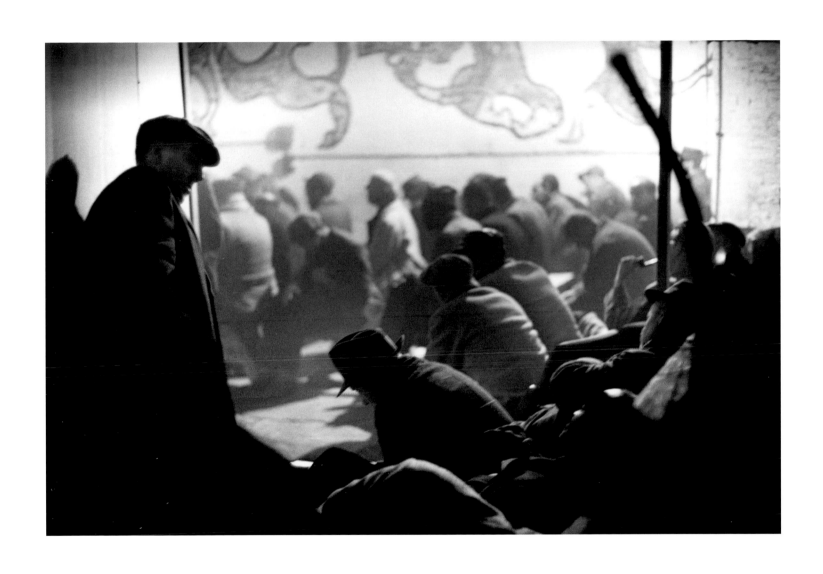

The Bowery, New York City · 1963

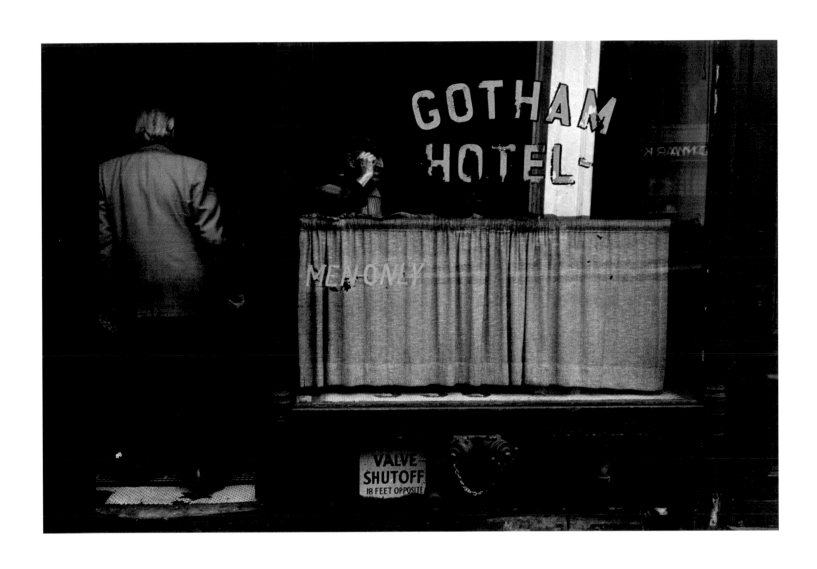

Lower East Side, New York City · 1963

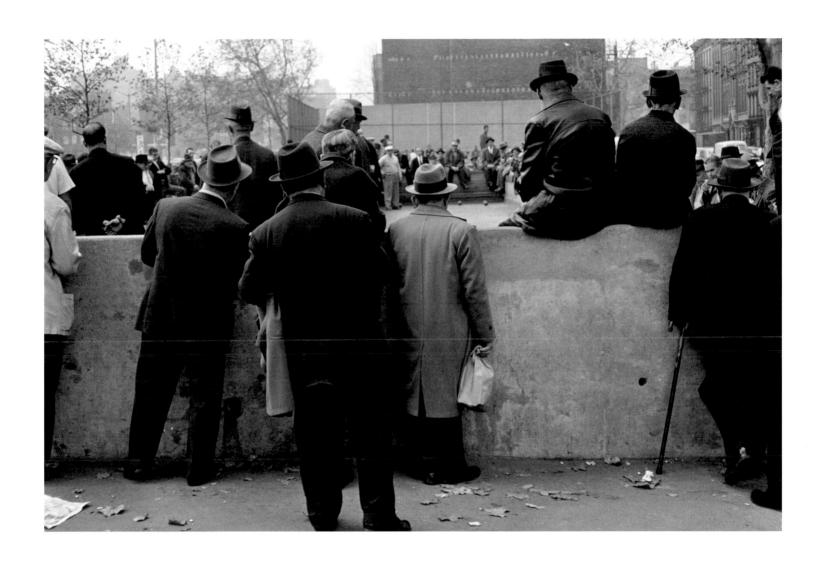

Lower East Side, New York City · 1962

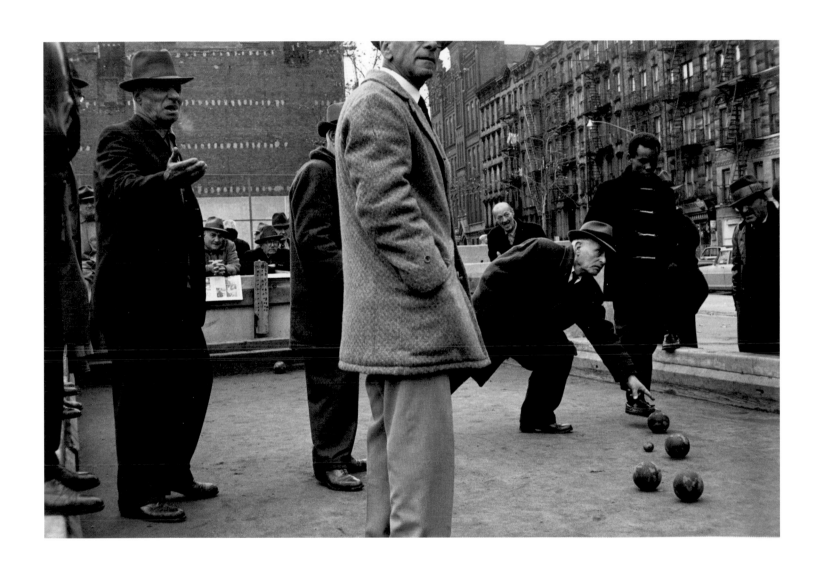

Washington Square, New York City · 1963

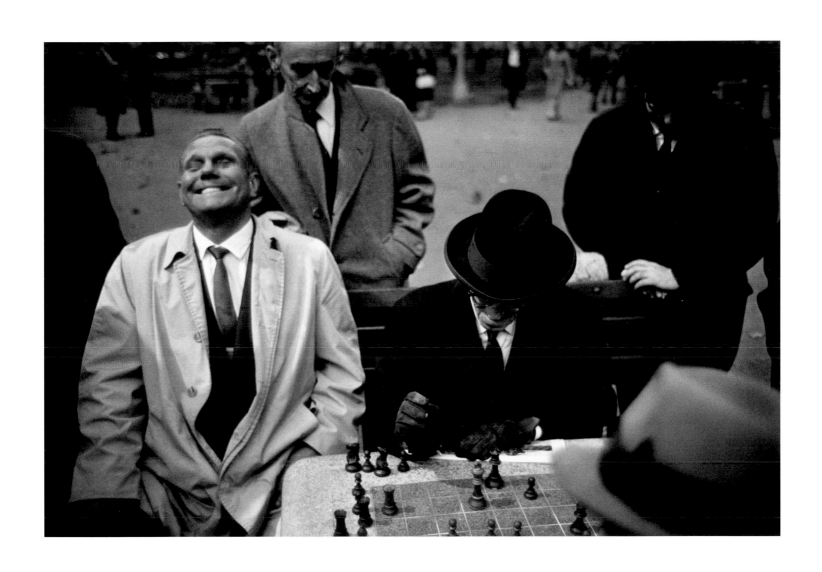

Washington Square, New York City · 1963

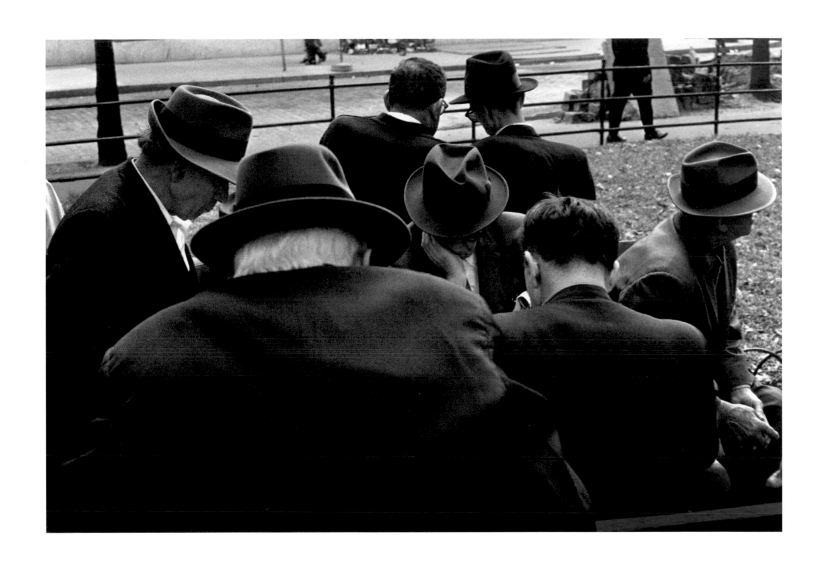

Lower East Side, New York City · 1963

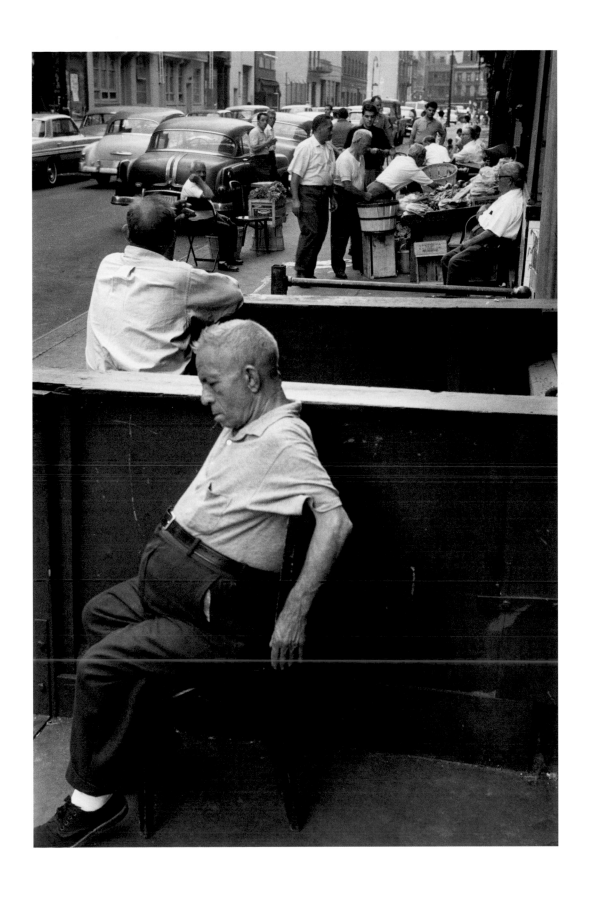

Lower East Side, New York City · 1963

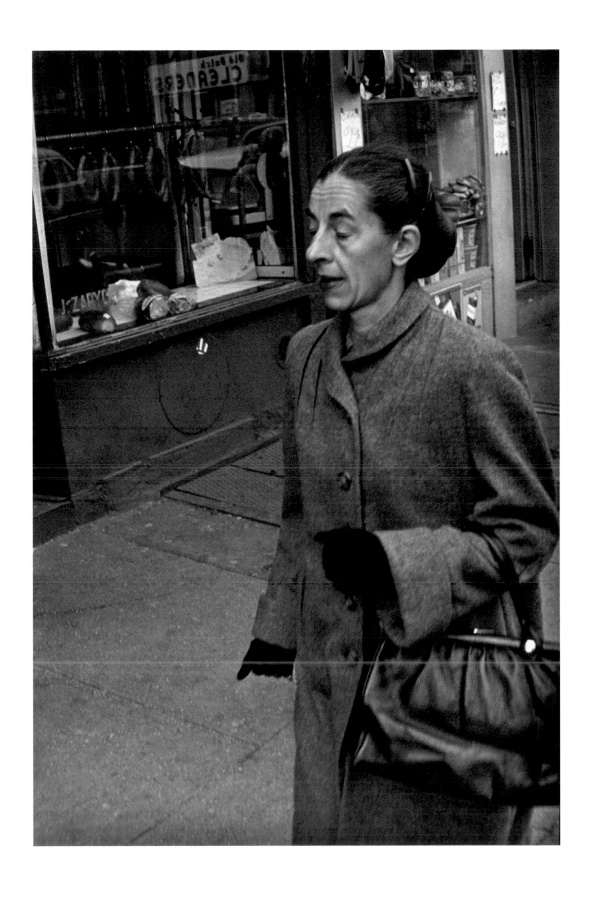

East Harlem, New York City · 1962

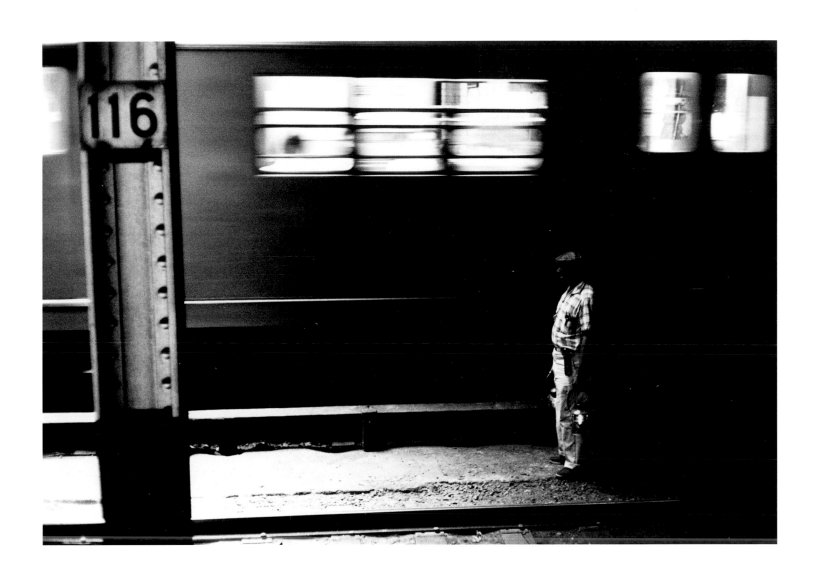

New York City · 1963

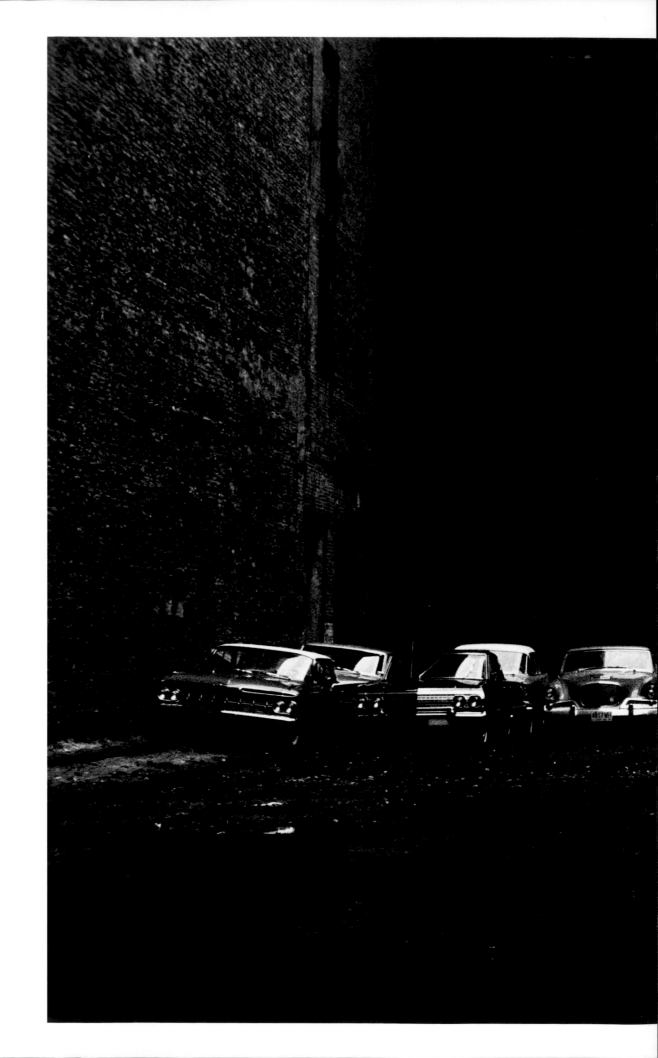

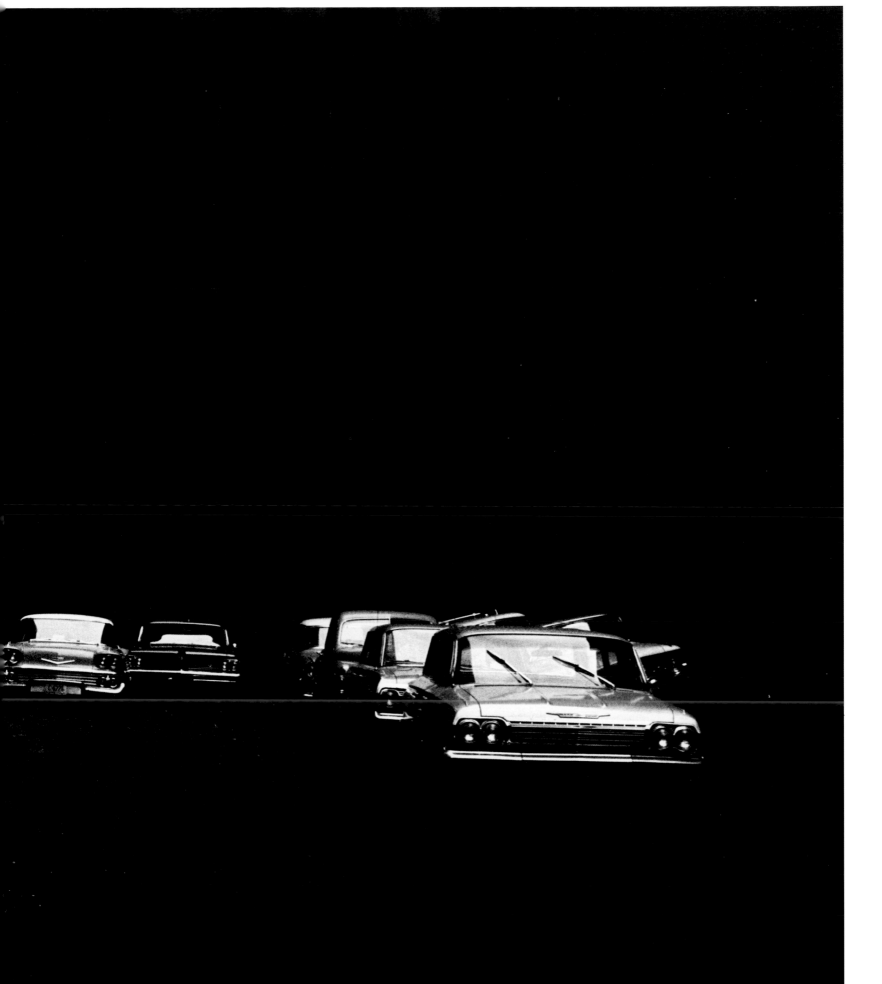

ever

present

never

twice

the

same

ever

changing

never

less

than

whole

ROBERT IRWIN

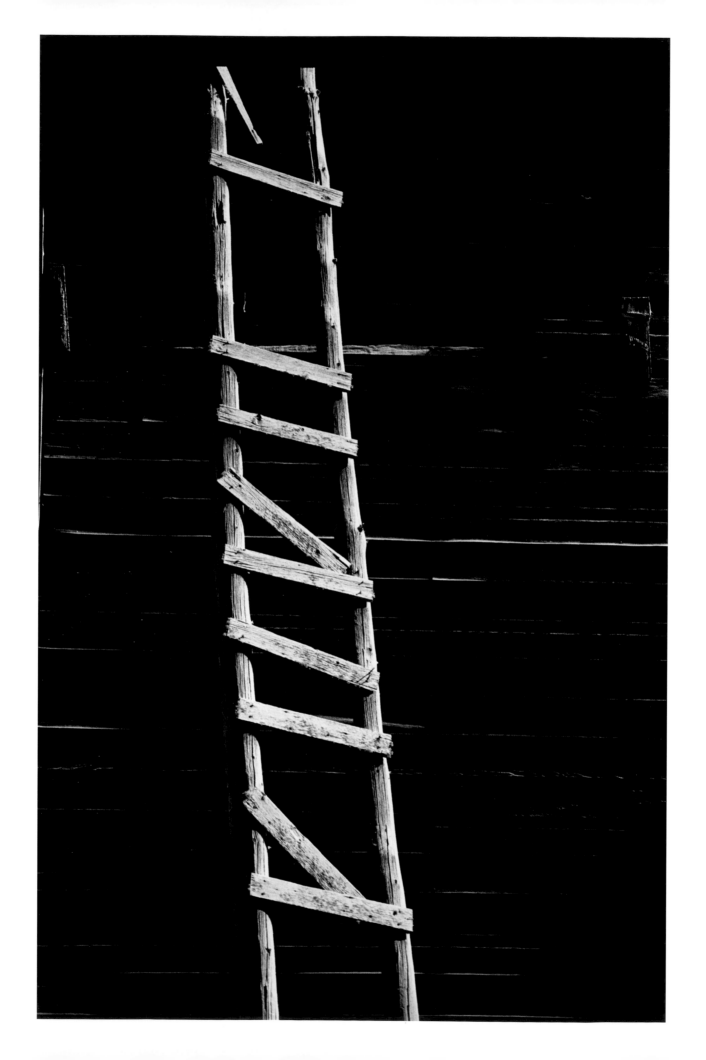

Pioneers

I traveled widely across America, searching out strands of the national character, and of myself. I drove a four-wheel-drive camper truck over the back roads of ten states, looking for creaking ghost towns and the histories of those who had inhabited them—the rough-and-ready miners who blasted open the Far West following the Gold Rush, helping shape who we are as a people.

* * *

Then I explored the Middle Western heartland. Like many, in the late 1920s my mother's father had closed his general store in a small Ohio town, and moved his family to California. In the corn belt and upper Midwest, between the Ohio River and the Canadian border, I found clues to our historical identity as the practical, God-fearing, progress-minded middle Americans who continue to plant the seeds and mind the store.

In New Orleans, I pursued another longtime passion: traditional jazz. I hung out with, and photographed, many of the earlier generations of musicians who created America's most original and enduring art form. I also learned why New Orleans has been called "the most European city in America."

* * *

Three books of pictures and text came out of these journeys. Extension of the eye and constant companion, my camera remained an essential window on the world of people.

Searching for—and finding—inner meanings in outer phenomena remained my modus operandi.

left: Eastern Oregon · 1970

Bodie, California · 1969

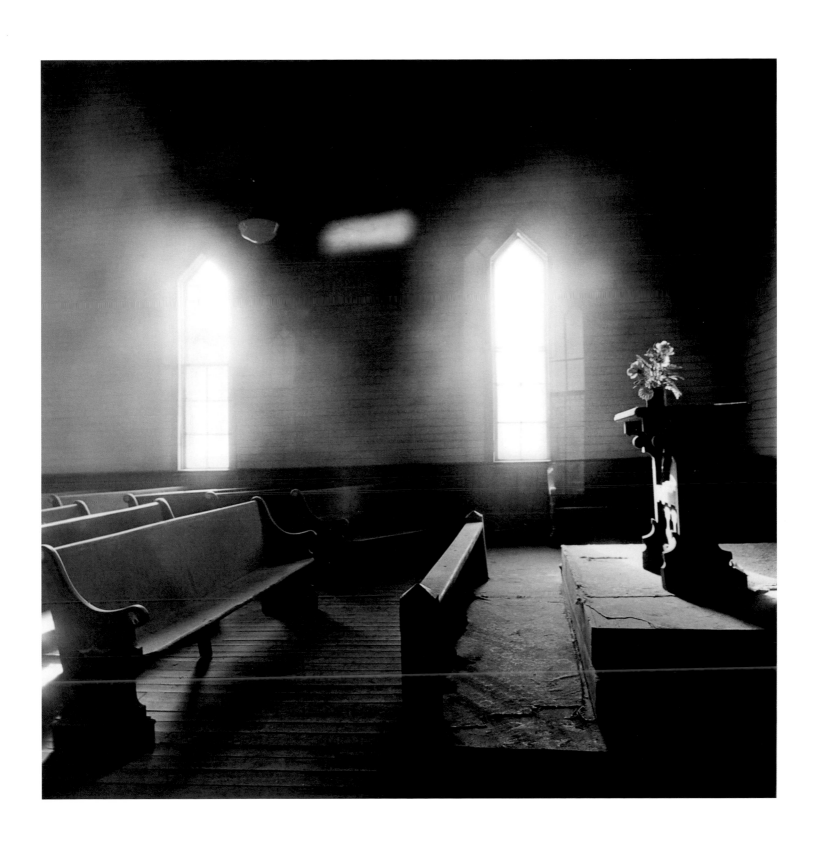

Mogollon, New Mexico · 1970

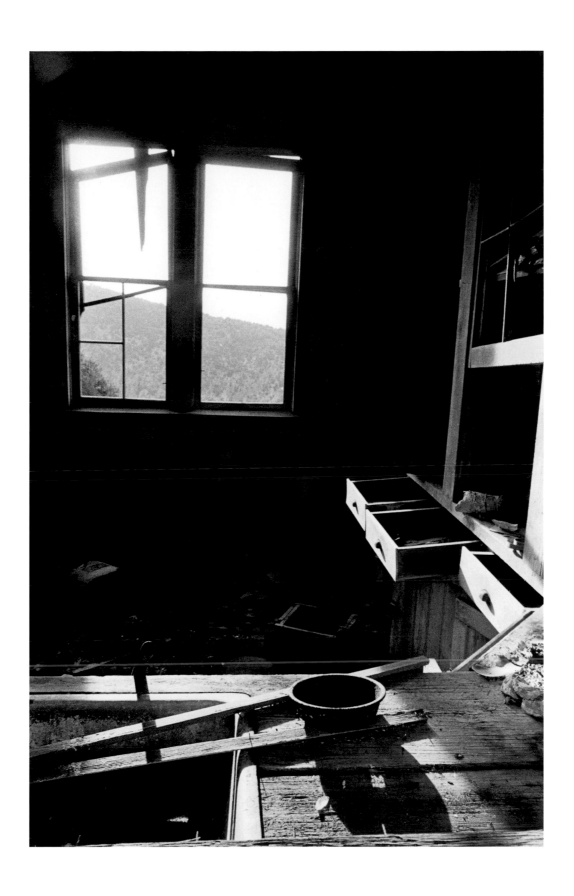

Rhyolite, Nevada · 1970

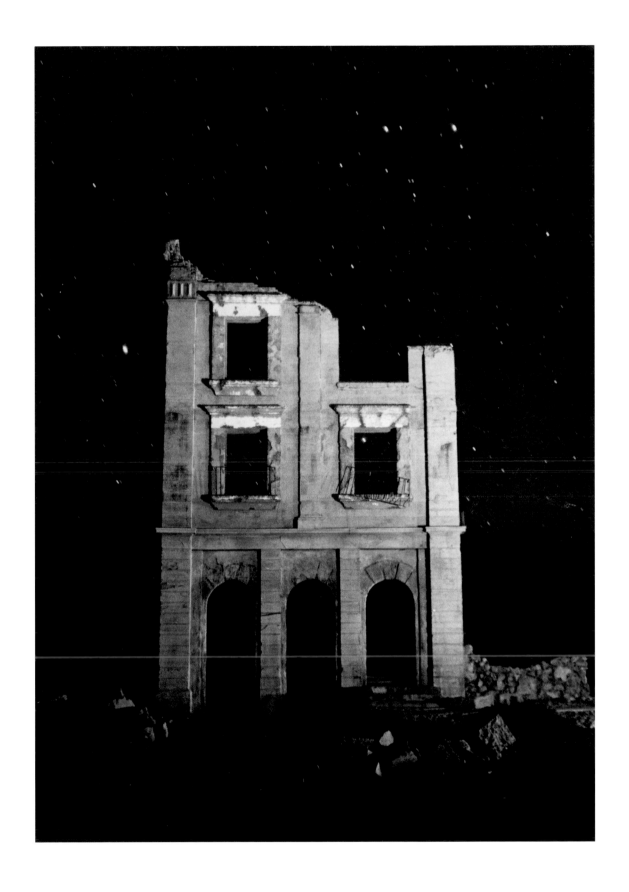

Reno, Nevada · 1962

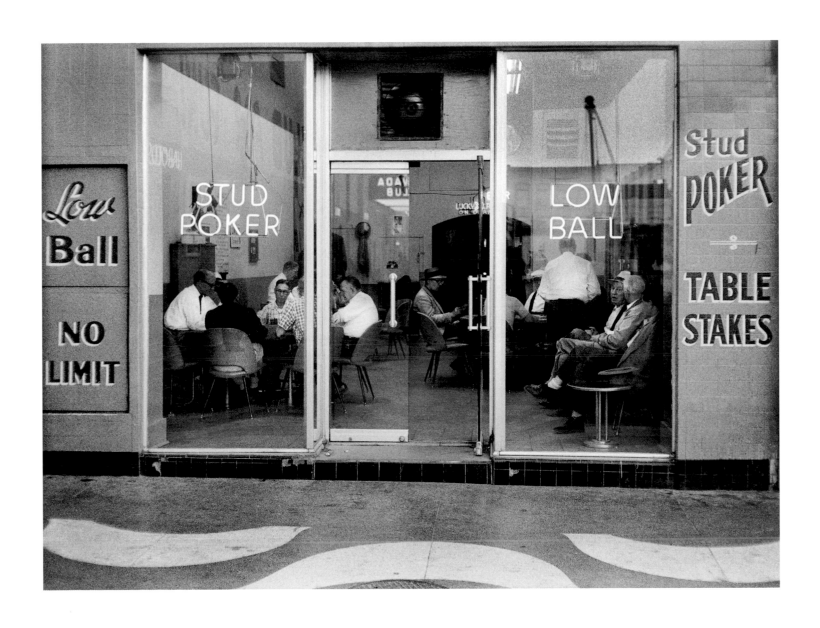

Central Nebraska · 1962

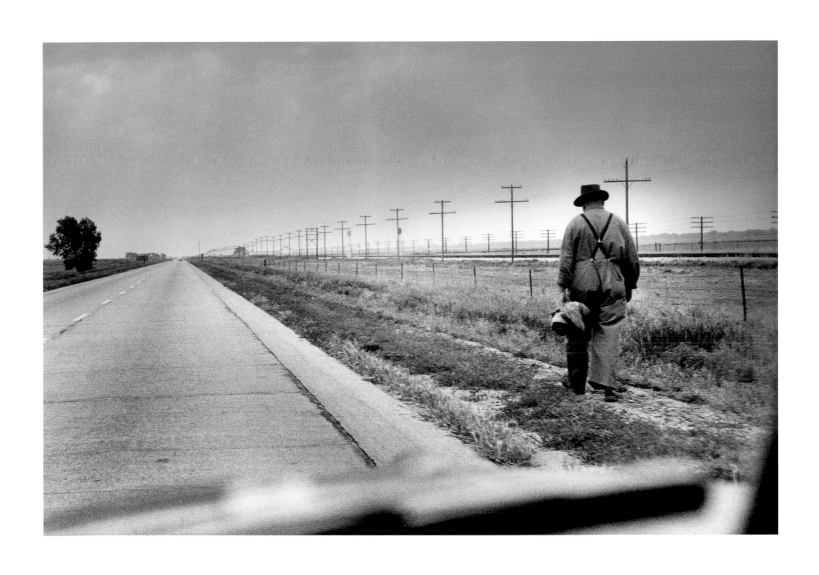

Southern Indiana · 1973

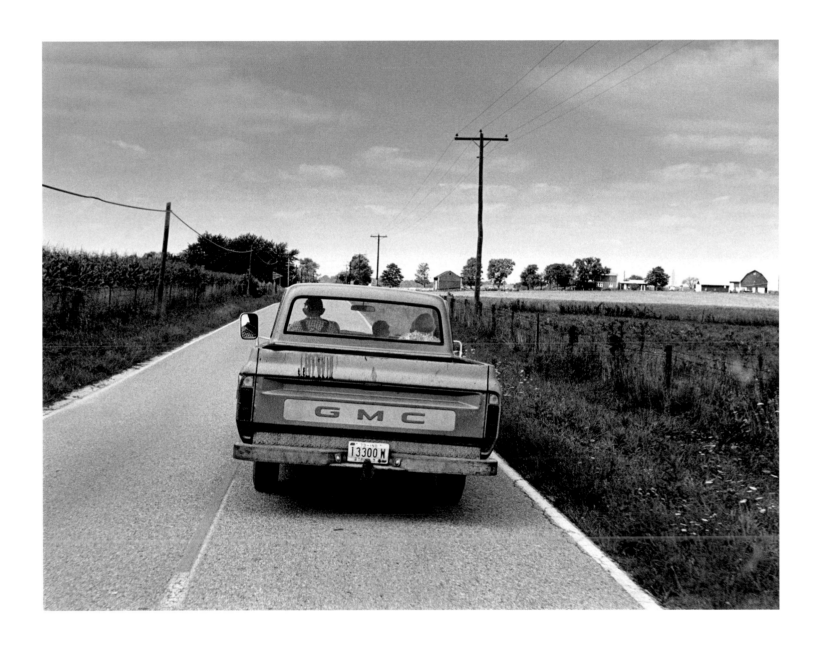

San Francisco · 1969

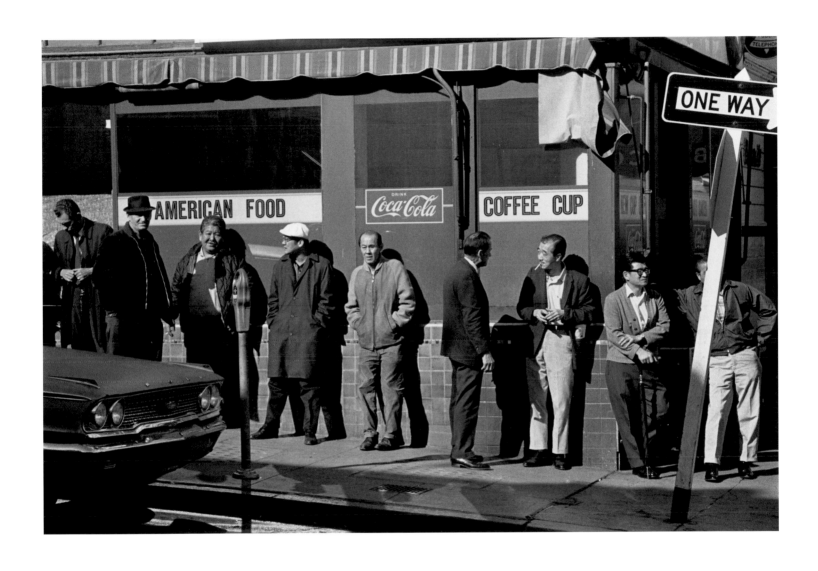

Northern Minnesota · 1973

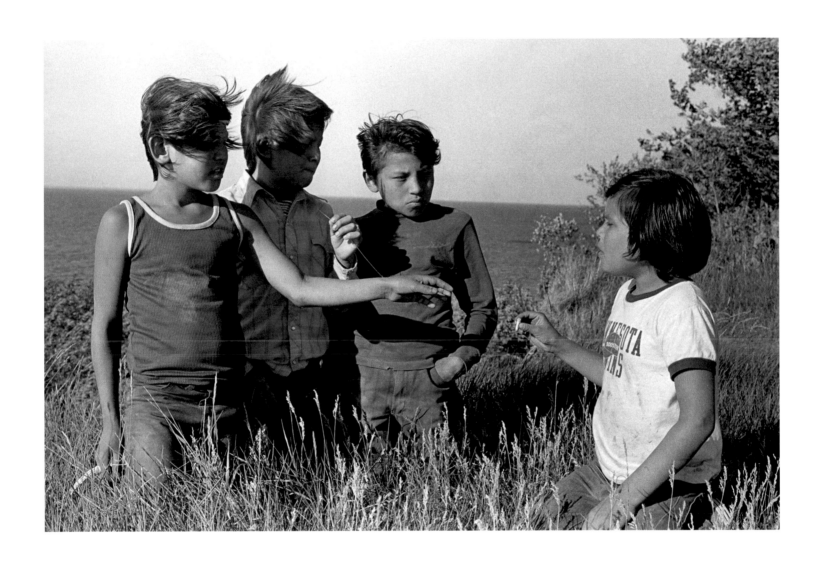

Northern Minnesota · 1973

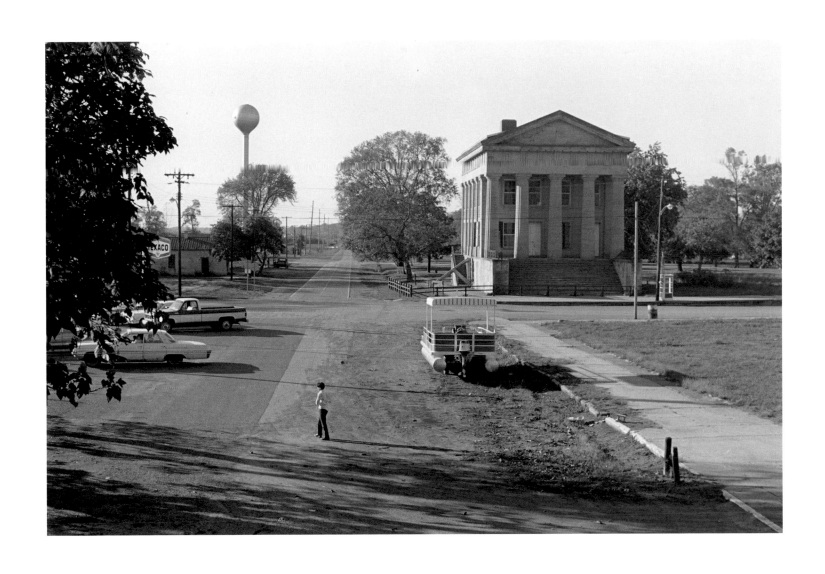

Northern Minnesota · 1973

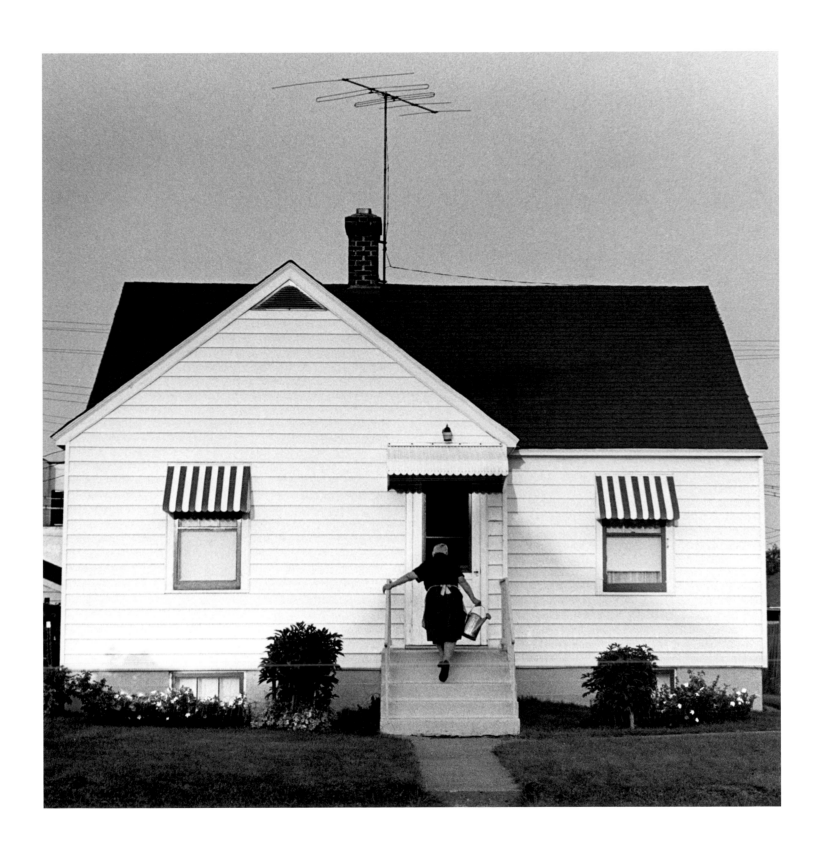

Kansas City, Missouri · 1974

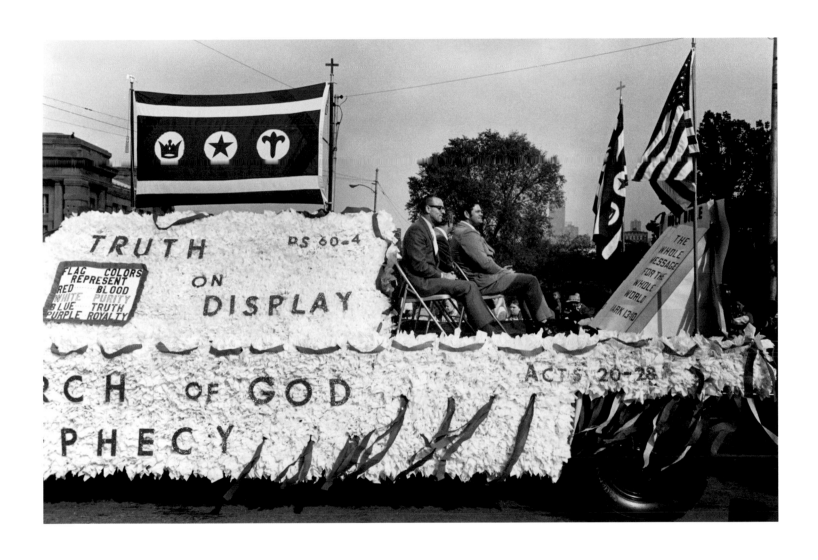

West Pittston, Pennsylvania · 2010

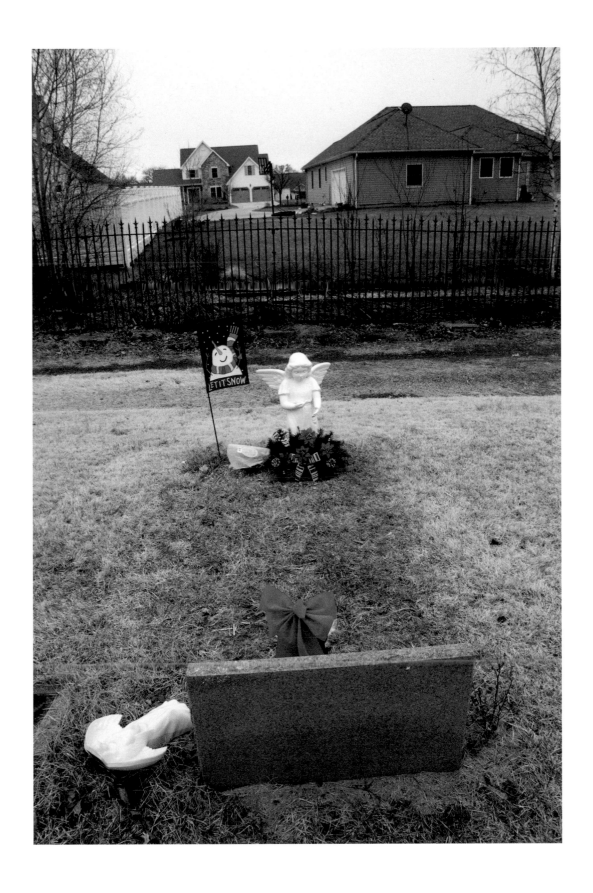

Near Jerome, Arizona · 1970

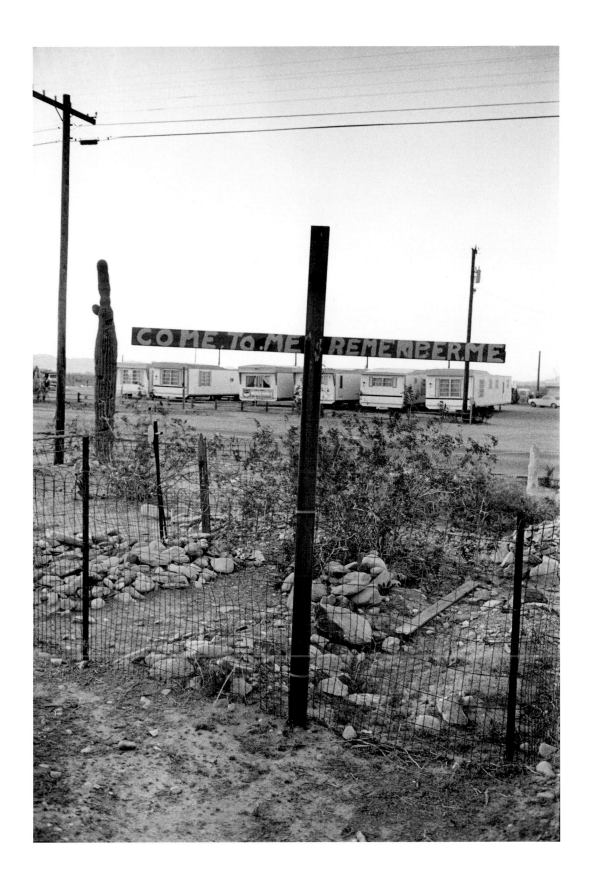

105

Near Jerome, Arizona · 1970

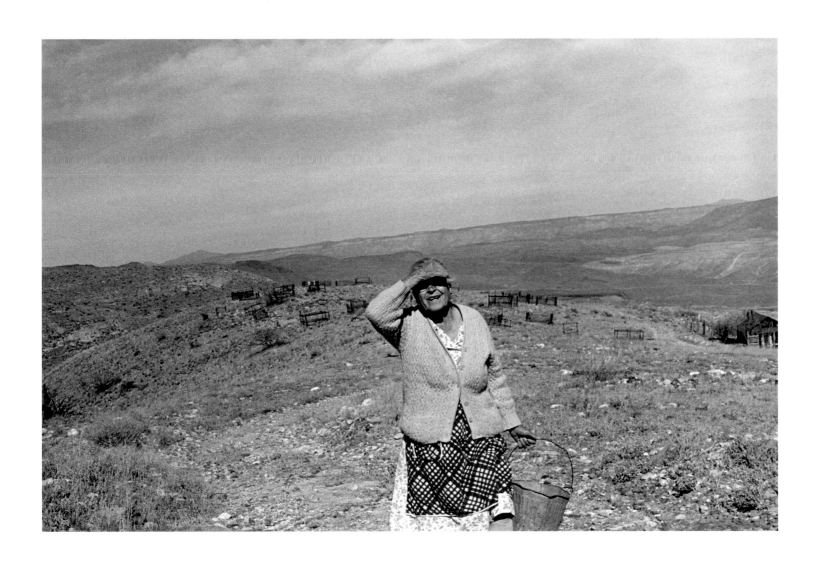

Southern Indiana · 1973

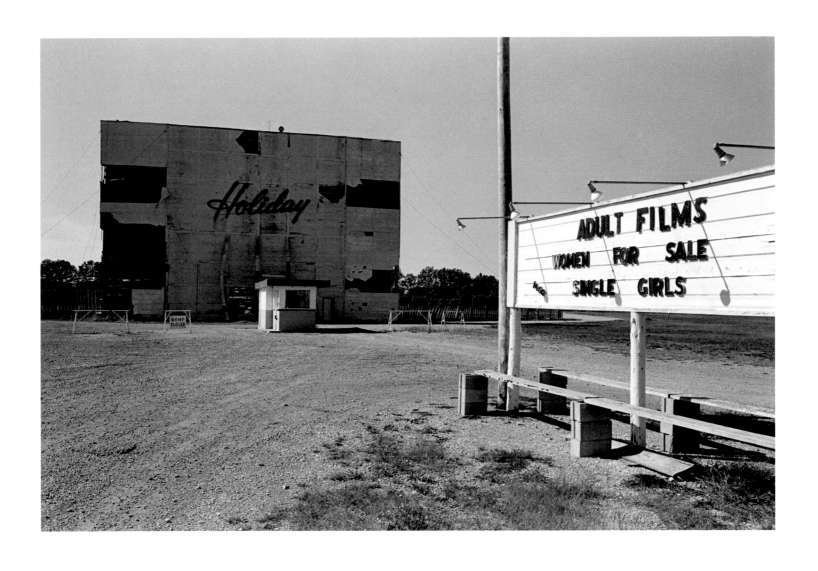

Central City, Colorado · 1970

New Orleans · 1985

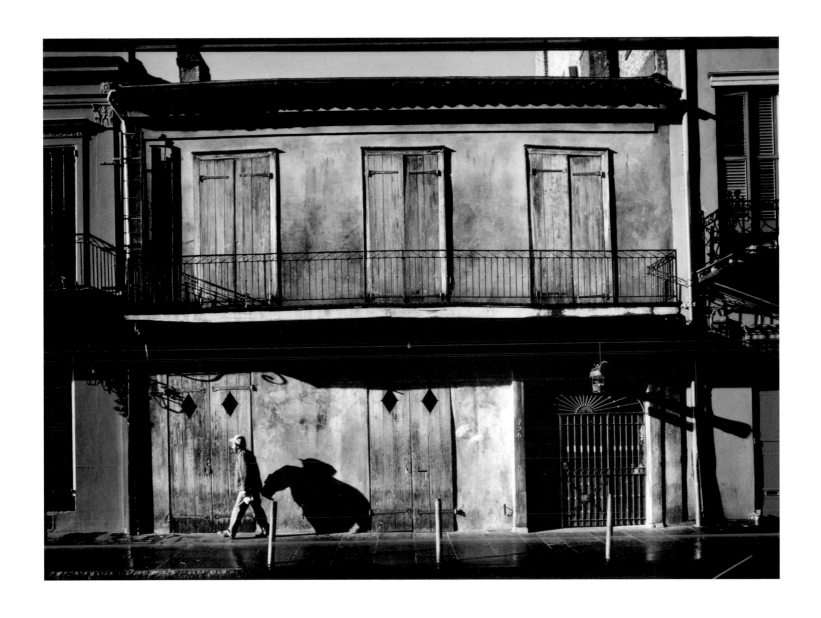

New Orleans · 1985

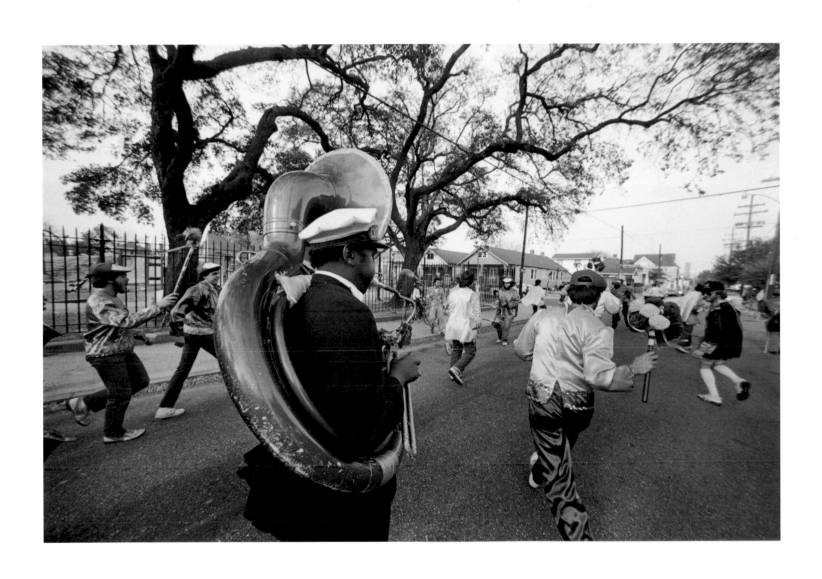

Oakville, California · 1971

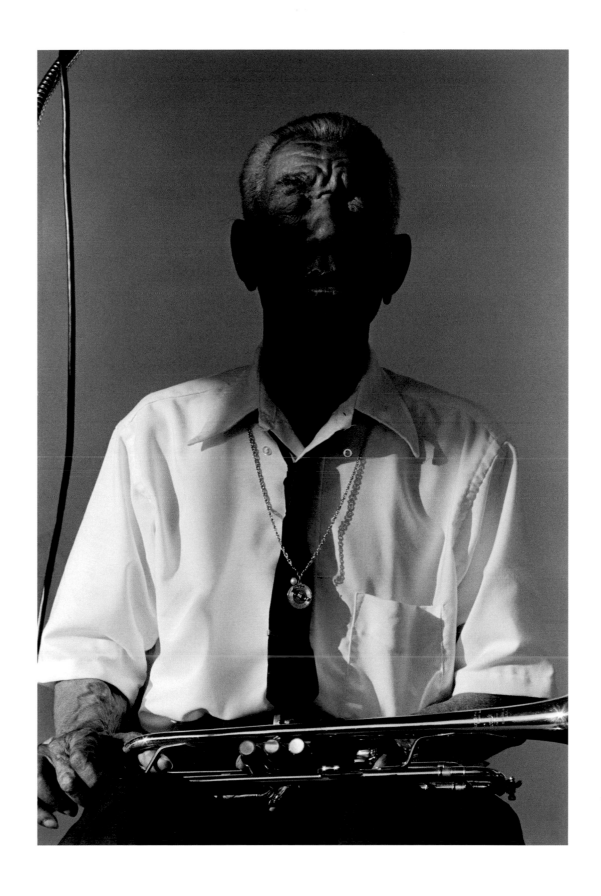

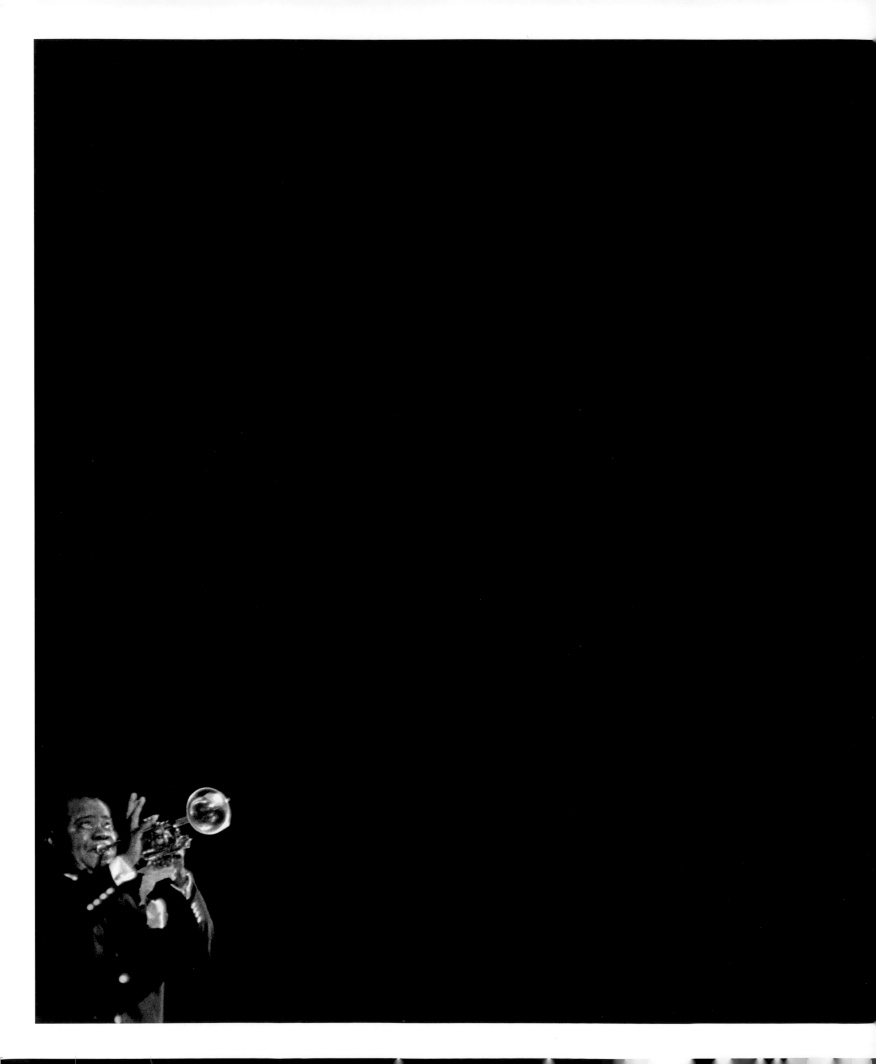

Louis Armstrong:
Cornell University, New York · 1962

Seattle · 1962

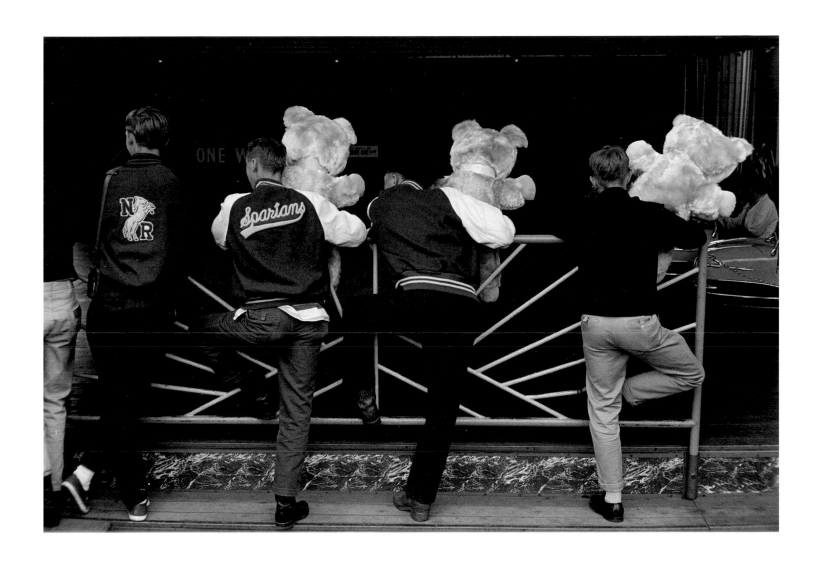

Oakland, California · 1961

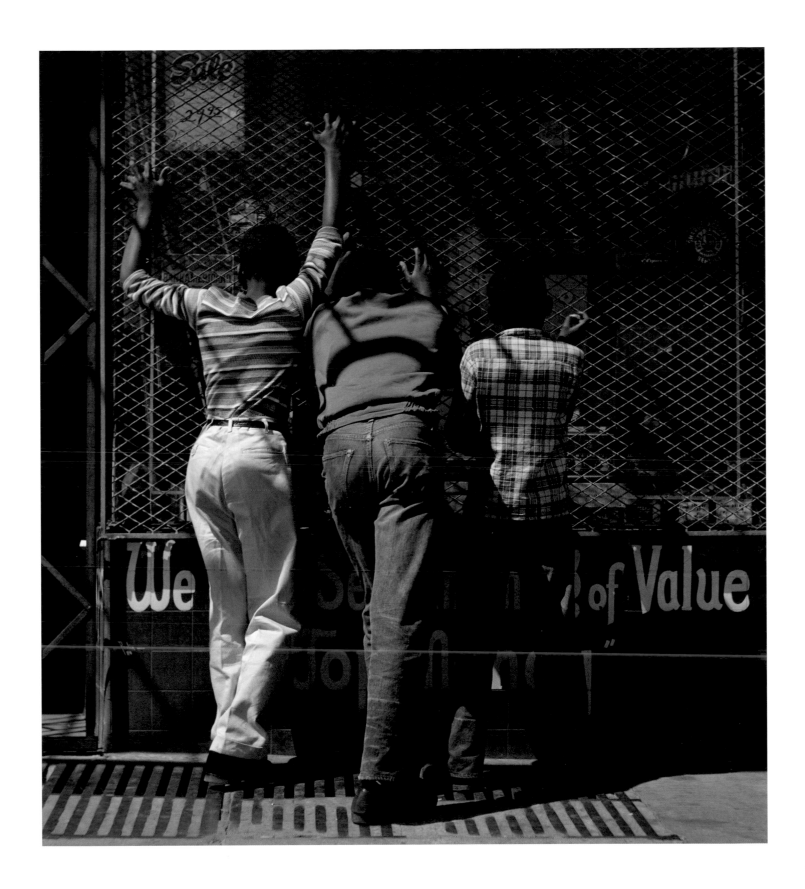

Detroit · 1973

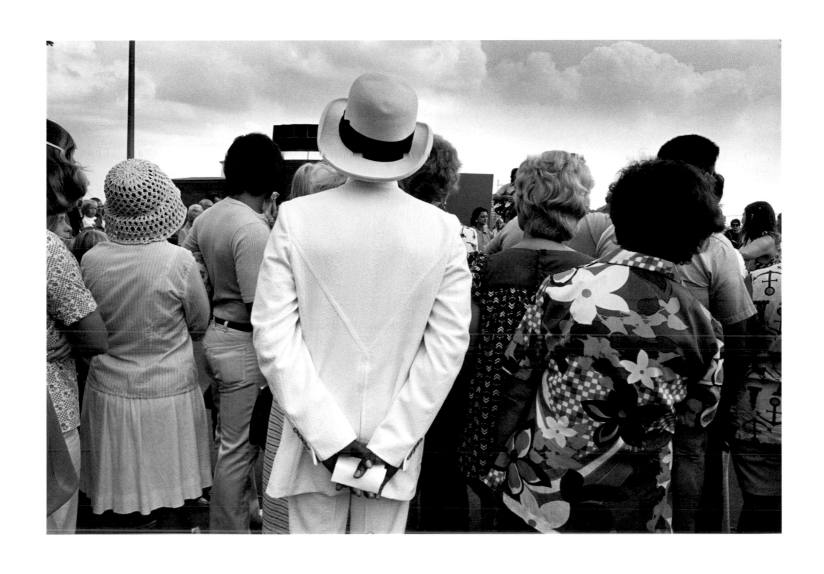

Geneseo, Illinois · 1973

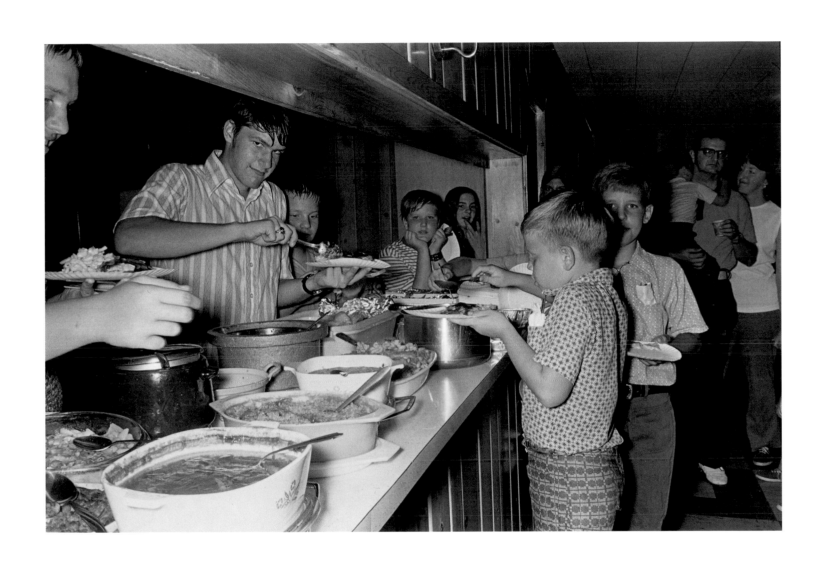

Geneseo, Illinois · 1973

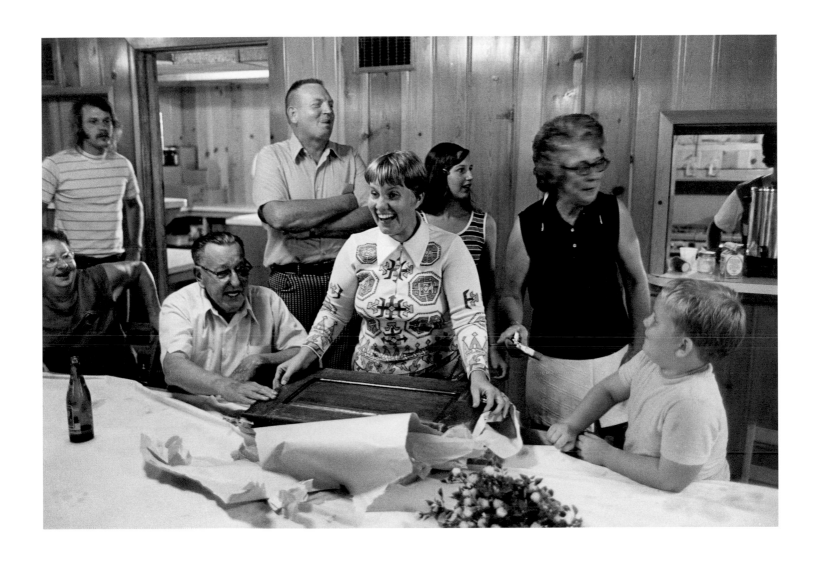

Indianapolis, Indiana · 1973

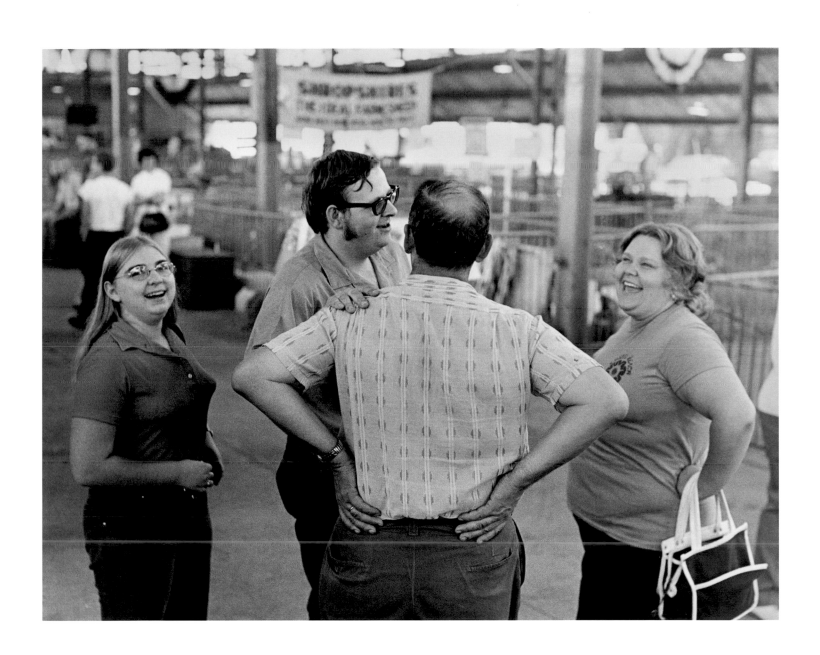

Southern Illinois · 1973

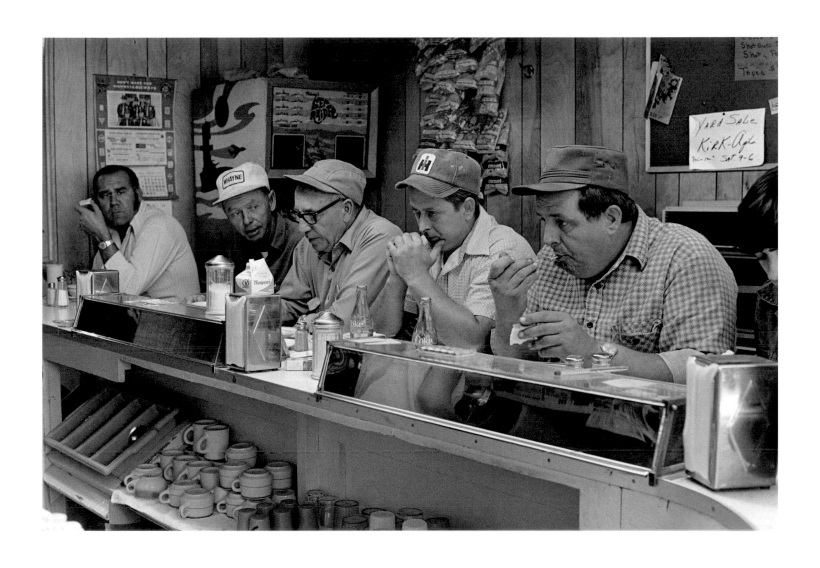

Southern Illinois · 1973

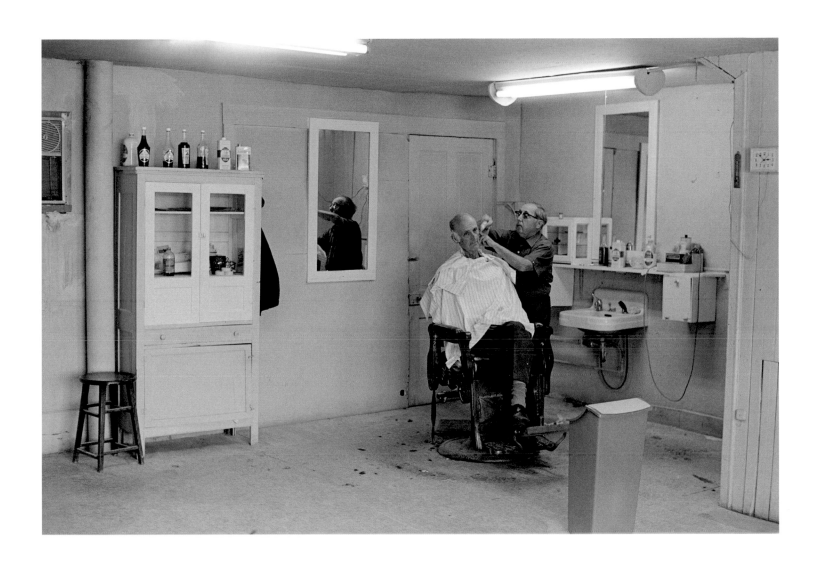

Southern Illinois · 1973

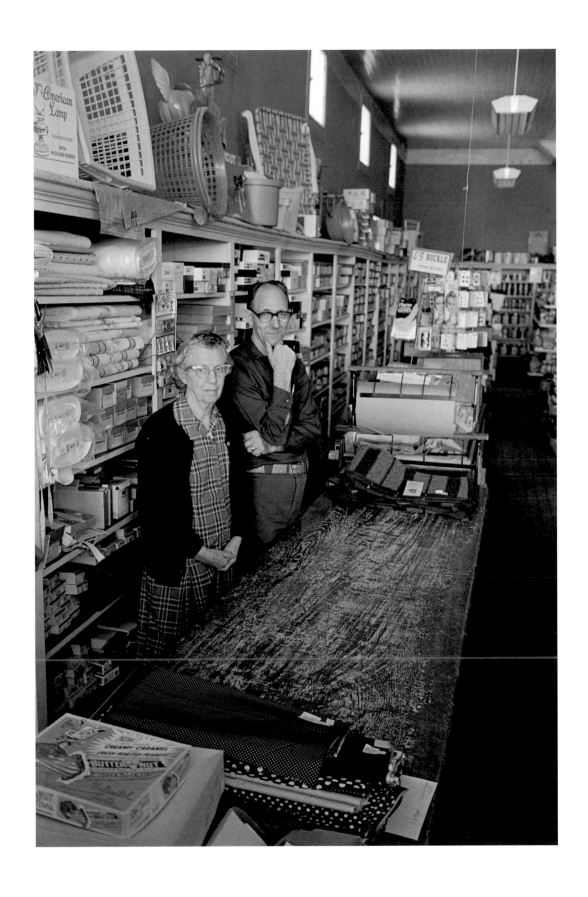

Southern Illinois · 1973

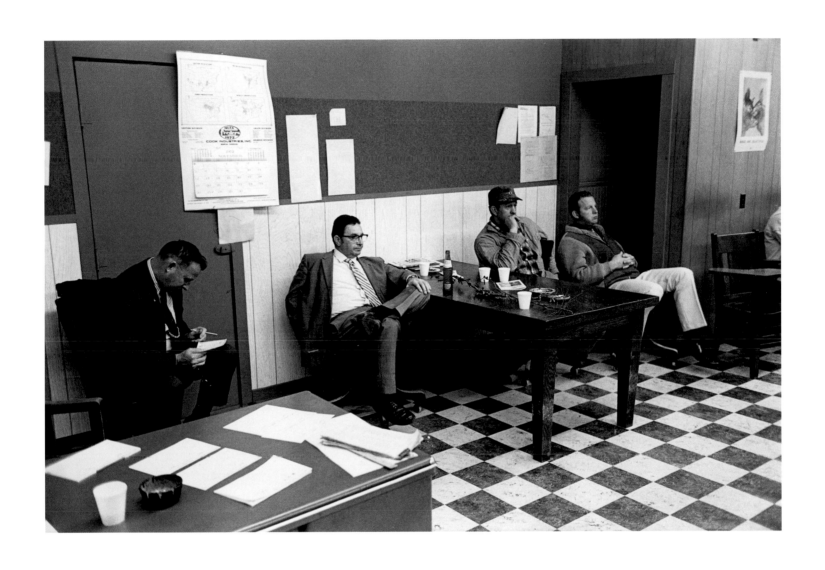

Indianapolis, Indiana · 1973

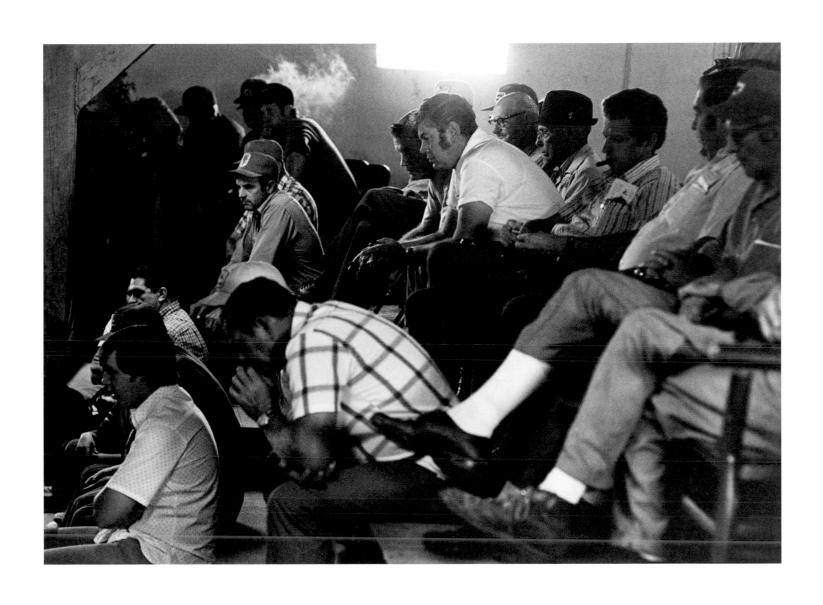

Detroit · 1973

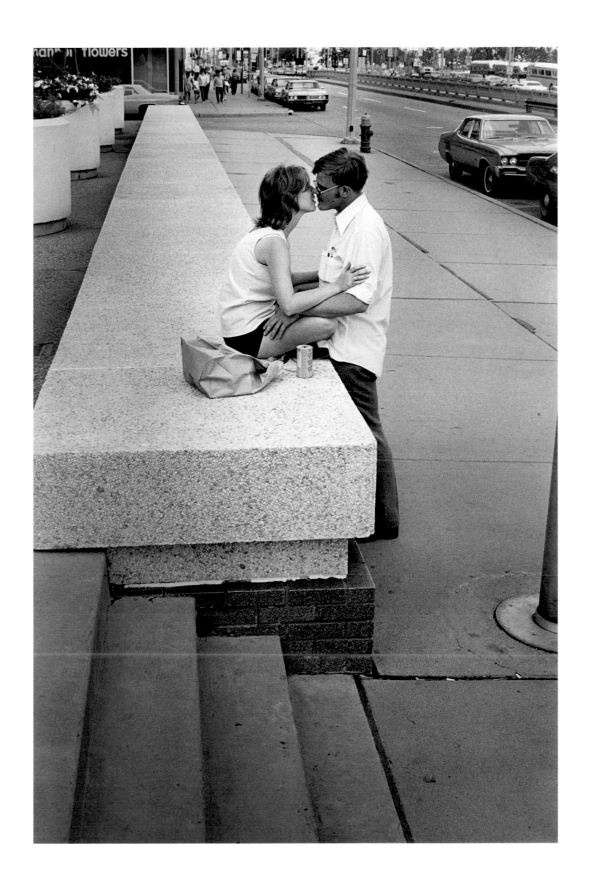

Chicago · 1962

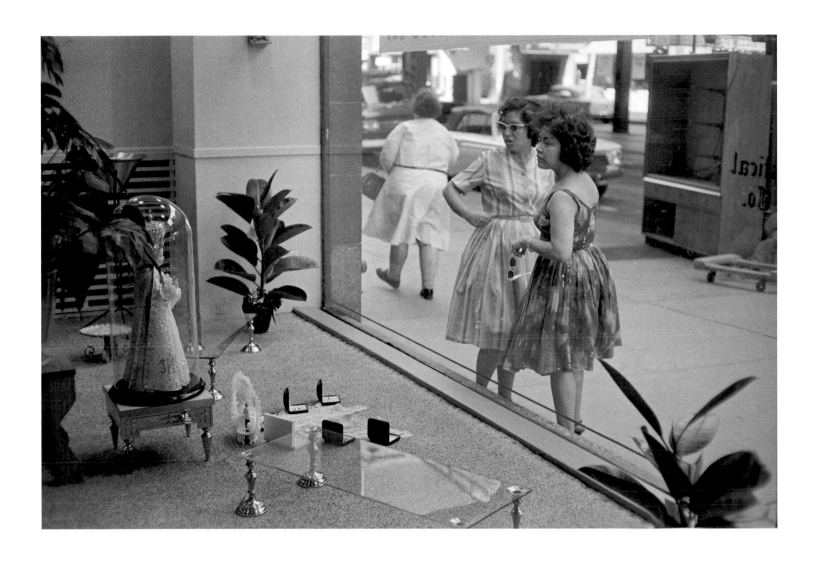

Marin County, California · 1970

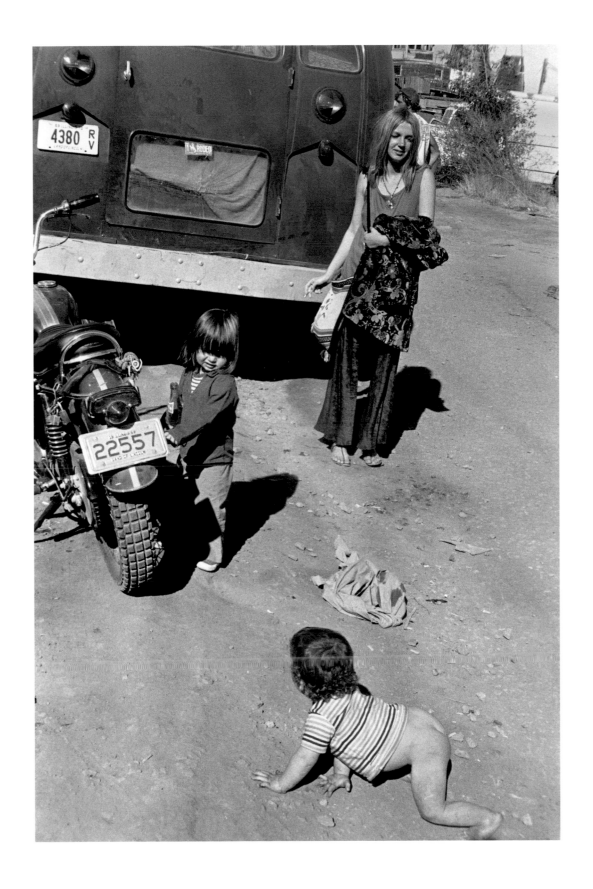

Seattle · 1962

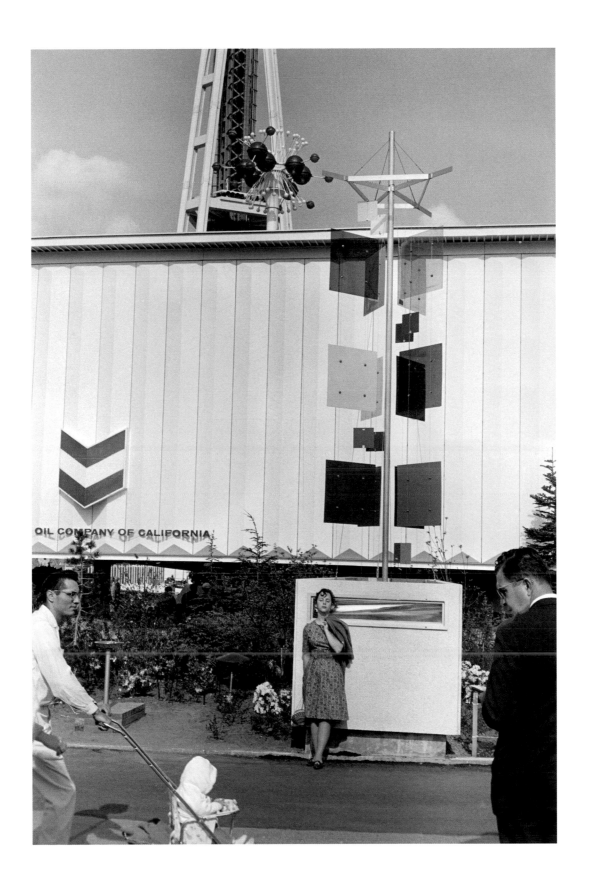

Mississippi River, Bellevue, Iowa · 1973

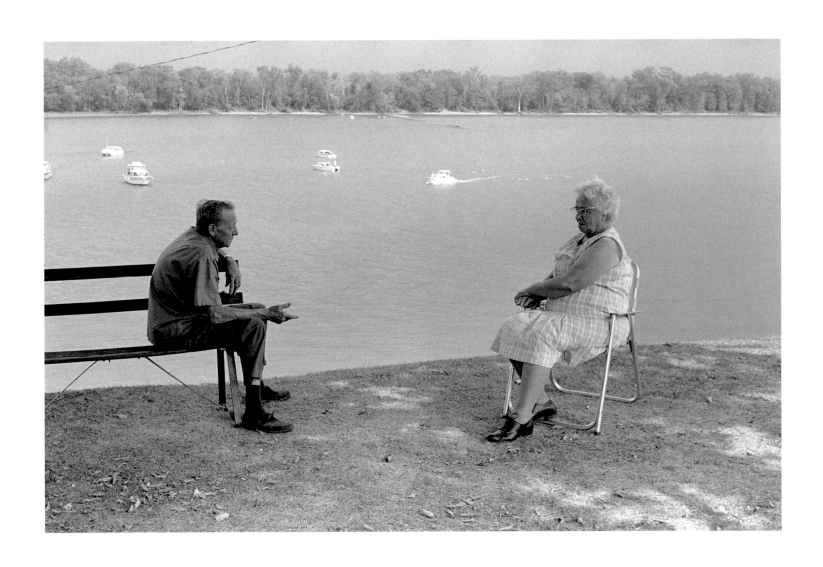

Northern Illinois · 1973

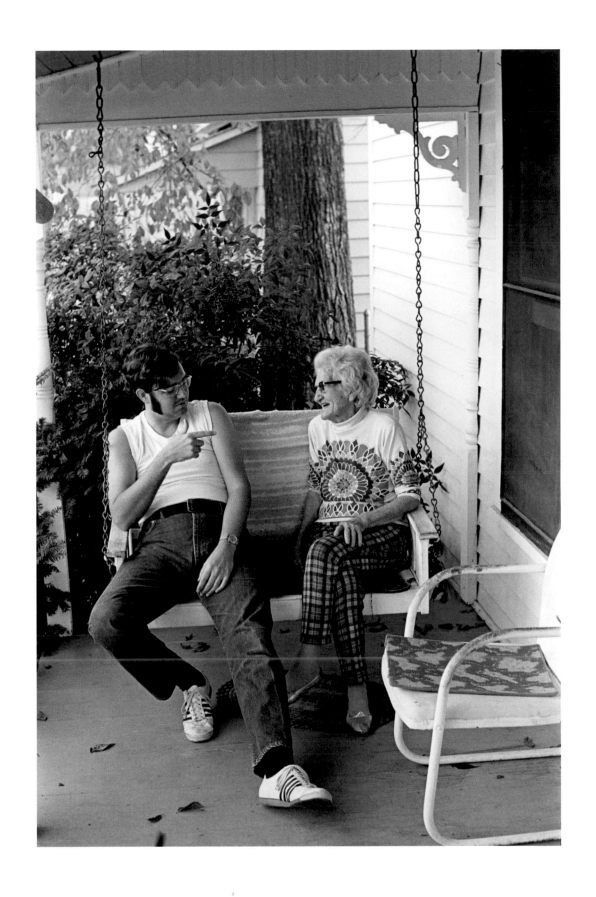

Atherton, California · 1972

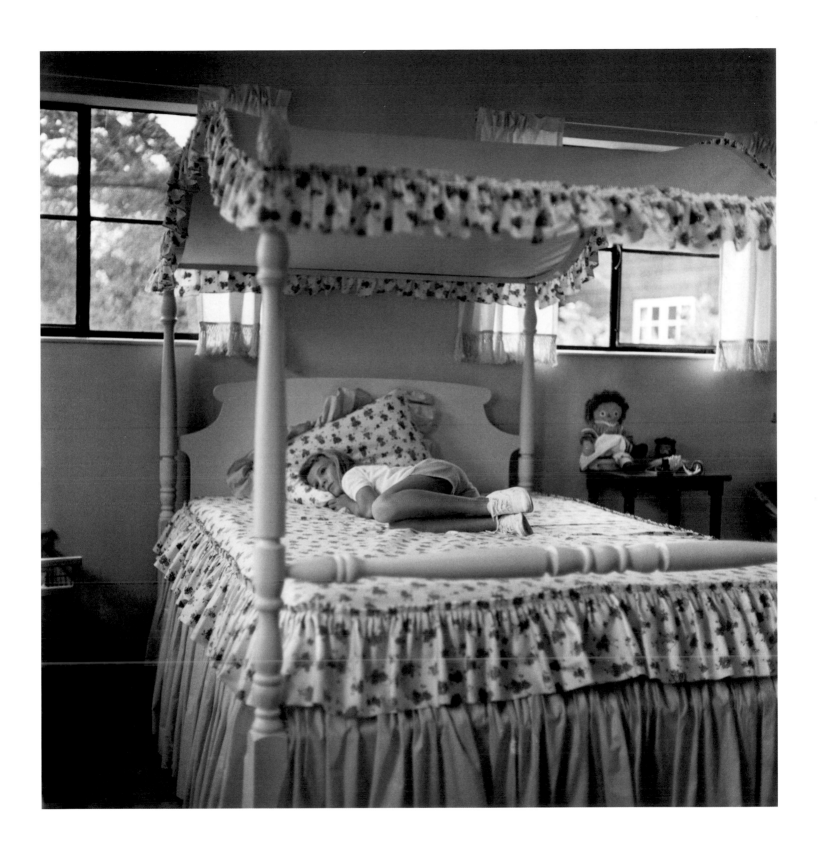

teach us to care...

...and not to care

T. S. Eliot

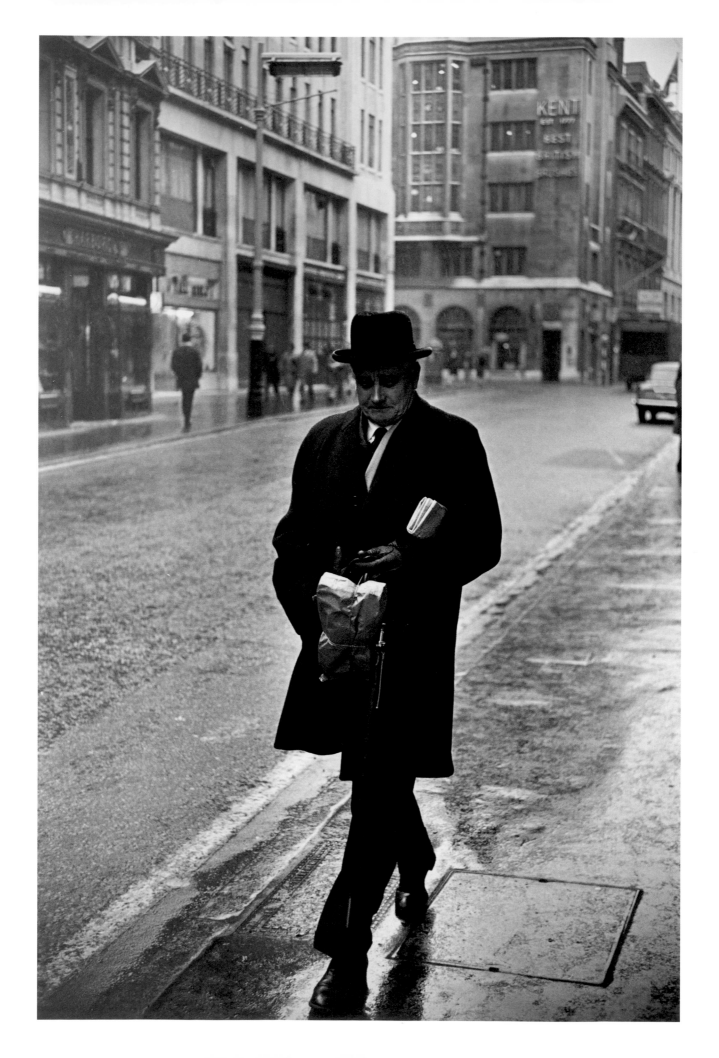

Eyes in the Street

Whereas Manhattan, for me, had begun and ended within one sharply defined neighborhood—the Lower East Side—London was more like life in a traffic circle. I lived upstairs over a cafe on Shaftesbury Avenue, near Picadilly Circus. The Number 24, 22, and 19 buses stopped right below my window; people riding on the upper deck were only a few feet from my second-floor breakfast table, but with British discretion their eyes seemed not to notice my American stare. I tried to photograph them—without success.

I was tempted to adopt England as my own. My British friendships proved to be few, but lifelong. These were somehow an object lesson in this parliamentary democracy's ability to span a huge, potentially discordant diversity, just as it had once bestrode a worldwide empire. I became a godfather in Salisbury Cathedral; forty years later I would return to the christening of *his* son in a village near Salisbury.

The sixties were an exciting time to be in a London poised between bowler-hatted bankers, Beatles fans, Carnaby Street, and the still widespread impoverishment of postwar England. The British Museum and National Gallery were five minutes from my flat; I could spontaneously spend half an hour with the Chinese bronzes, or with Titian, or with Modigliani and Cezanne over at the Courtauld. Some Sundays I sat in playing clarinet in traditional jazz pubs.

Many of my assignments were for Fairchild, publisher of Women's Wear Daily and other New York newspapers. Because fashions were being set in London before arriving in Manhattan six months later, it was vital for folks in New York's "rag trade" to see what was being worn on the streets of London. I roamed chic Chelsea, posh Mayfair, and the no-nonsense City, playing paparazzi to the pedestrians. Or I would accompany a correspondent to interviews with movie stars. Back in my darkroom in teeming, working-class Leather Lane, I developed the film, then rushed it to the Fairchild Bureau near Buckingham Palace to be air-freighted to Manhattan. I took off to France to cover the Winter Olympics, to Holland for a geographical story, and around the world for TWA's annual report.

Paradoxically, I was often lonely. I knew little, and cared less, about fashion or the famous. My self-assignment was to go beyond barriers of class and clothing to catch something of the common humanity in the faces hurrying by my lens.

Had I had a motto for those London years, it could have been a line from one of T.S. Eliot's dark London hymns:

"I have seen eyes in the street."

Dublin · 1967

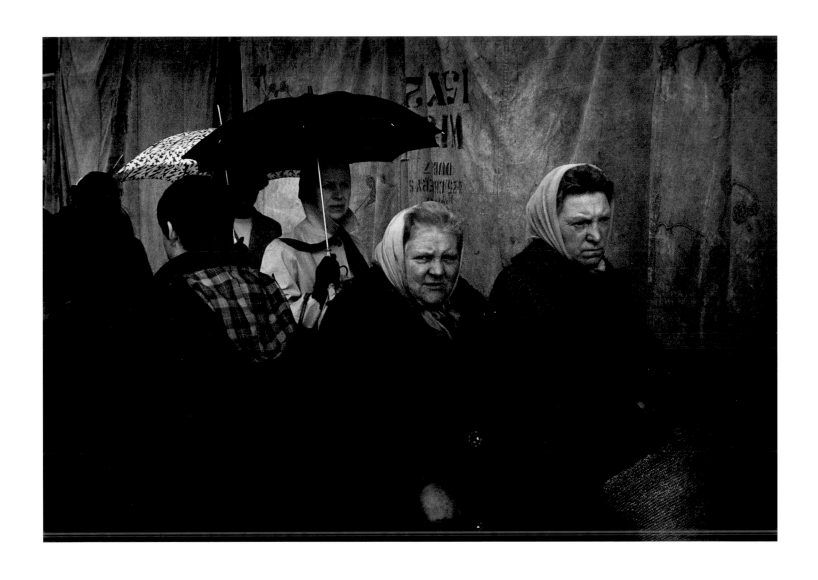

Covent Garden, London · 1964

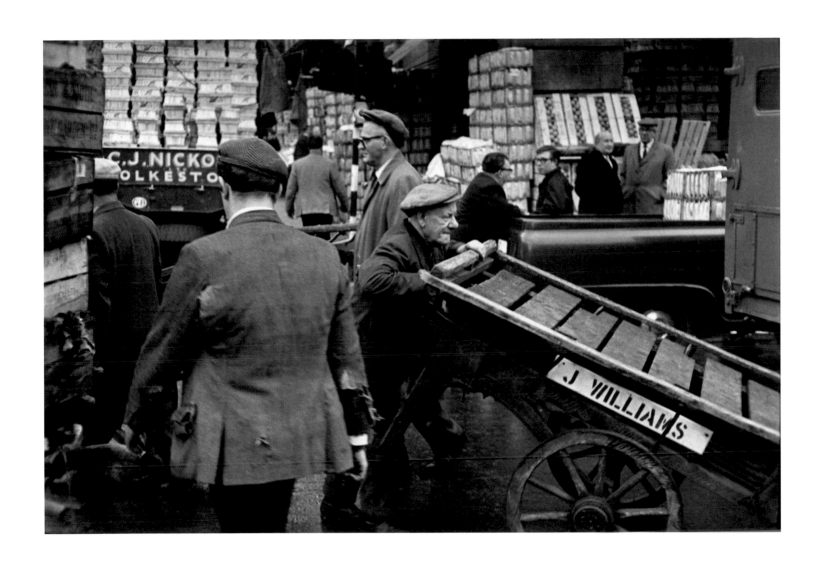

Covent Garden, London · 1964

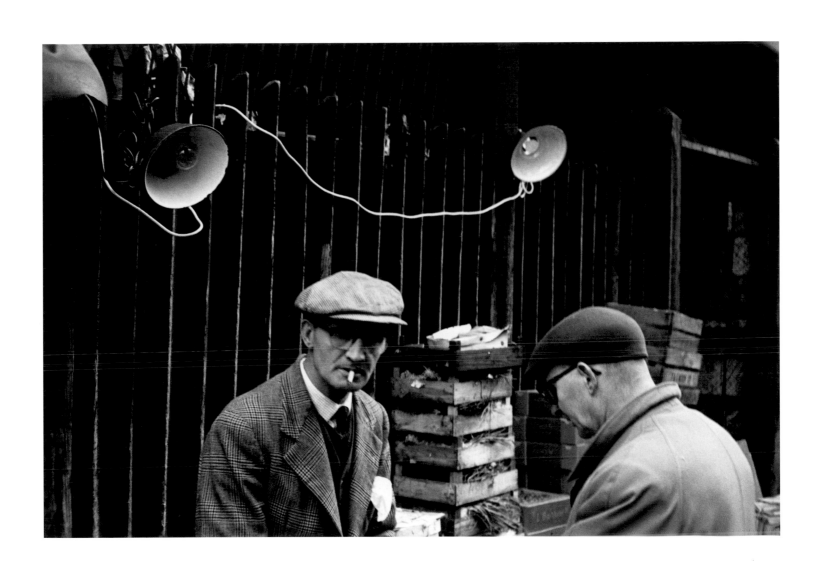

Portobello Road, London · 1964

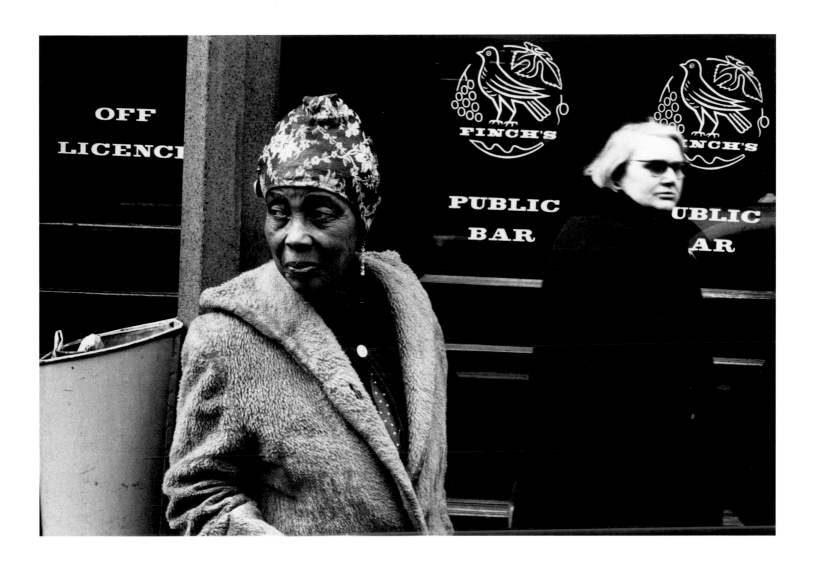

West End, London · 1968

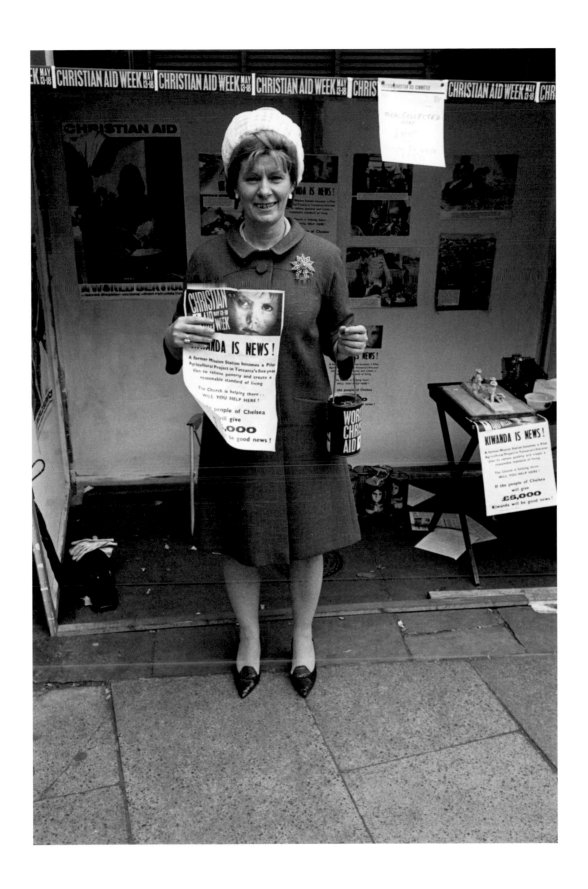

Salisbury, England · 2008

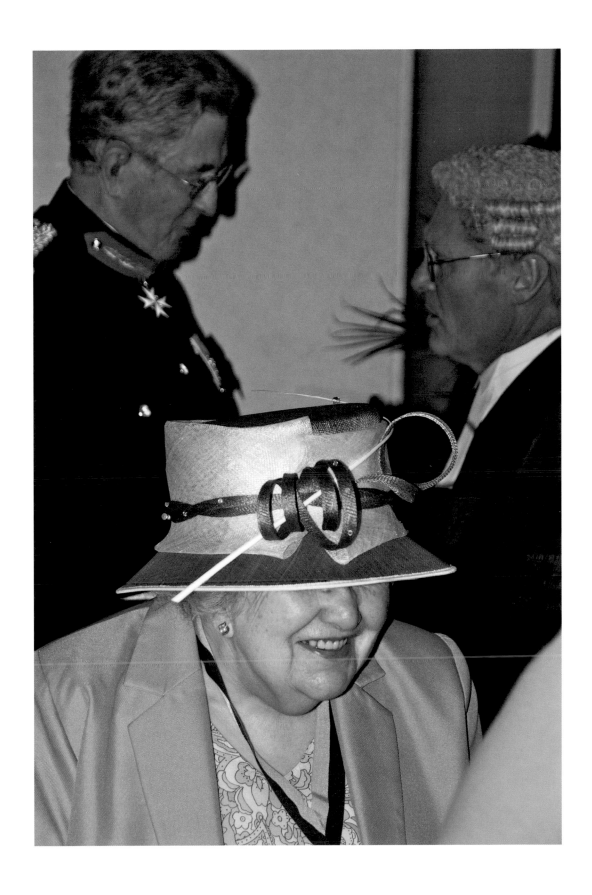

British Museum, London · 1964

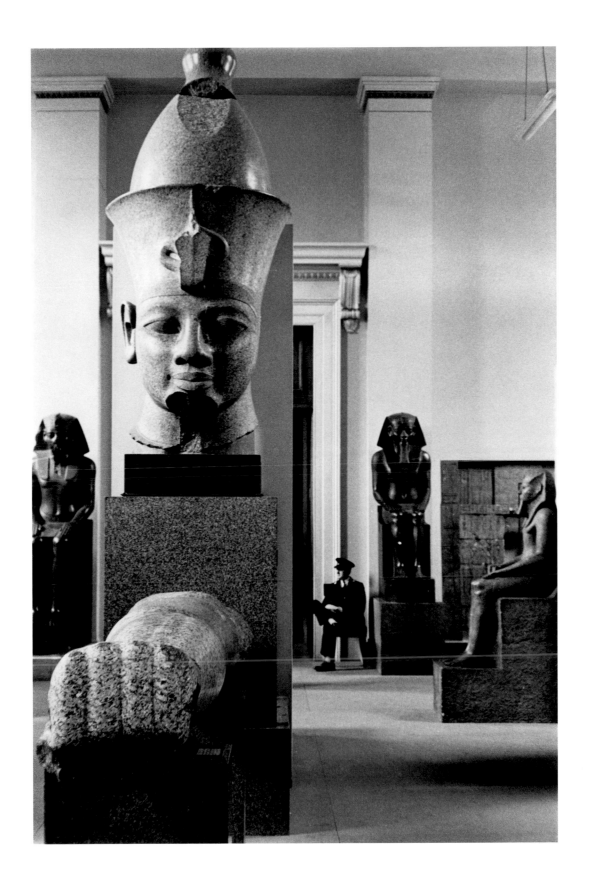

British Museum, London · 1964

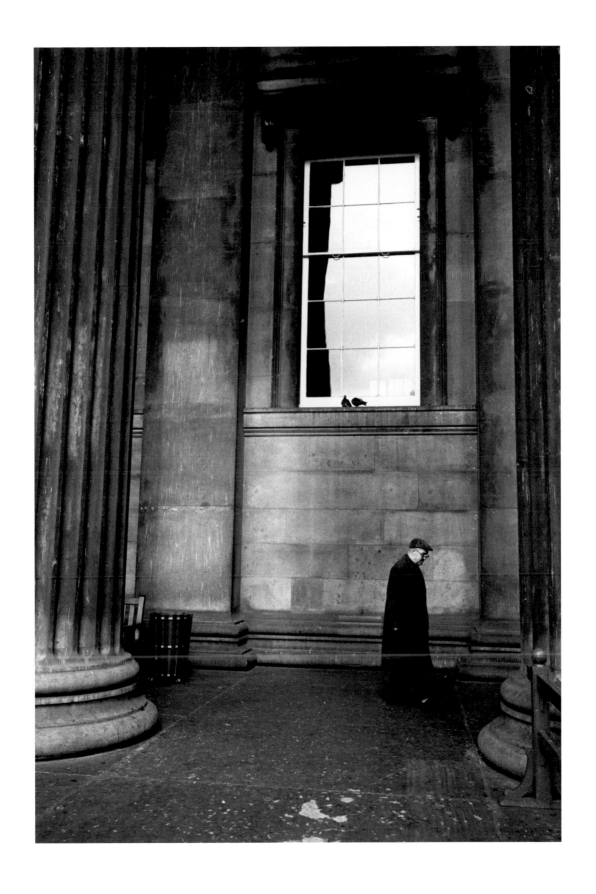

West End, London · 1967

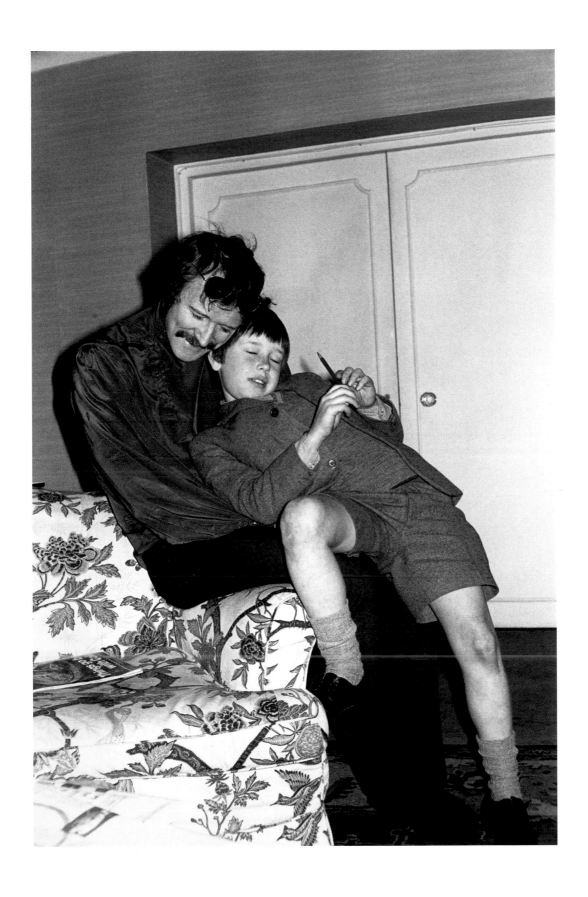

Highgate, London · 1964

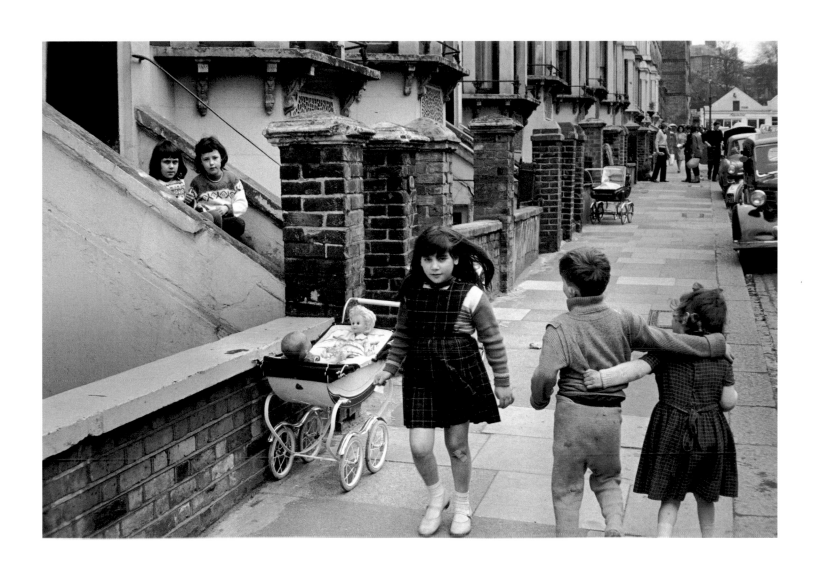

Right Bank, Paris · 1966

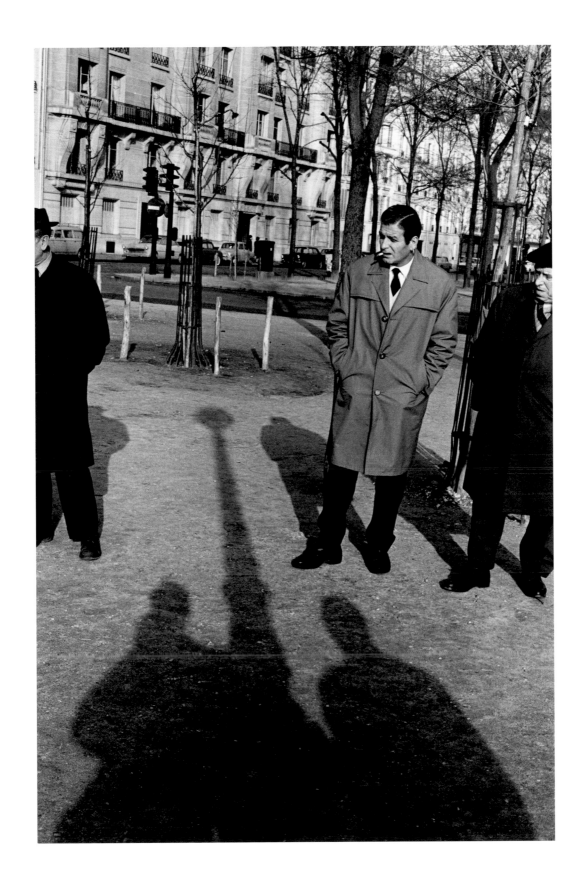

Fuengirola, Spain · 1968

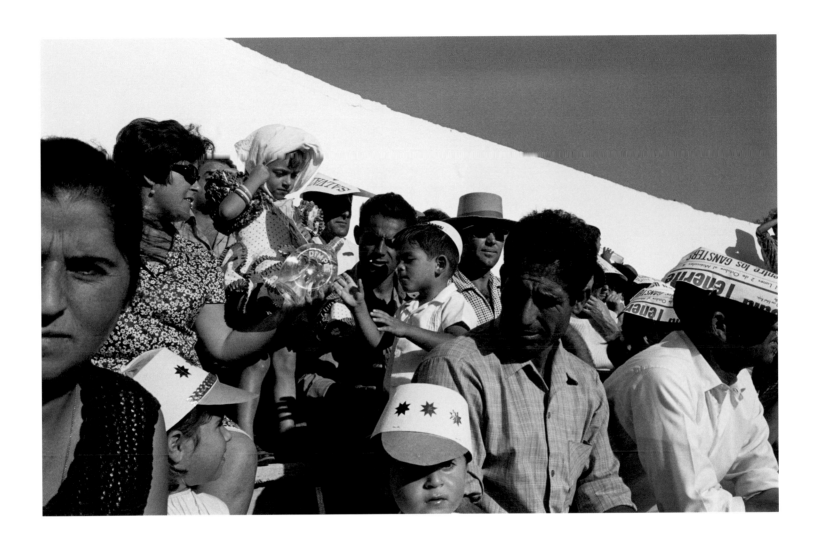

Fuengirola, Spain · 1968

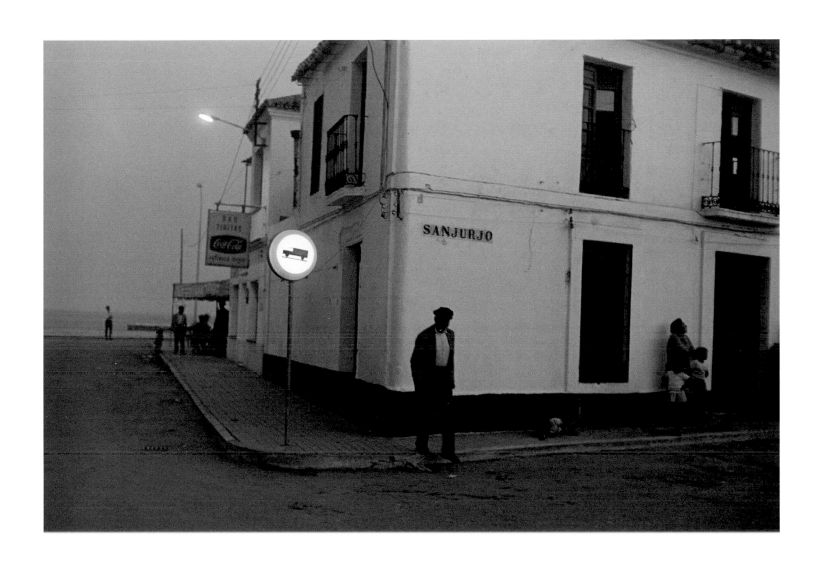

Mijas, Spain · 1968

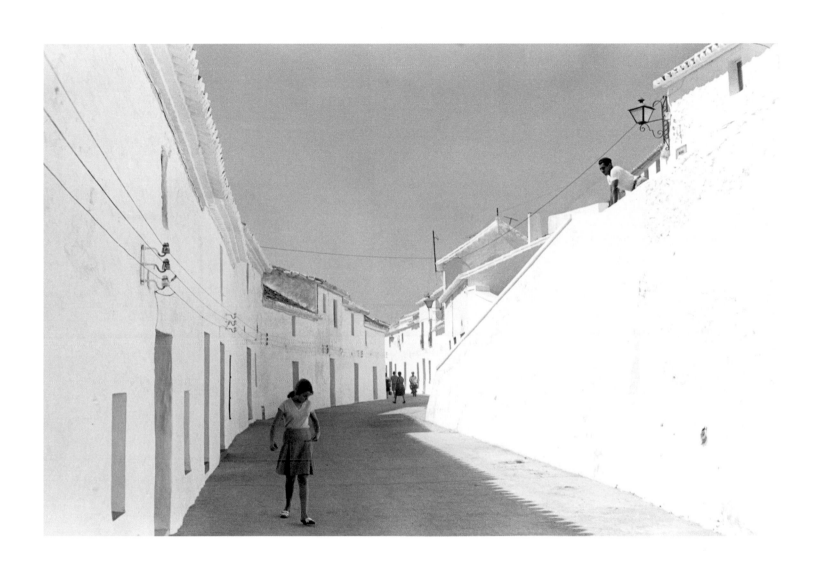

Our
vision
must
increase
our
ardor
must
increase
our
radiance
must
increase

DANTE

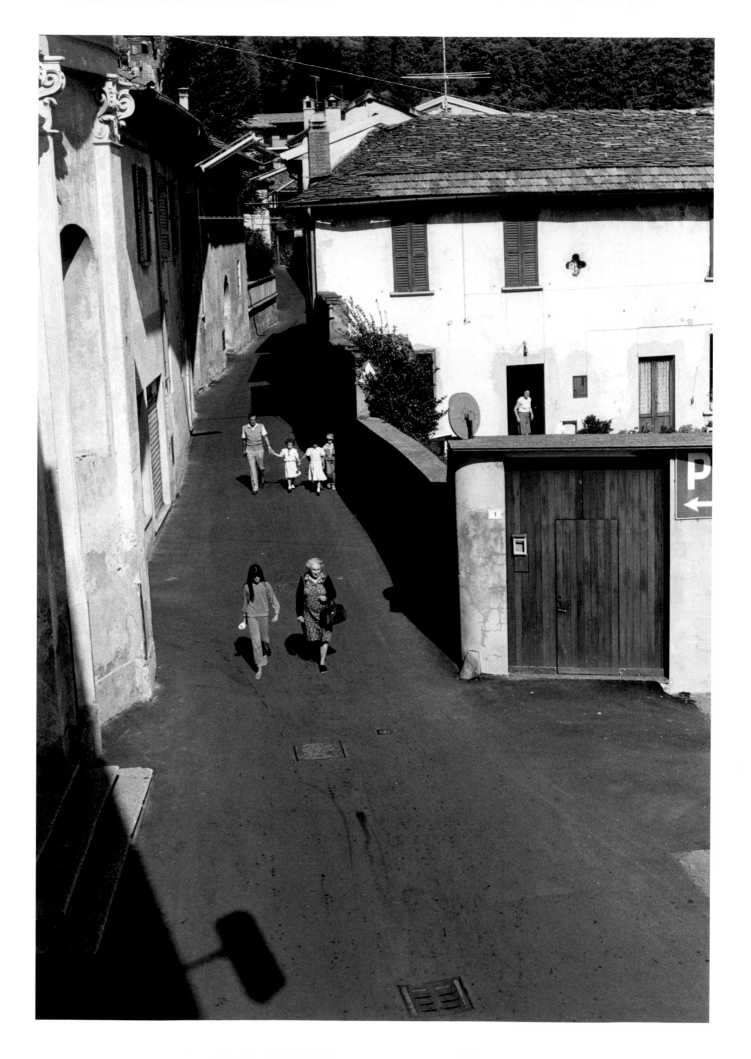

Gift of Place

I was fortunate to spend a month a year for twenty years, starting in 1988, in a hundred-and-fifty-year-old former farmhouse outside Ameno, a small village in northern Italy. My wife, Ulla, a German citizen, had bought the two-acre property many years earlier. While getting to know a number of local people, and welcoming European family and friends as guests, we continued to repair and improve the ruined structure, with its thick stone walls, generous gardens and surrounding forests. Meanwhile, I explored Piemonte with my cameras.

Europeans tend to approach their rural landscapes and towns differently than do Americans. Sustainer of civilizations for millennia, agricultural land is infused with values beyond the commercial. Rural towns—most famously Italian hill towns—are organic units, not happenstance collections of unrelated structures. Their residents never think, for instance, of painting their homes in other than traditional colors.

Where man and nature have been fruitful partners over the centuries, there is little argument either to preserve virgin wilderness in the way of America's national parks—or to tear open great swaths of "empty" land as in U.S. strip-mining. For one thing, there are no "wide open spaces" awaiting cowboys and pioneers as in the American West. Look, instead, at centuries of European landscape paintings: typically, you will see a sensitive human hand: beauty and prosperity emergent from a long cooperation with the natural world and its spiritual symbols (e.g., the heavens, the lamb, the dove).

American photographers and writers, more typically, have been caught up in the romantic cycle of illusion-disillusion. Many of our hymns to a new Eden, as the frontier rolled west, eventually flipped to irony. This disillusion phase of the romantic cycle, as I think of it, was going full tilt amid America's culture wars of the eighties and nineties. In movements such as the "New Topographics" photographers scoured the planet to find (or impose) weird evidence in support of the tired conceit that good old beauty had been despoiled by bad new civilization. A rare exception was Robert Adams, whose photographs went beyond the conventional dichotomy of "natural" vs. "manmade" to reveal how, in the eyes of at least one beholder, an overarching sense of beauty and unity fused thesis and antithesis into a new synthesis.

Weeks in Italy brought welcome relief from such concerns. There is something quietly transformative and unifying in the respect Europeans have always paid to nature, even small bits of it like tiny garden plots along the canals in Holland, or the care lavished on steeply sloping vineyards along the Rhine, or the longstanding interest in herbal cures.

City dwellers rely on getting away regularly to the country or the seaside. Supporting these migrations, annual holidays are longer than in the U.S. Poets and authors down the centuries have

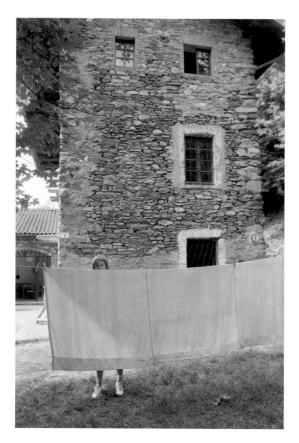

Ulla at home, Ameno, Italy · 2002

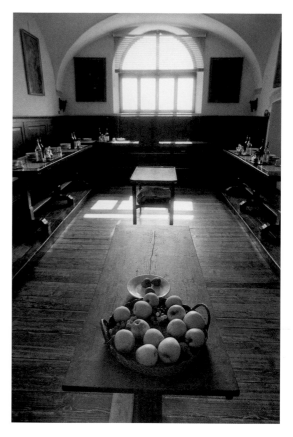

Monte Mesma (Lake Orta) Italy · 1989

drawn on town-country polarities to symbolize—and sometimes go beyond—the themes of experience versus innocence, tension versus release. One year, I was invited to join a procession through the streets of the town of Brà, near Alba, playing in a brass band to celebrate one of Piemonte's most productive agricultural regions—where the worldwide Slow Food movement originated.

* * *

In 1988-1999, I photographed Monte Mesma, our 600-year-old local monastery, and presented an album of prints to its Father Superior, Padre Corrado. A decade later, Corrado had been transferred, but we discovered that his Franciscan brothers had carefully taken the album apart and posted the pictures along the stone walls of one of their flower-bedecked courtyards.

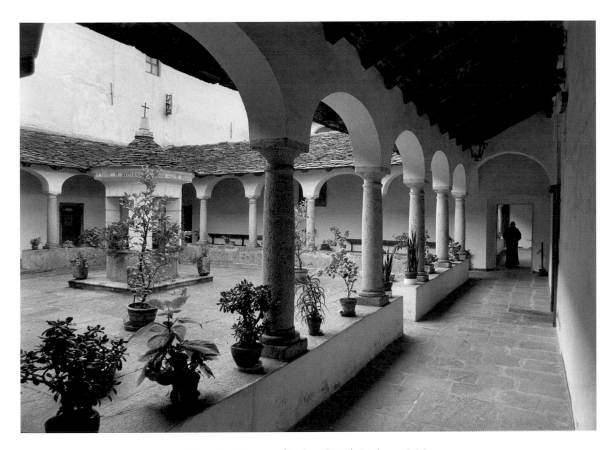

Monte Mesma (Lake Orta) Italy · 1989

When Ulla and her children finally sold the Italian house to friends in 2007, I couldn't bear to take down my photographs of things like leaves, stone textures, the village church, and the nearby Lake Orta. The pictures kept telling me they belonged on those walls. So I left them, hoping the next owners would share my feeling that they seemed part of the place.

The Italians attend to each other (including their aging family members) as much as to their landscape (even though they do often bicker beyond our comprehension in their local dialects). One example is how nicely the villagers maintain their churchyards. Ulla's last act, after dropping off the house keys for the new owners, was to stop at the Chiesa Principale and place flowers at the grave of a longtime friend, the lady who had discovered the property and helped her buy it some thirty-five years earlier.

Corconio (Lake Orta) Italy · 1989

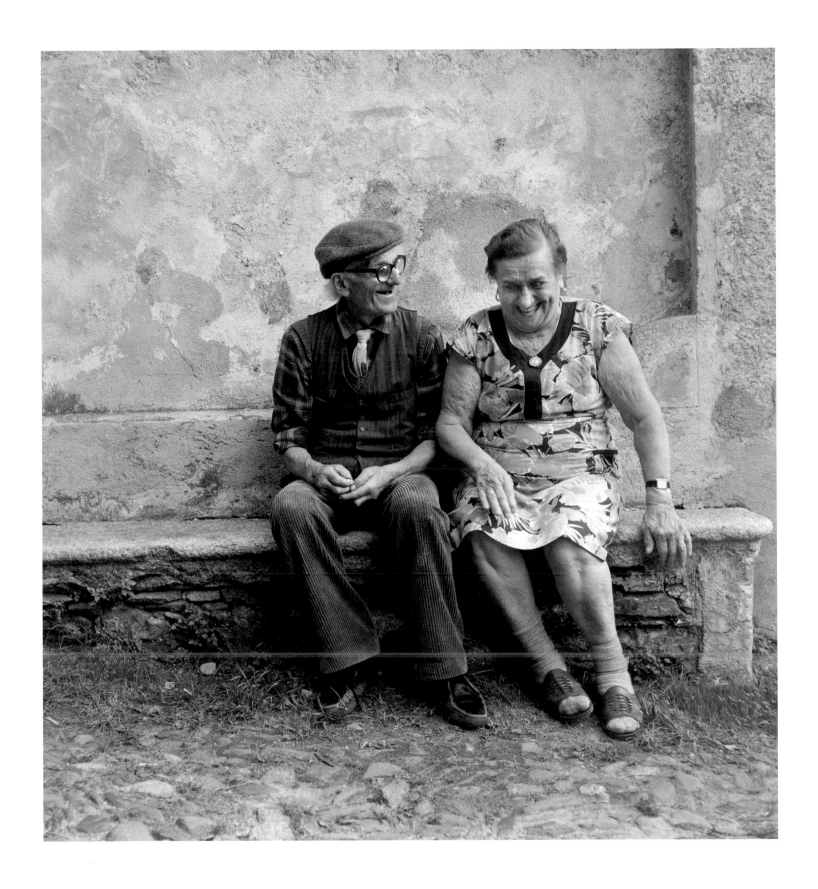

Corconio (Lake Orta) Italy · 1989

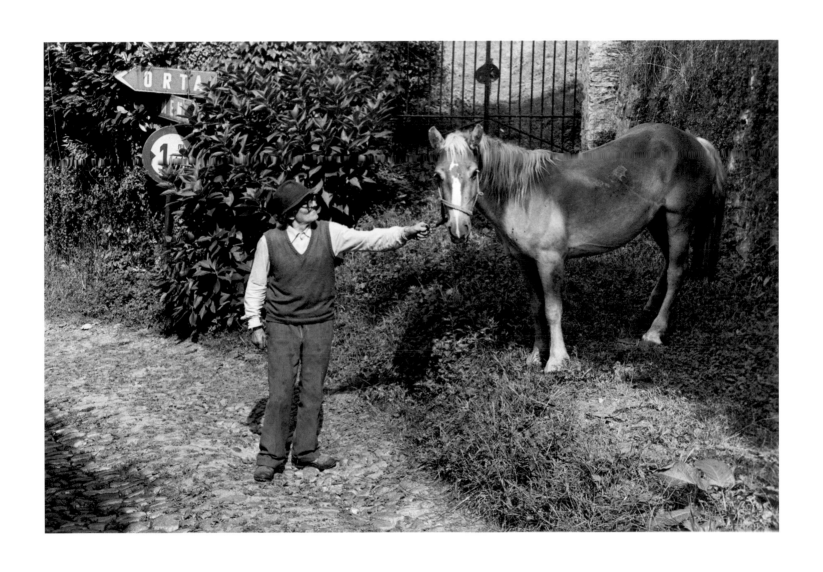

Pizzasco (Lake Orta) Italy · 1989

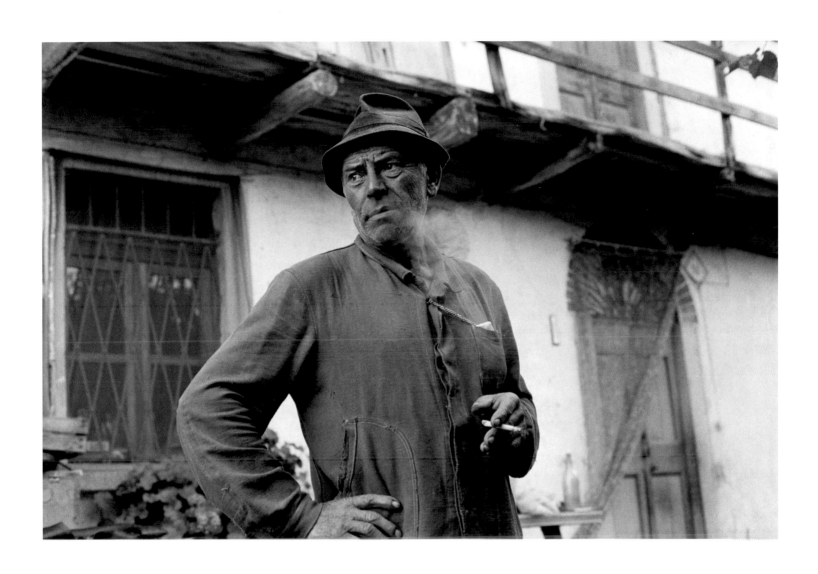

Pizzasco (Lake Orta) Italy · 1989

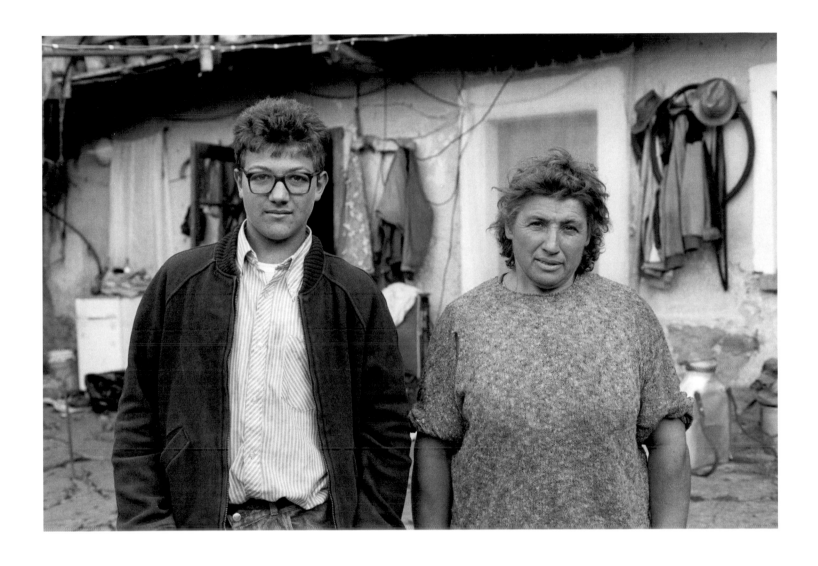

Near Ameno (Lake Orta) Italy · 1988

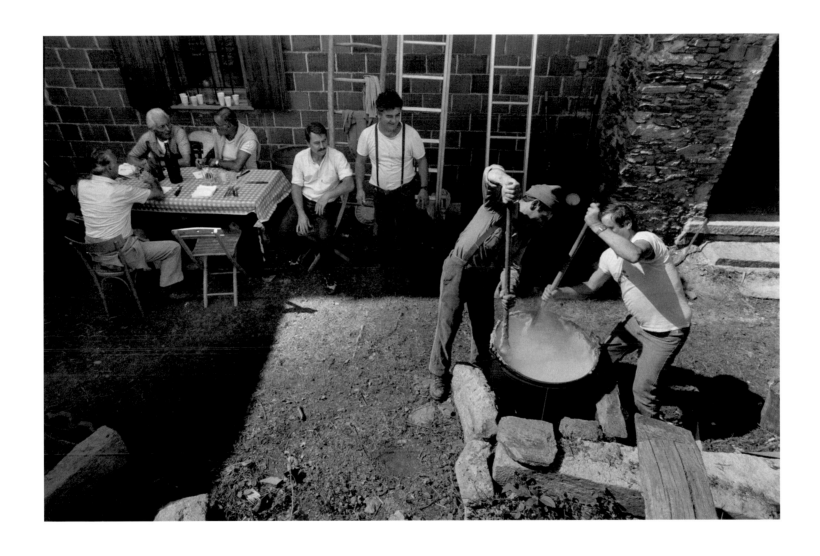

Ameno (Lake Orta) Italy · 1988

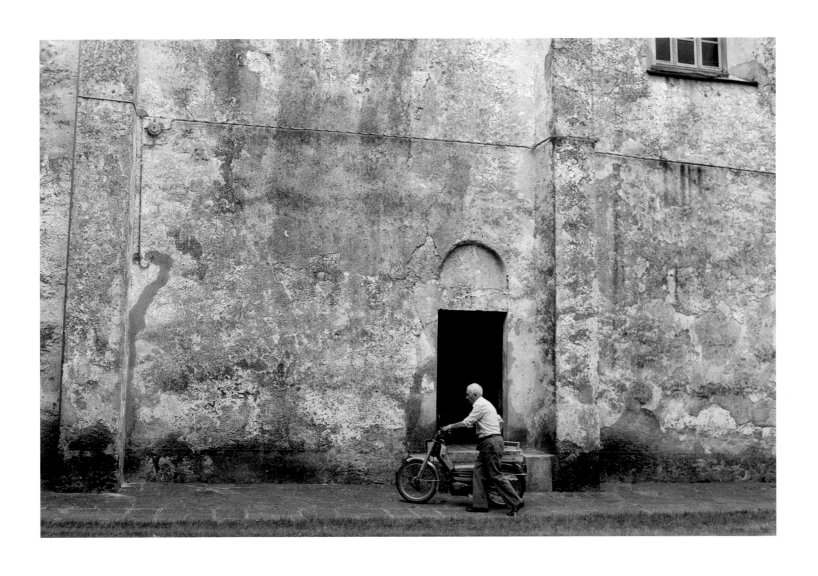

Ameno (Lake Orta) Italy · 1988

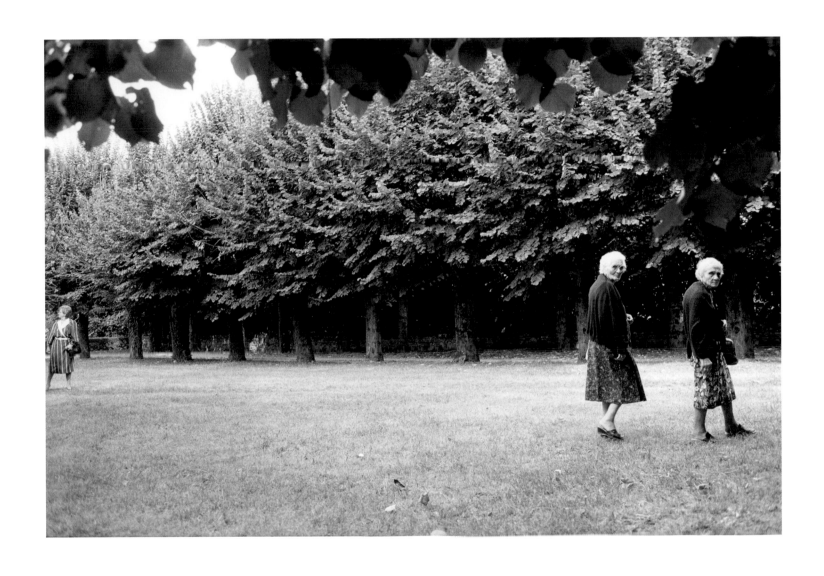

Lortallo (Lake Orta) Italy · 2005

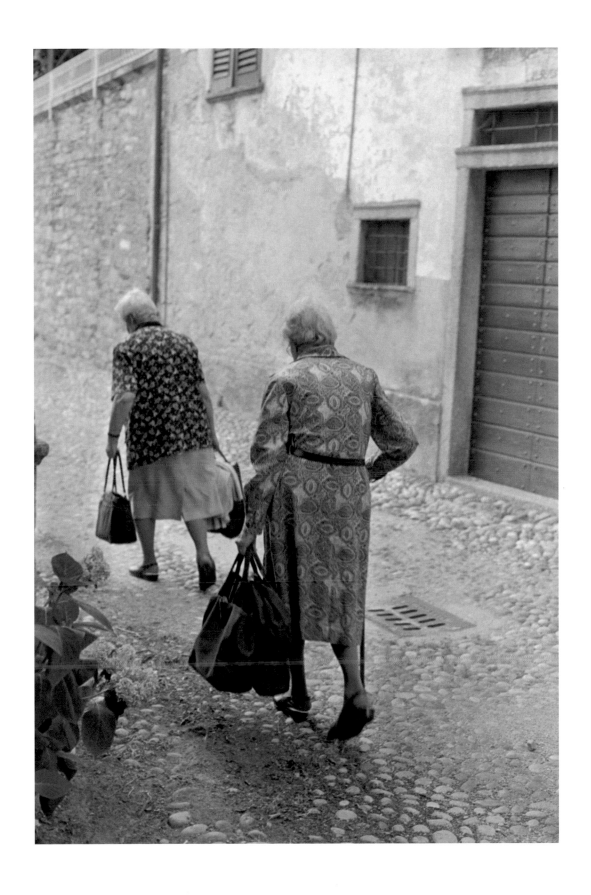

Ameno (Lake Orta) Italy · 1988

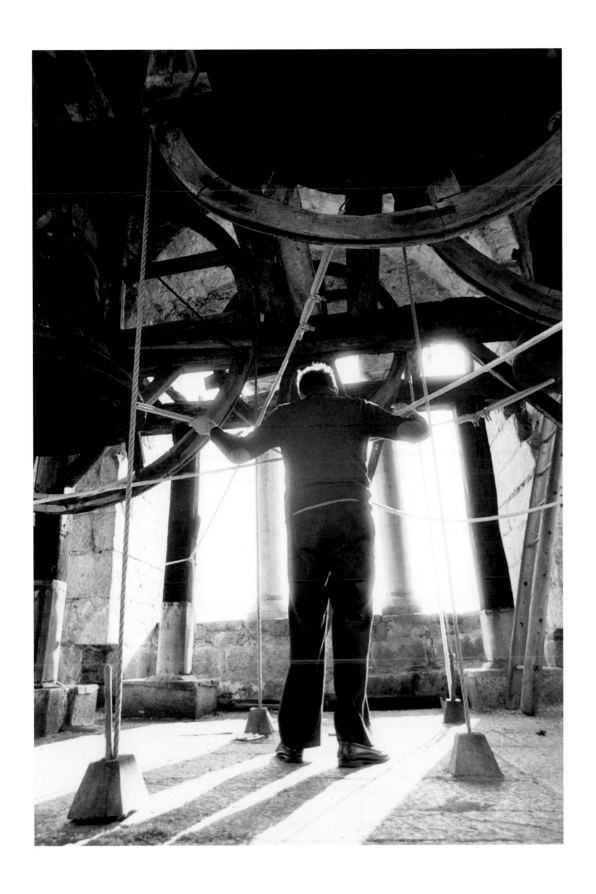

Isola San Giulio (Lake Orta), Italy · 1989

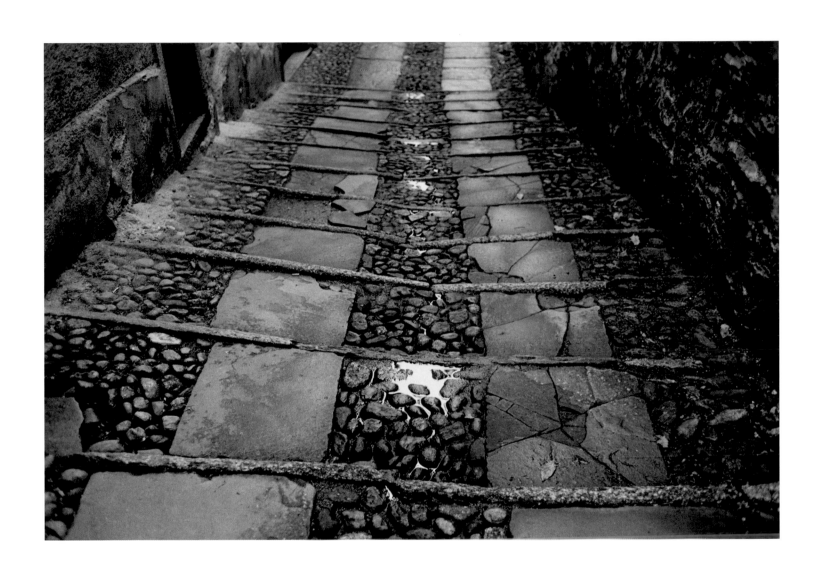

Saint Antimo's Abbey (Tuscany), Italy · 1998

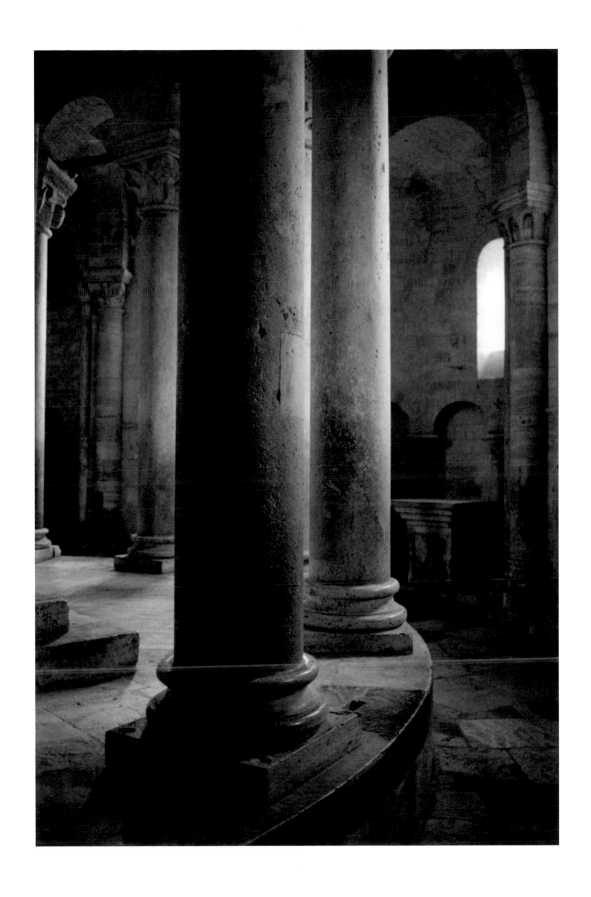

Corconio (Lake Orta), Italy · 1989

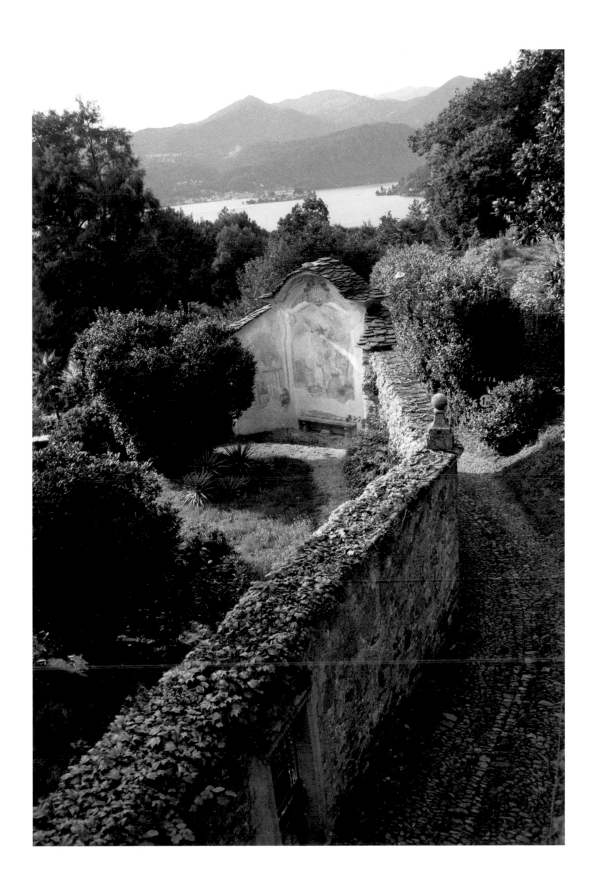

Sacro Monte (Lake Orta), Italy · 1996

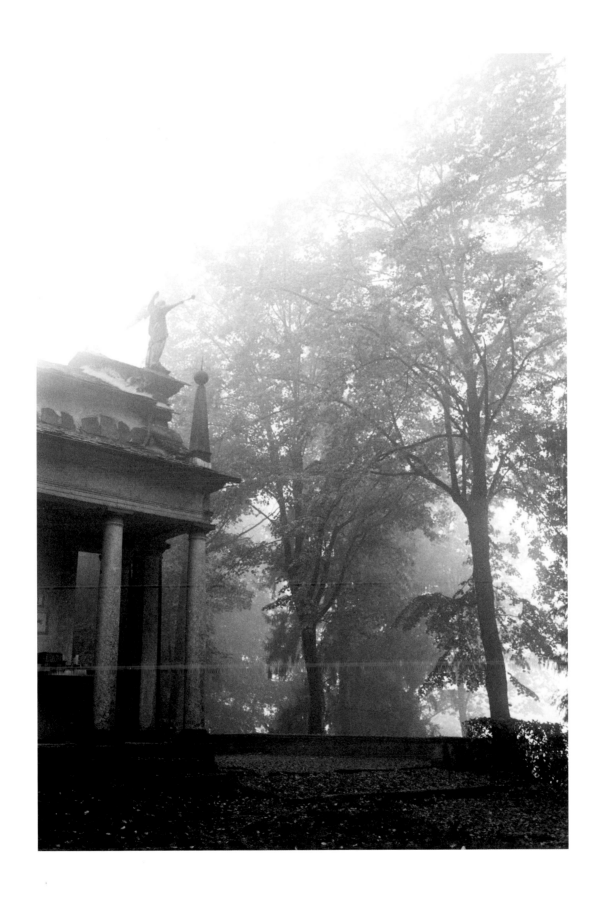

Piemonte, Italy · 1989

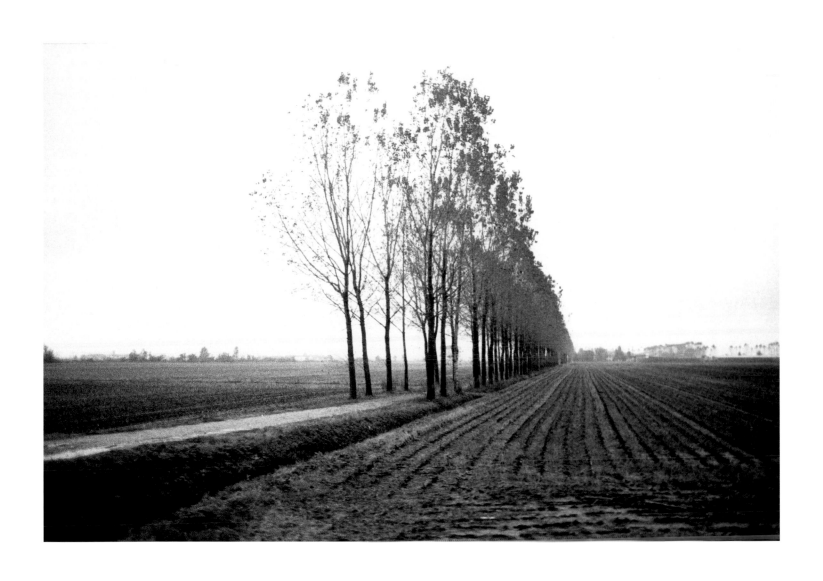

all the hearts
of the people
are my identity,
so take away
my passport

Mahmoud Darwish

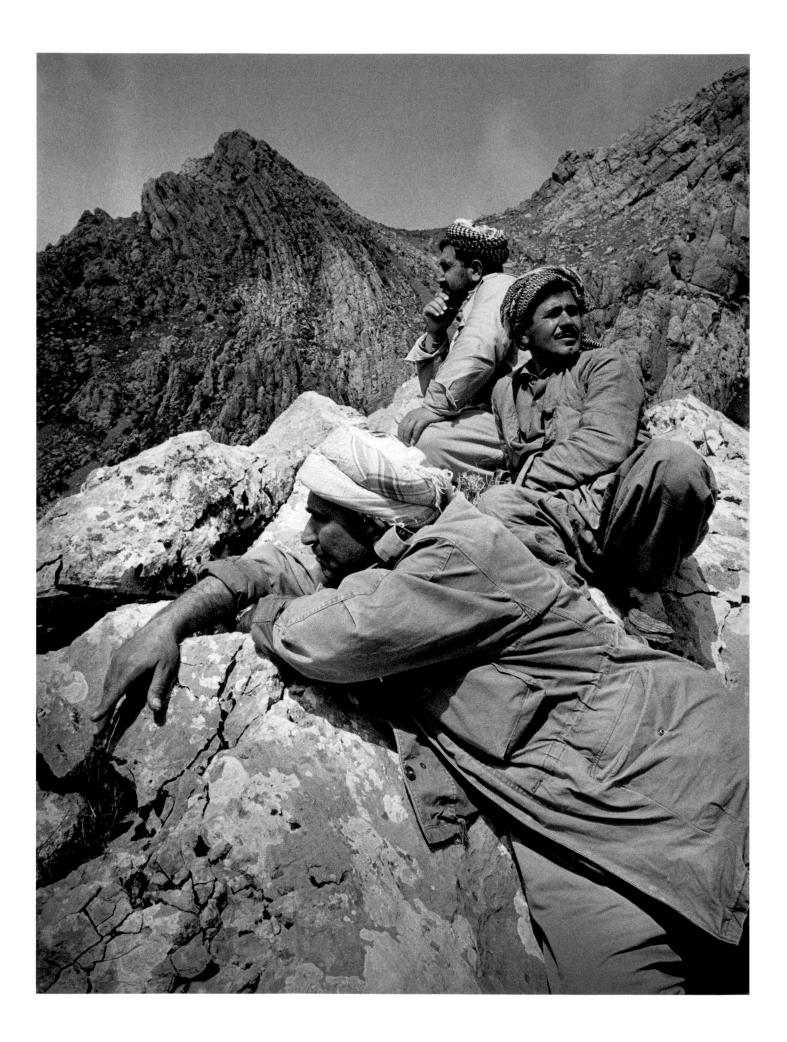

The Uncharted

I had to learn quickly when I arrived in Beirut in the autumn of 1964. I had little prior knowledge of Middle Eastern peoples and places, history and civilizations.

When a New York photo agency who served journalistic and corporate clients said they needed someone in that part of the world, I quickly volunteered.

Amid the flurry of getting press credentials and finding an apartment, I met a seasoned Middle Eastern hand: New York Times bureau chief Dana Adams Schmidt. Twice my age, Dana had pounded the unpaved paths and tiled courtyards of the Arab world for decades. He said, "Listen. Next week, I'm leaving for Cairo. Then via an Egyptian military plane to Yemen, where a civil war is on. After that, by Land Rover south across the South Arabian desert, via some British bases, to Aden. The Brits are putting on an election there, a final outpost of their former empire east of Suez. Do you want to come?"

"Yes!" I blurted. I bought film and did some hasty research. At the library of the American University of Beirut, I read a sociological study saying that relationships in this part of the world, personal and political, were mainly governed by sectarian affinities and hostilities—tribal and religious subgroups. It was a lesson reinforced often, and starkly, in the coming two years—one the Brits had already learned, but which it would take Washington another painful half century to begin to comprehend.

To a budding photojournalist, Cairo was an ancient, busy, sophisticated wonder. But the towns and back roads of Yemen seemed a slice of life that had fallen outside of time altogether. The vitality of the men's faces in the mornings—I never saw a woman's face—melted to a semi-stupor in the afternoons, as most males reverted to chewing a locally grown narcotic called ghat. In this remote future tinderbox, world powers were already vying for "hearts and minds": the Americans and Soviets were competing to build roads. I even grabbed a few shots of uniformed Chinese laborers, digging the tough earth with pickaxes, before being chased away.

Accompanying Dana Schmidt through the deserts and canyons, and on interviews with folks of every type, from the president on down, was an education in itself. But as we got to know one another, Dana revealed details and contacts involved in his historic reporting on another, even harder-to-reach people: the Kurds of northern Iraq. Back in Beirut, I cabled my agent asking if anyone wanted a picture story from there. She cabled an assignment from LIFE—a big break.

Officially, it was impossible to get to northern Iraq, because of the interminable warfare between the Kurds and the Baghdad government. But the following spring, a network of covert contacts got me there. This involved flying to Iran (then a U.S. ally) and fording the river border to Iraq at night, dressed as a Kurdish nomad, riding on a donkey. It was a glorious adventure, traveling on foot for a month, with bands of spirited pesh merga guerrillas, guided mainly by a former Iraqi army colonel who spoke good English. The result was a six-page story that helped establish me professionally.

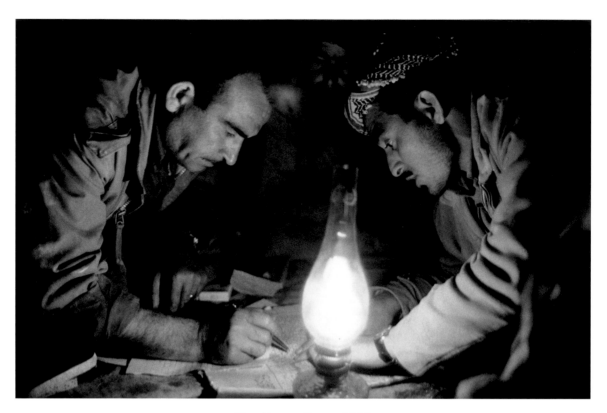

Kurdistan, Iraq · 1965

The next year in Beirut was less dramatic, but no less memorable. Day-to-day drumming up local work, whether covering a celebrity (such as the pope's visit) or doing pictures for annual reports or stock-photo libraries, was punctuated by travel elsewhere in the Middle East.

I became aware of how preexisting ideas can affect the ways we see, or how our clients see. People often think of photographs as a kind of xerox of "reality." That turns out to be true only if you understand "reality" as a combination of what is "out there" and what is inside the viewer's own brain and blood. As I mentioned earlier, "One sees the world as one is."

The era of imaging "the Orient" in terms of harems and dreamy David Roberts landscapes was over. But the process of blending ones inner and outer views takes unexpected turns. I had a photographer friend in Beirut, representing a different agency, who did a lot of work for National Geographic. Repeatedly, that magazine sent him back to a certain Egyptian pyramid until he finally sent them just the shots they had in mind for a particular story.

More than once, I saw aid to the hungry, bags of flour stenciled with the words "Gift of the People of the United States of America," piled up and used as edible sandbags around machine gun emplacements.

Two years in a row, I traveled to the Holy Land (then in Jordan) to photograph Christmas in Bethlehem for cover stories in a Midwestern family magazine. I had to step around and ignore the tangled disputes and even violence that still erupt yearly between rival sects over control of the Church

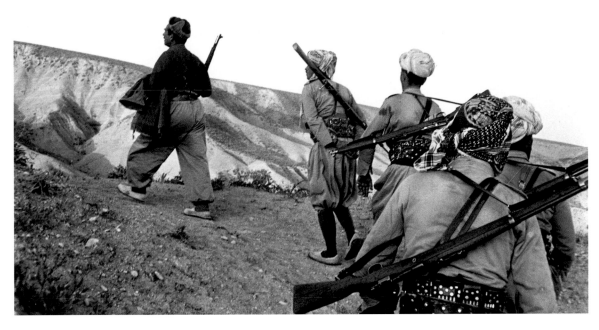

Kurdistan, Iraq · 1965

of the Nativity. Not to mention the underlying fault lines between various groups of Arabs and Jews. Knowing, without asking, what middle-American readers wanted, I sent warm color slides of glowing, candle-lit faces of singing western pilgrims lined up to file past the Saviour's birthplace. Plus some semi-staged scenes on the Mount of Olives involving camels, shepherds, and colorfully decorated tents.

Such assignments eventually brought me a not altogether pleasant awareness of a not always conscious self-censorship. I was also brought face to face with the constant layerings of meanings, the minglings of long history and intense myth, that pervade the two-thousand-year-old stones of Jerusalem or Persepolis or Damascus or Beirut. I was imbibing a lesson tough for many Americans to take: in such ancient, tribally based regions, little can be "fixed" by brilliant analyses or just-in-time interventions.

Parallel contradictions were emerging in Vietnam–the end of our innocence. Some of my colleagues were drawn there, but not I. The closest I came to war photography was when an Iraqi shell demolished the hut next to the one where I was sleeping in the mountains above Kirkuk. My first thought was that I probably had more important things to do with the rest of my life.

One of the nicest comments I've heard about me came from a teacher in India whose words I greatly valued. When a local photographer envied my expensive equipment, the teacher replied, "He doesn't take pictures with his camera. He takes pictures with his heart."

Jerusalem · 1964

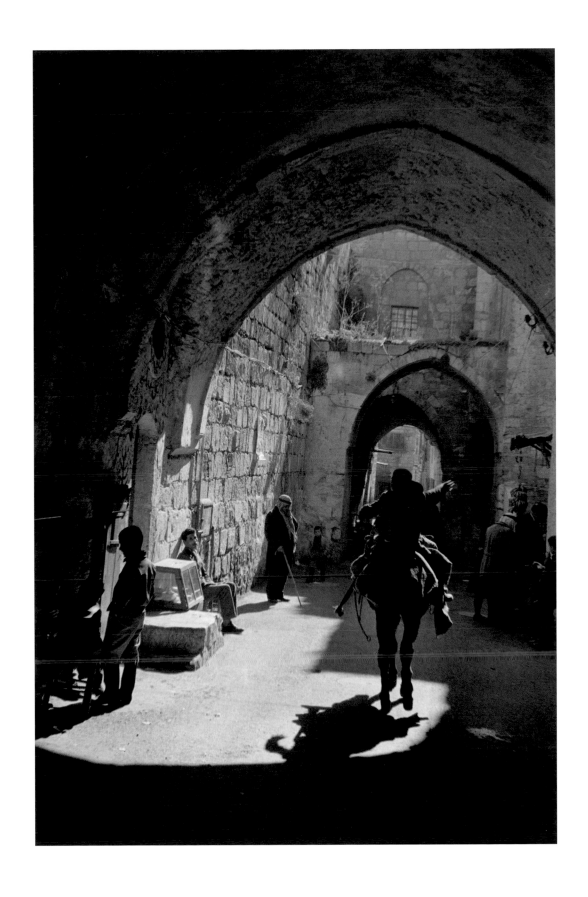

Isfahan, Iran · 1998

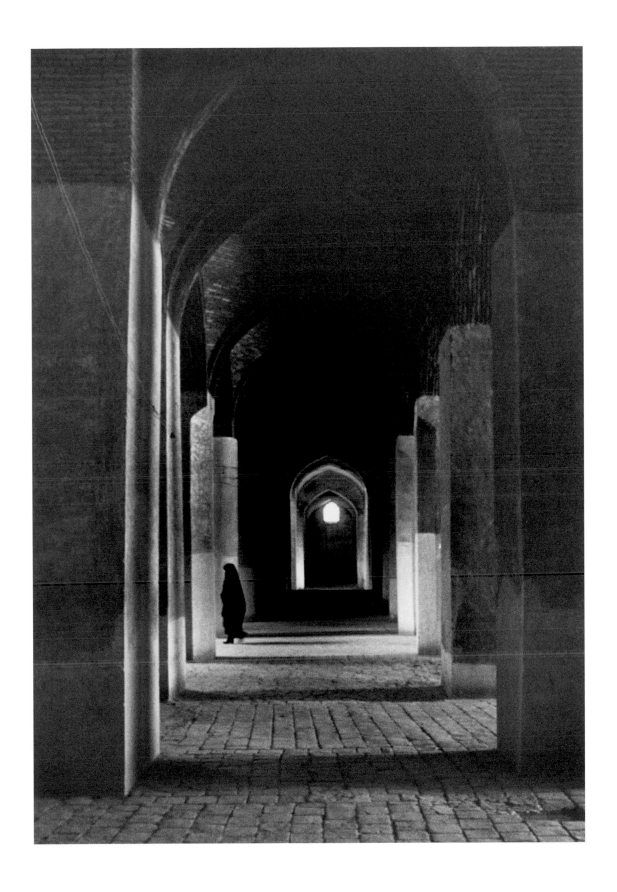

Yazd, Iran · 1998

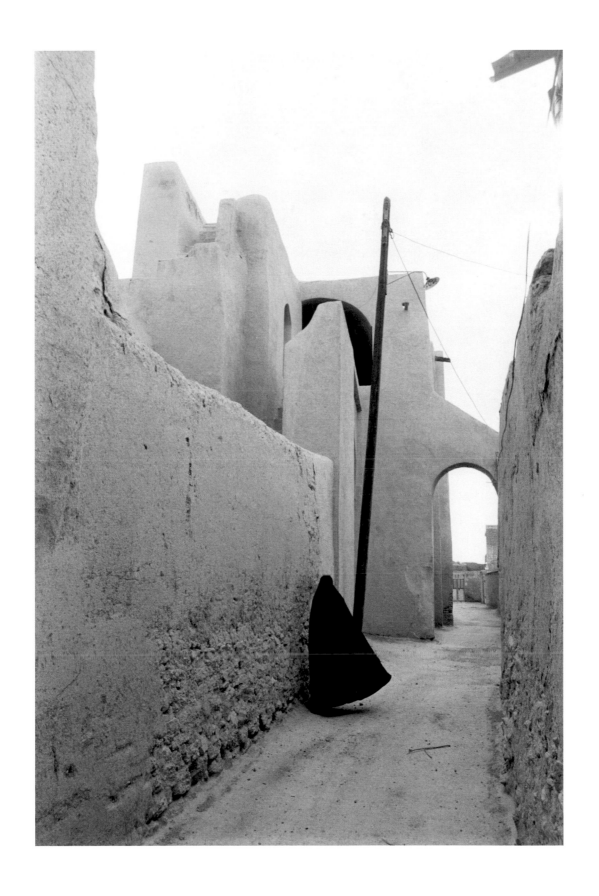

Sa'da, Yemen · 1964

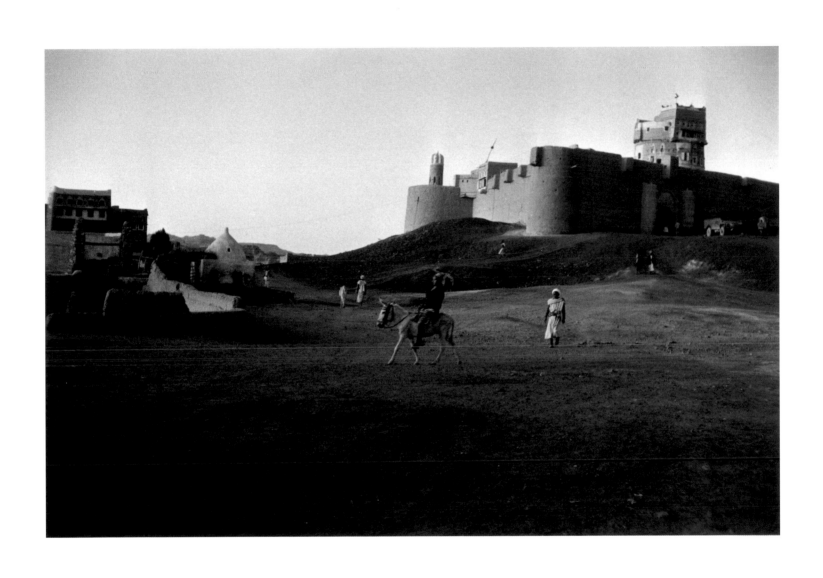

Gaza, Palestine · 1993

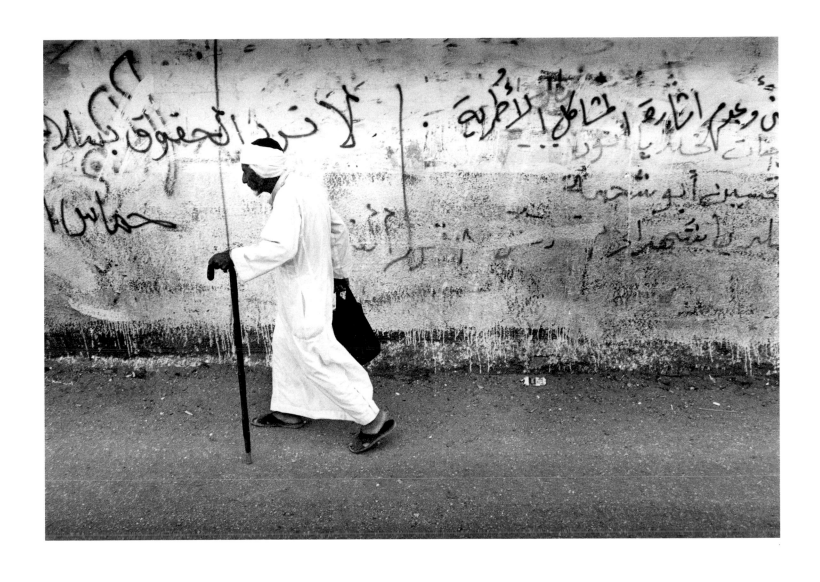

Cairo · 1964

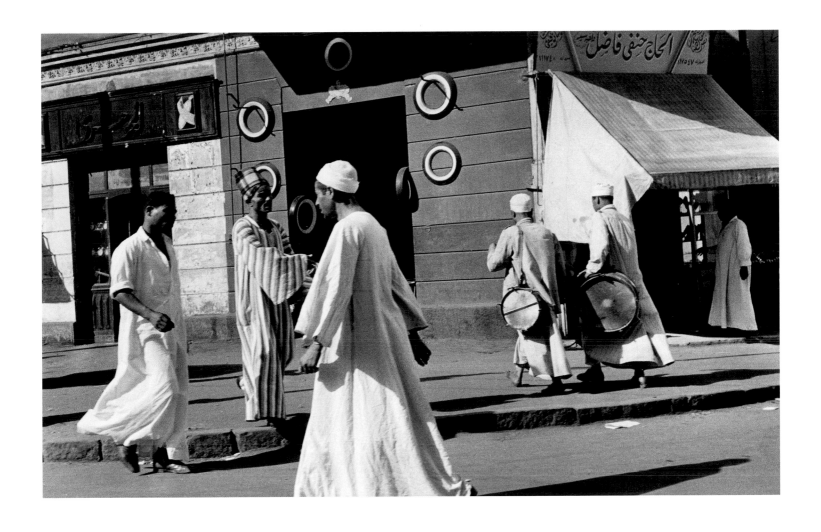

Near Taiz, Yemen · 1964

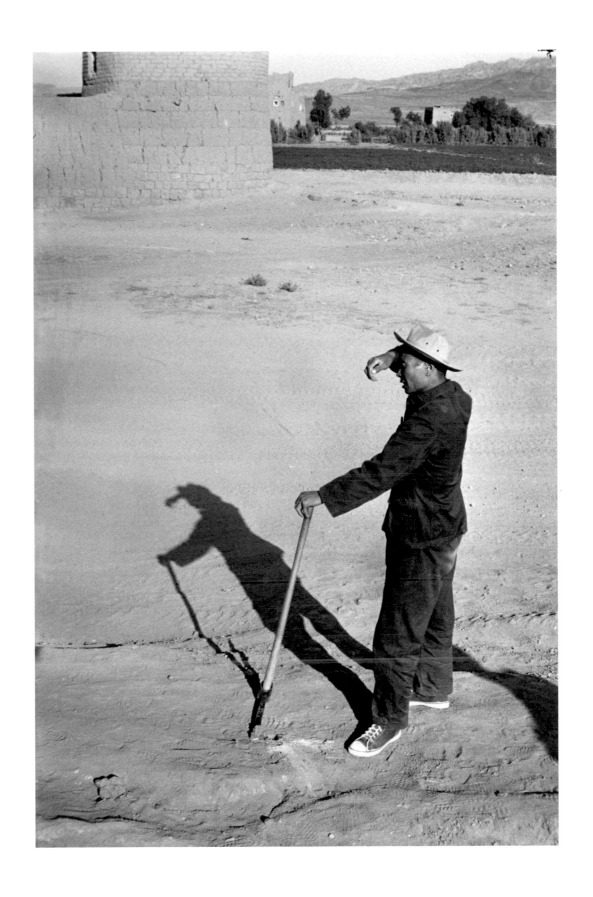

North of Sana'a, Yemen · 1964

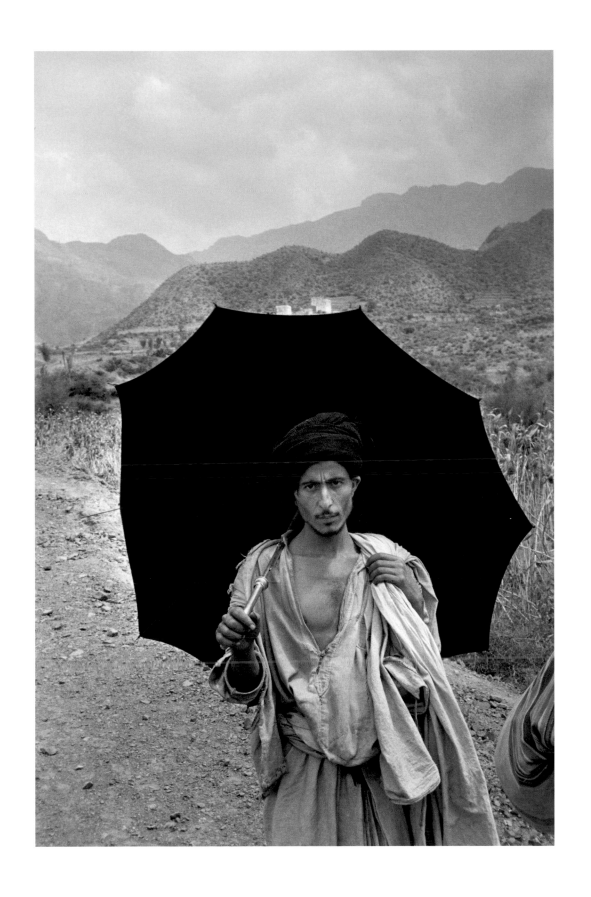

North of Sana'a, Yemen · 1964

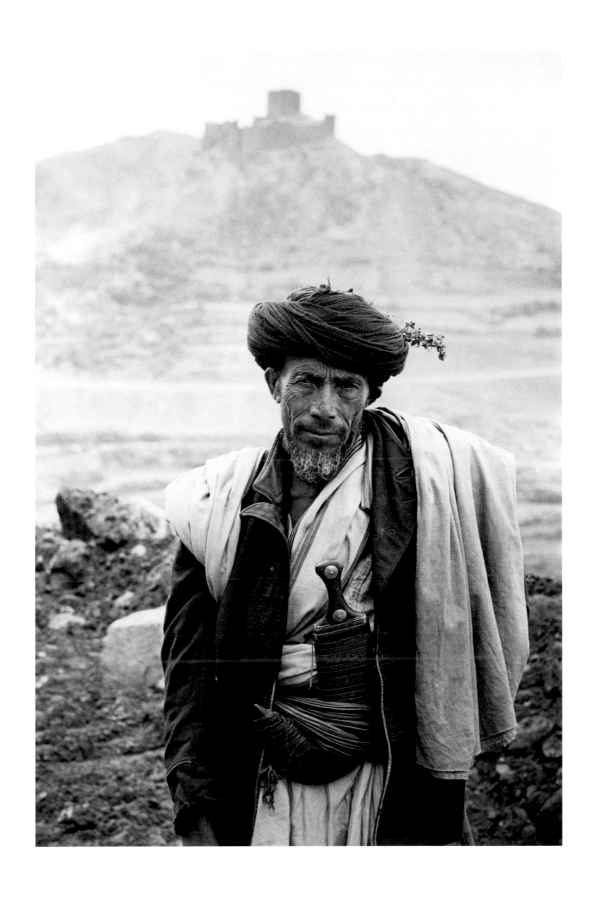

Aden, South Arabia · 1964

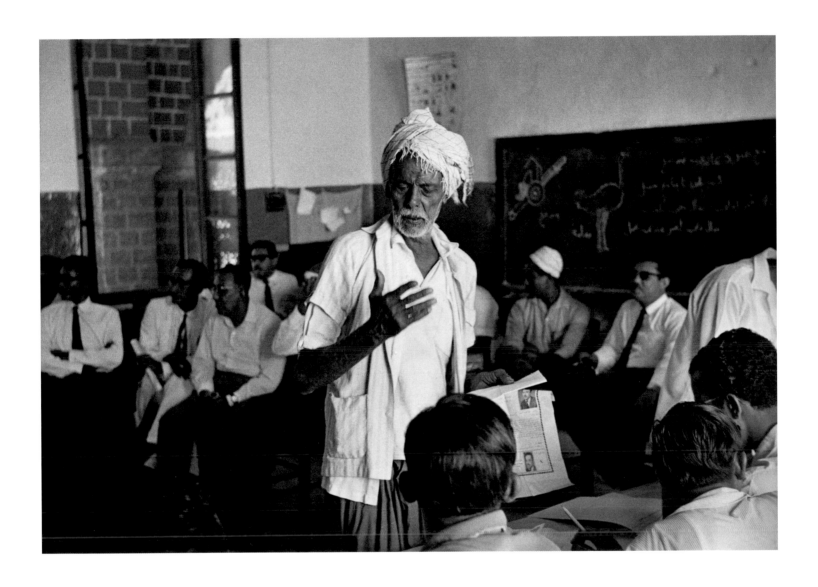

West Bank, Palestine · 1993

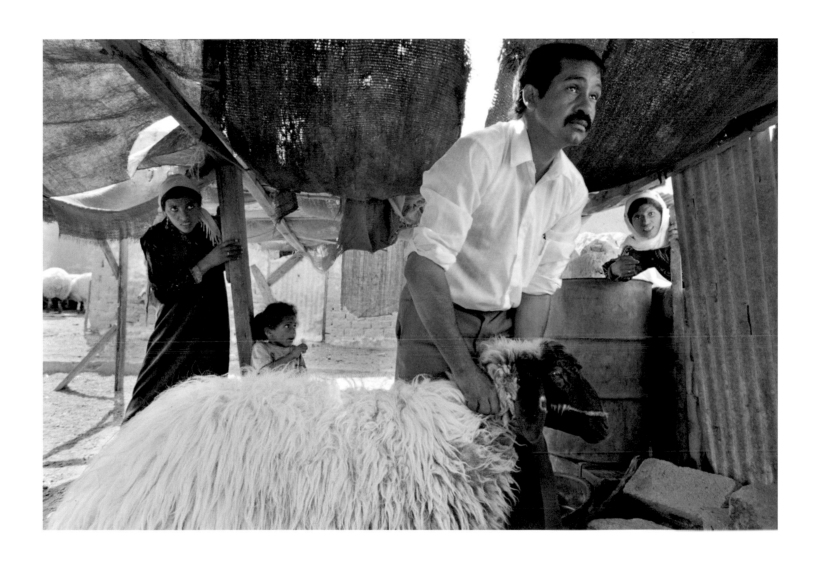

Gaza, Palestine · 1993

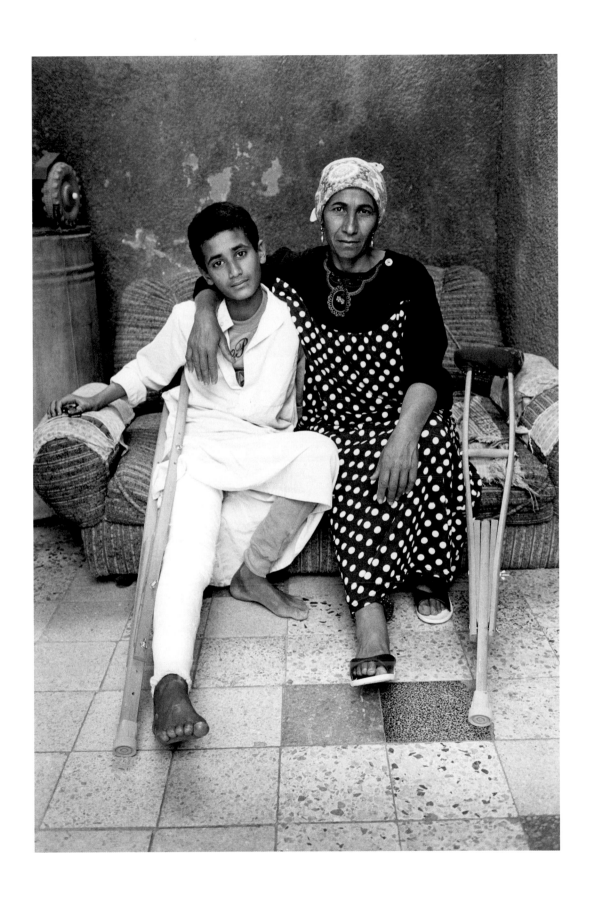

Sana'a, Yemen · 1964

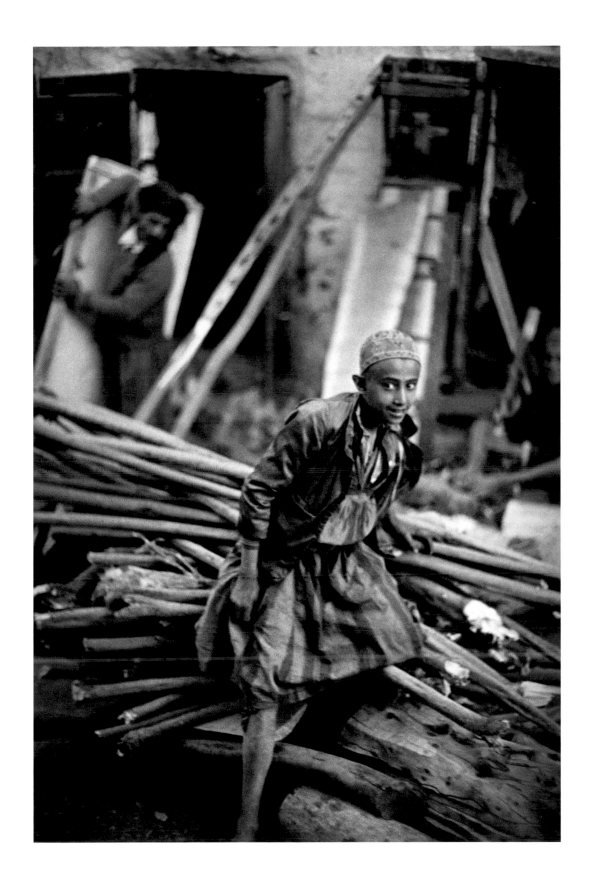

Near Sana'a, Yemen · 1964

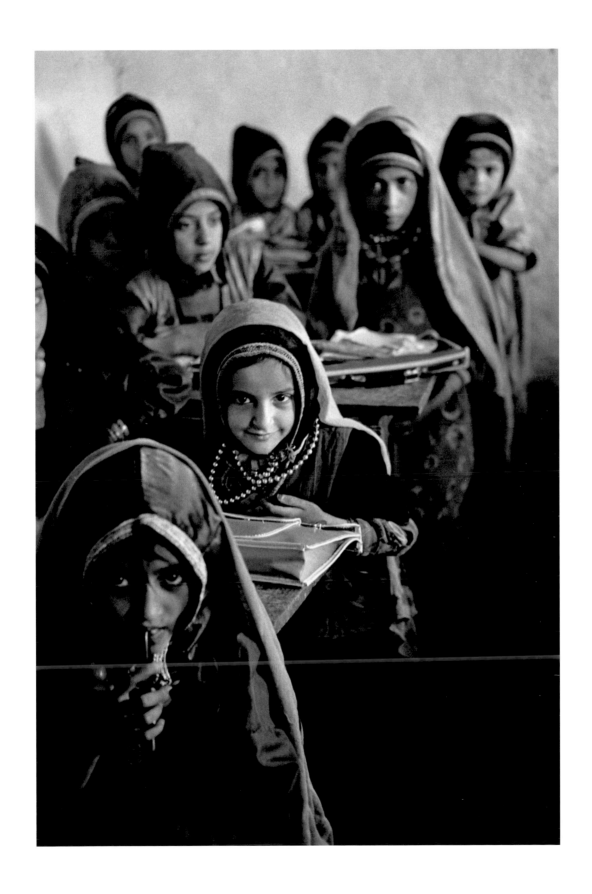

Kurdistan, Iraq · 1965

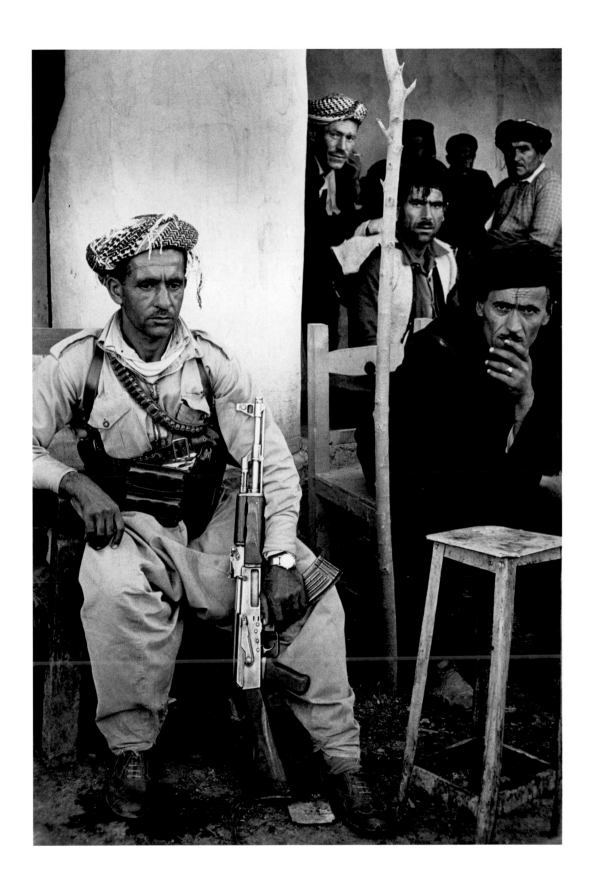

Kurdistan, Iraq · 1965

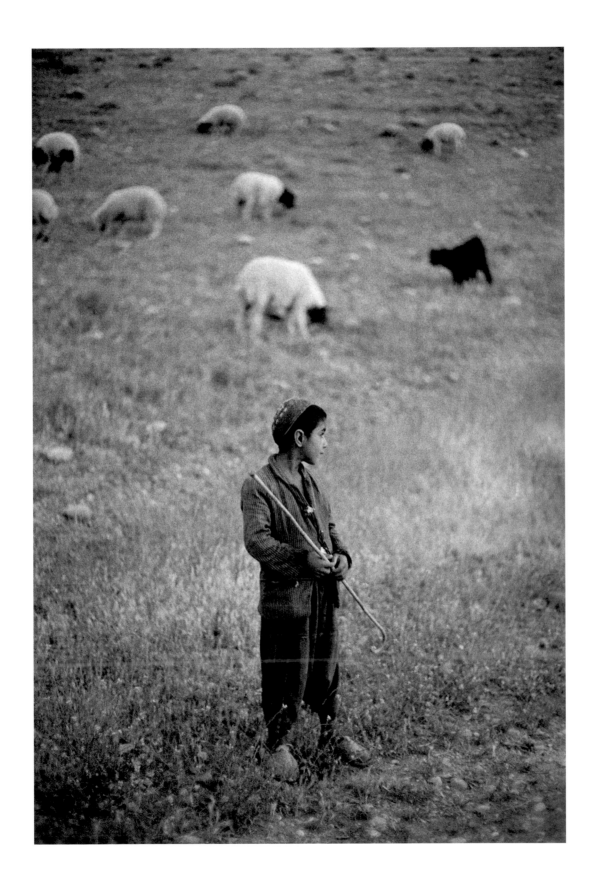

Kurdistan, Iraq · 1965

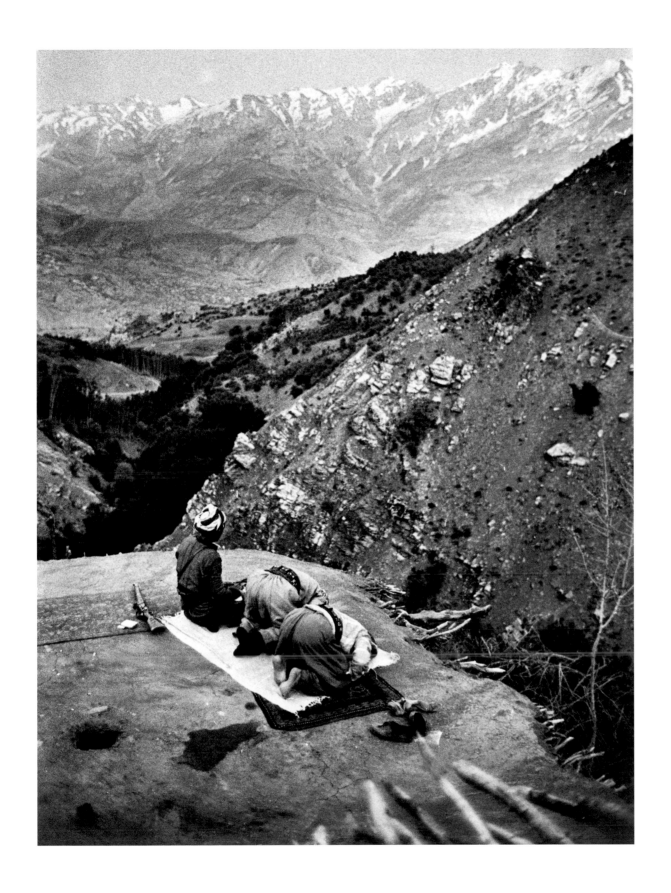

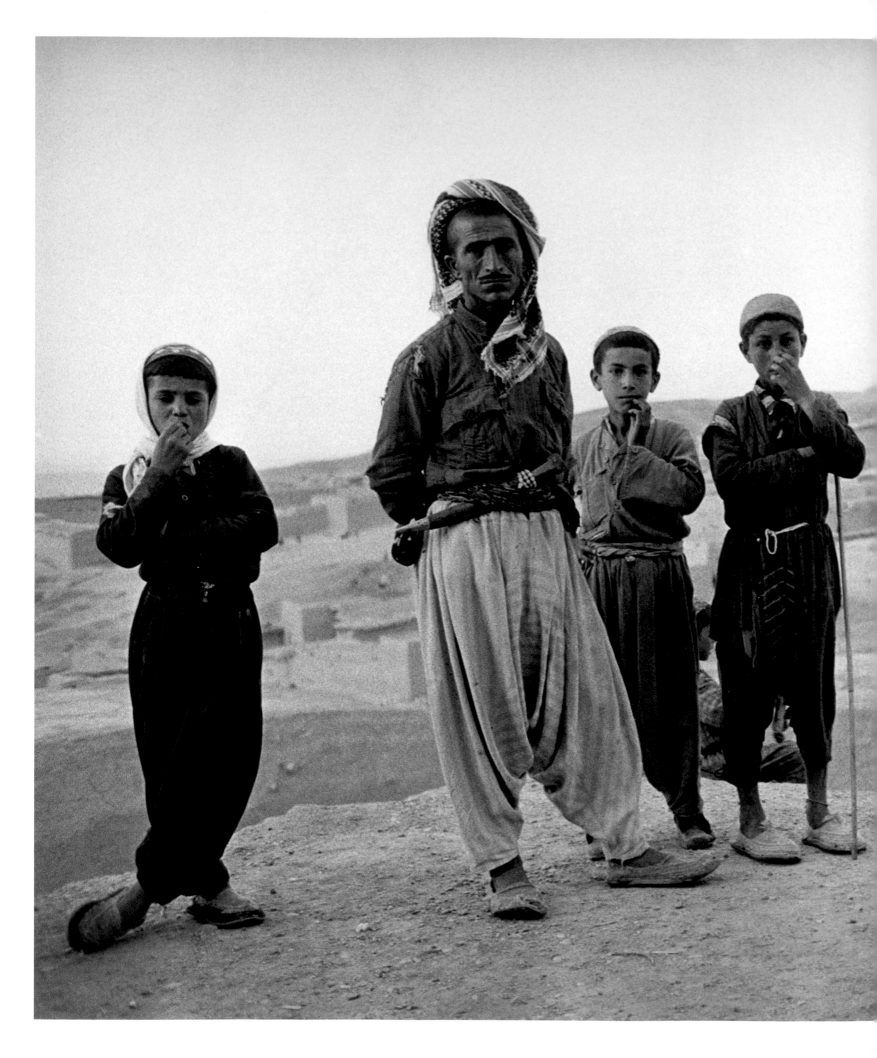

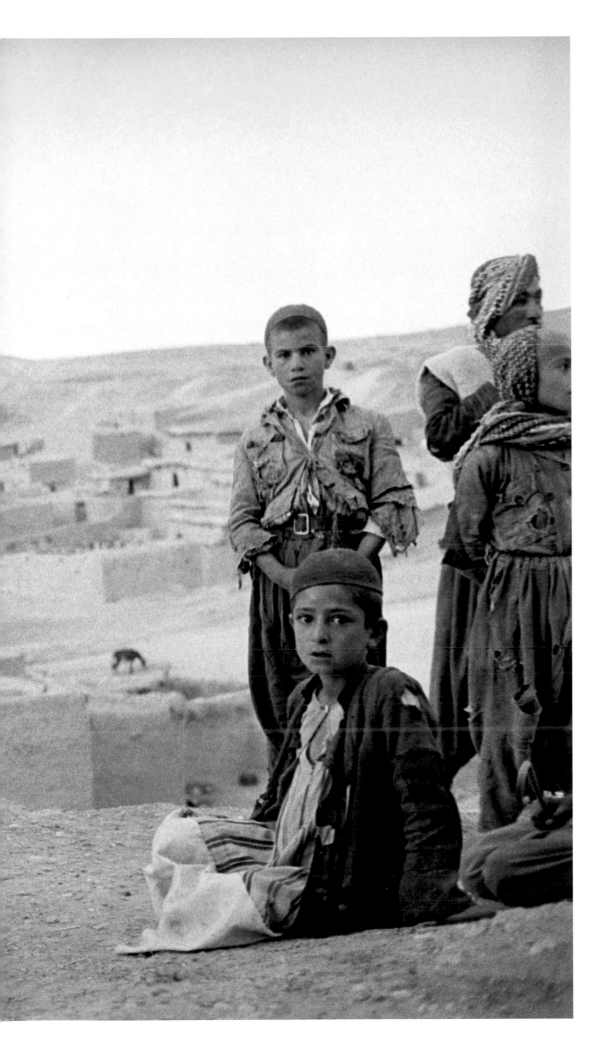

Kurdistan, Iraq • 1965

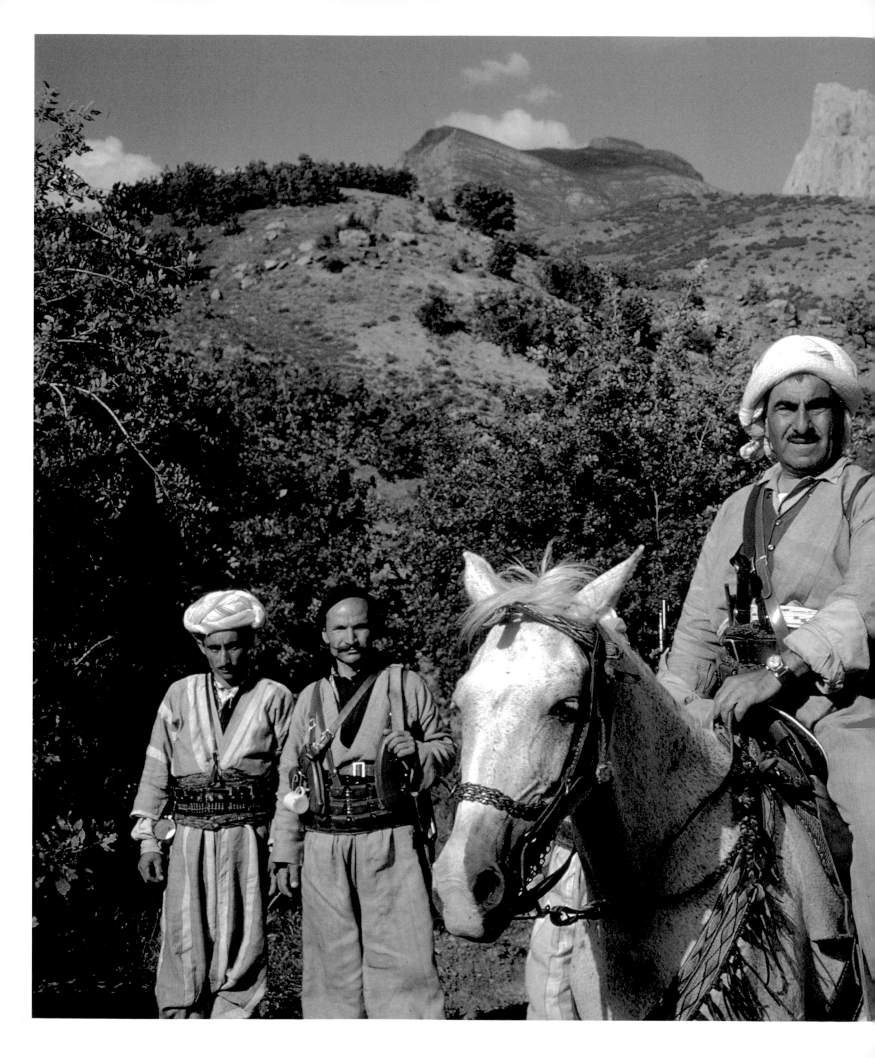

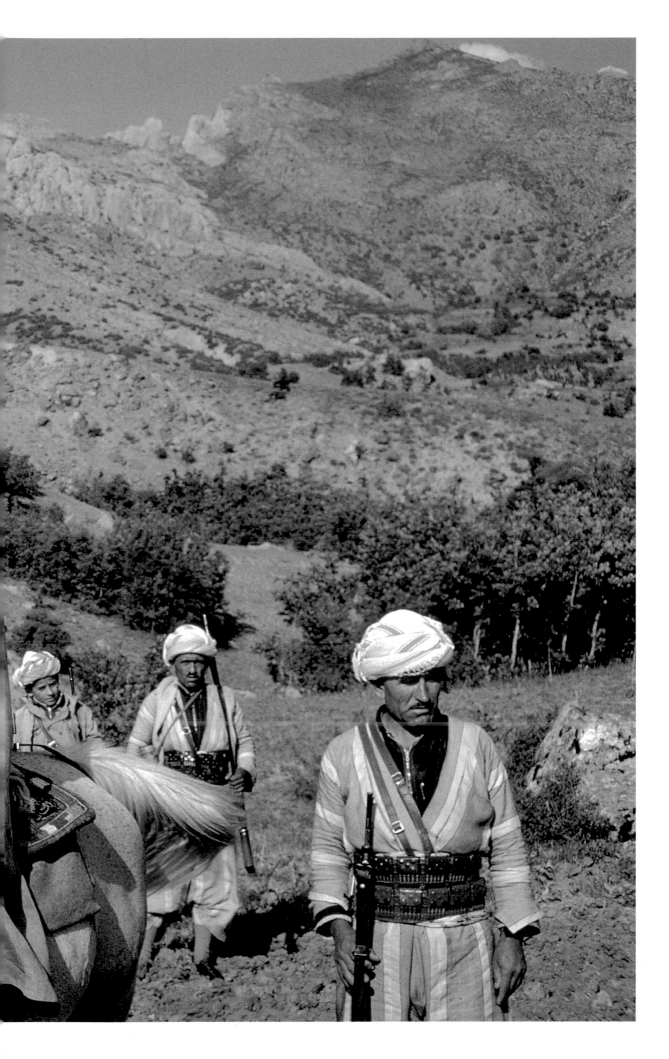

Kurdistan, Iraq • 1965

use

another

eye

RUMI

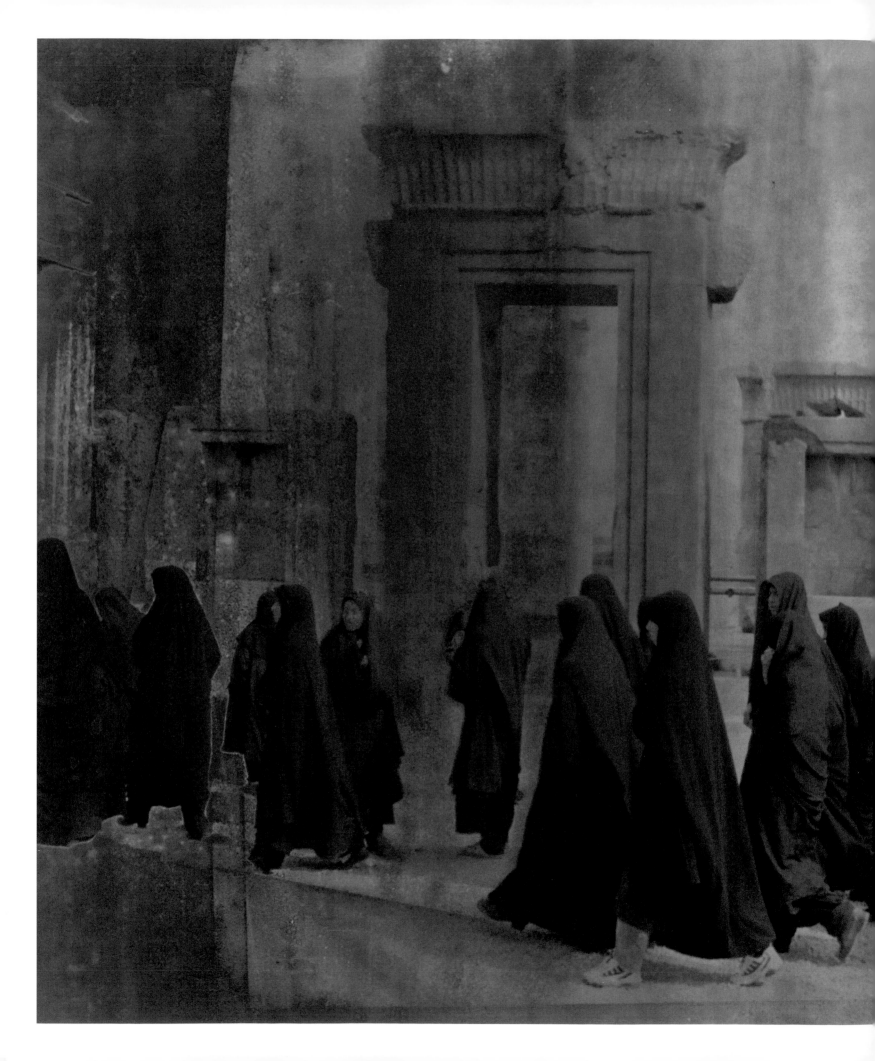

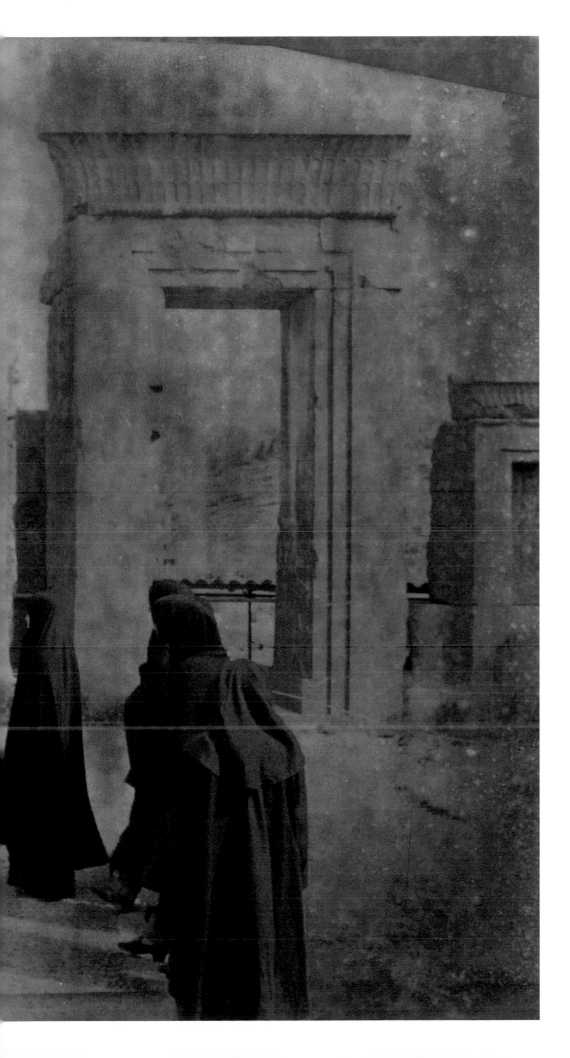

Persepolis, Iran · 1998

Maharashtra, India · 1982

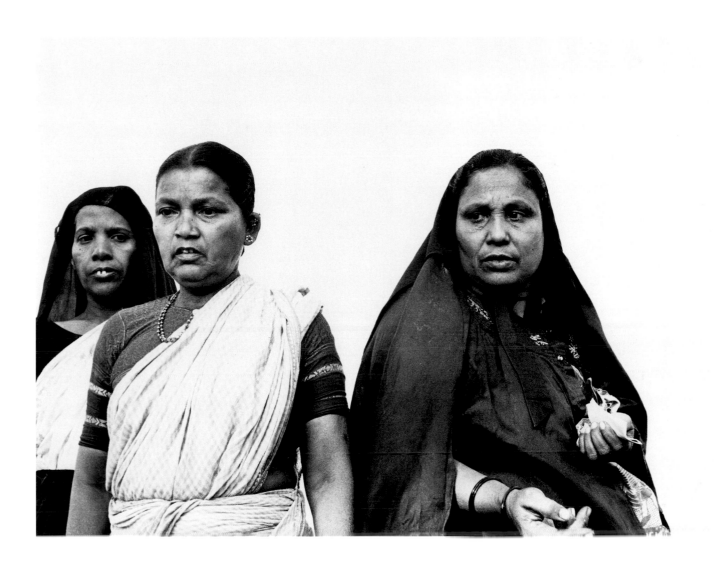

Maharashtra, India · 1982

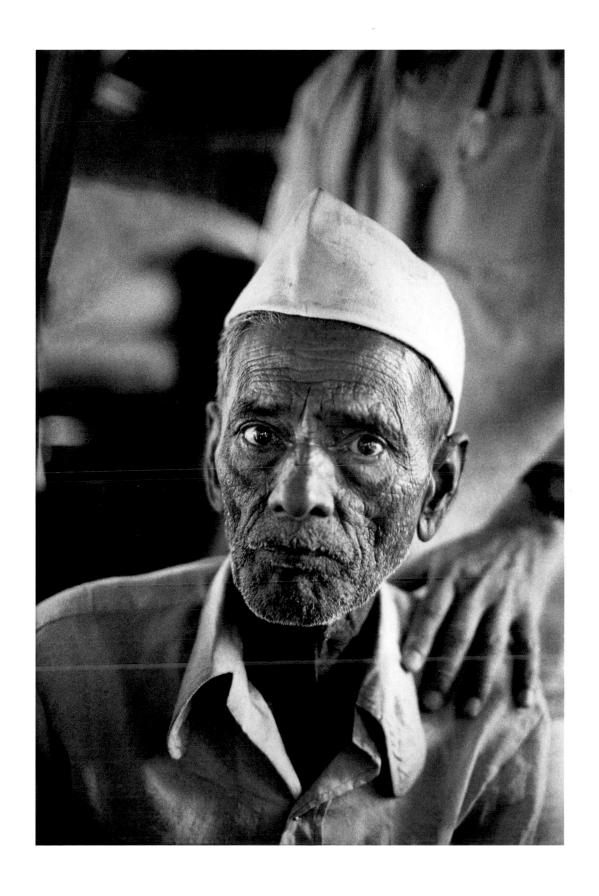

Maharashtra, India · 1982

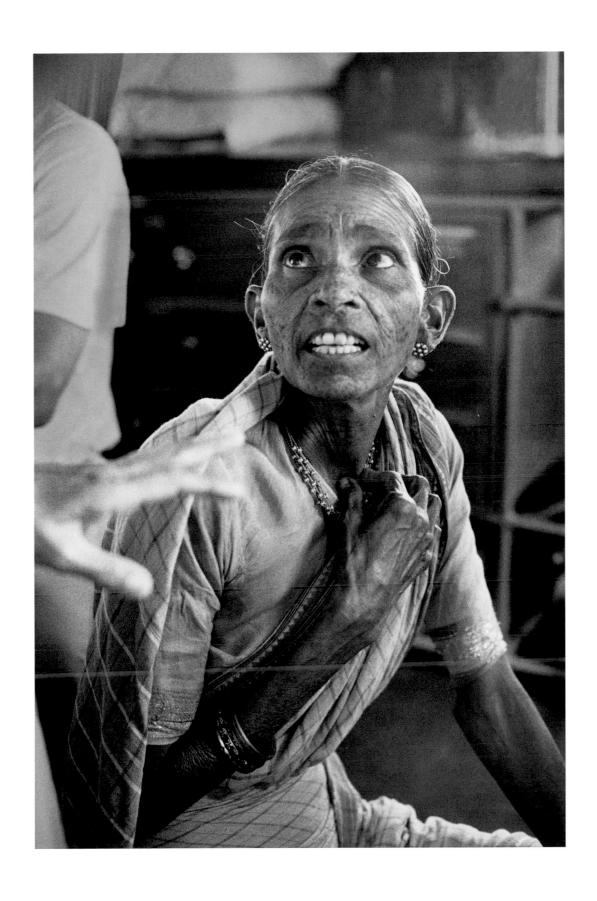

Near Shigatse, Tibet · 1992

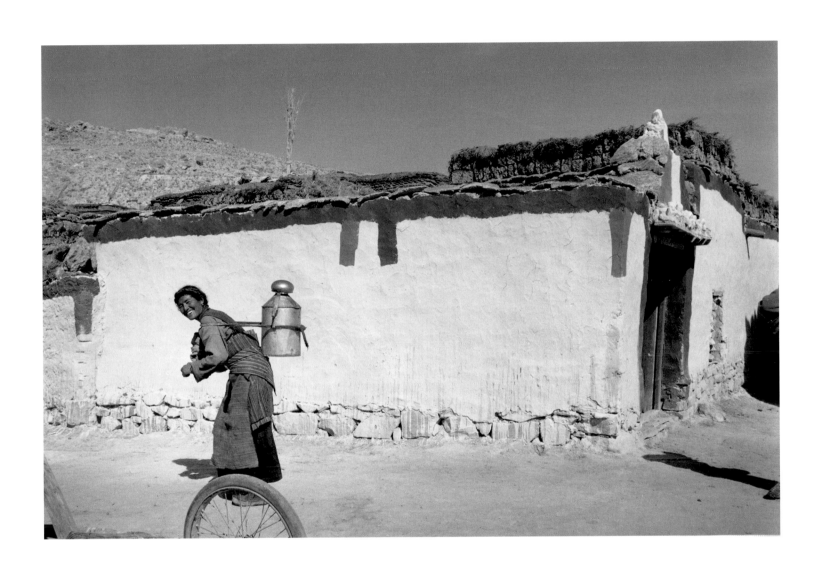

Tashilumpo Monastery, Tibet · 1992

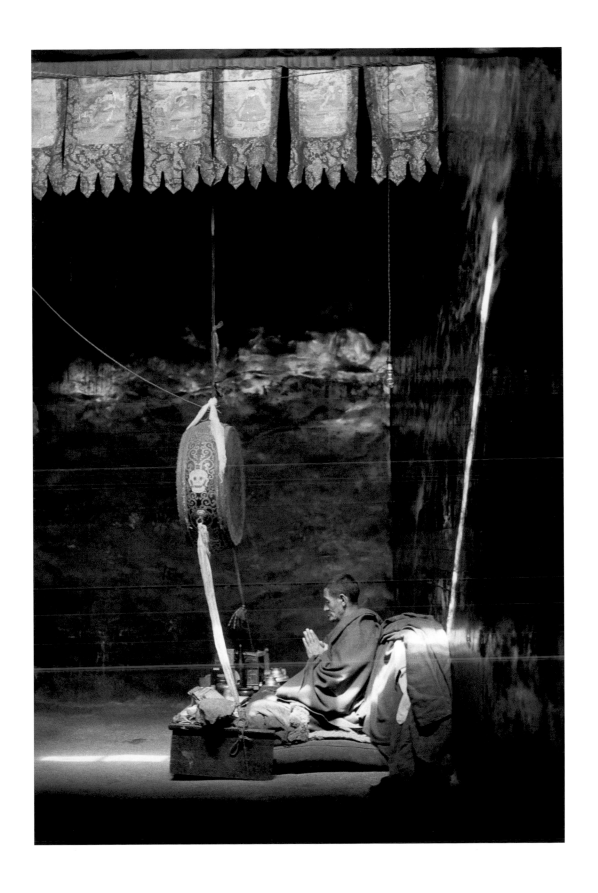

Yarlong River, Tibet • 1992

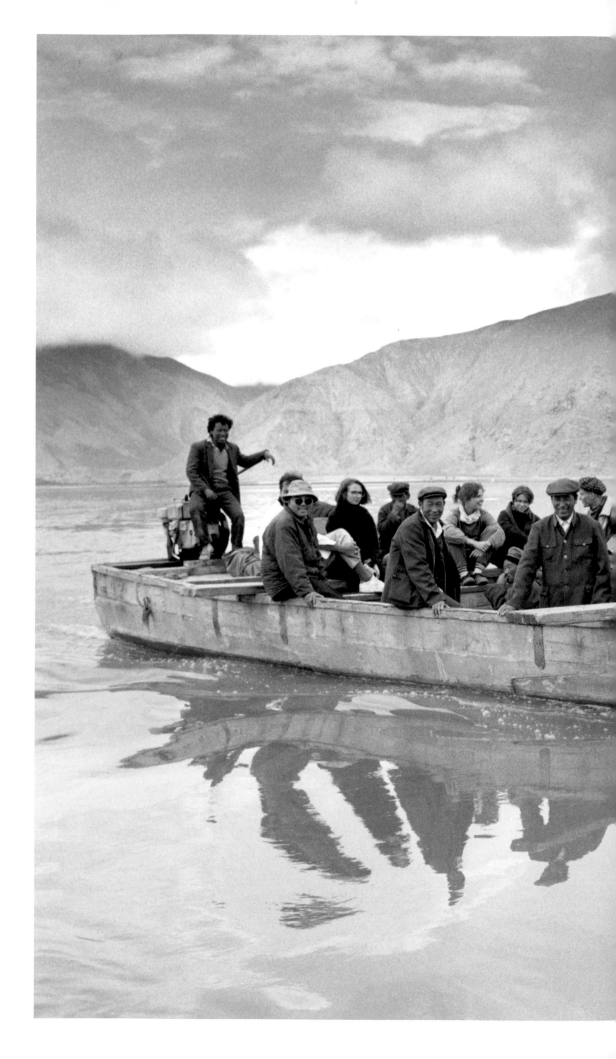

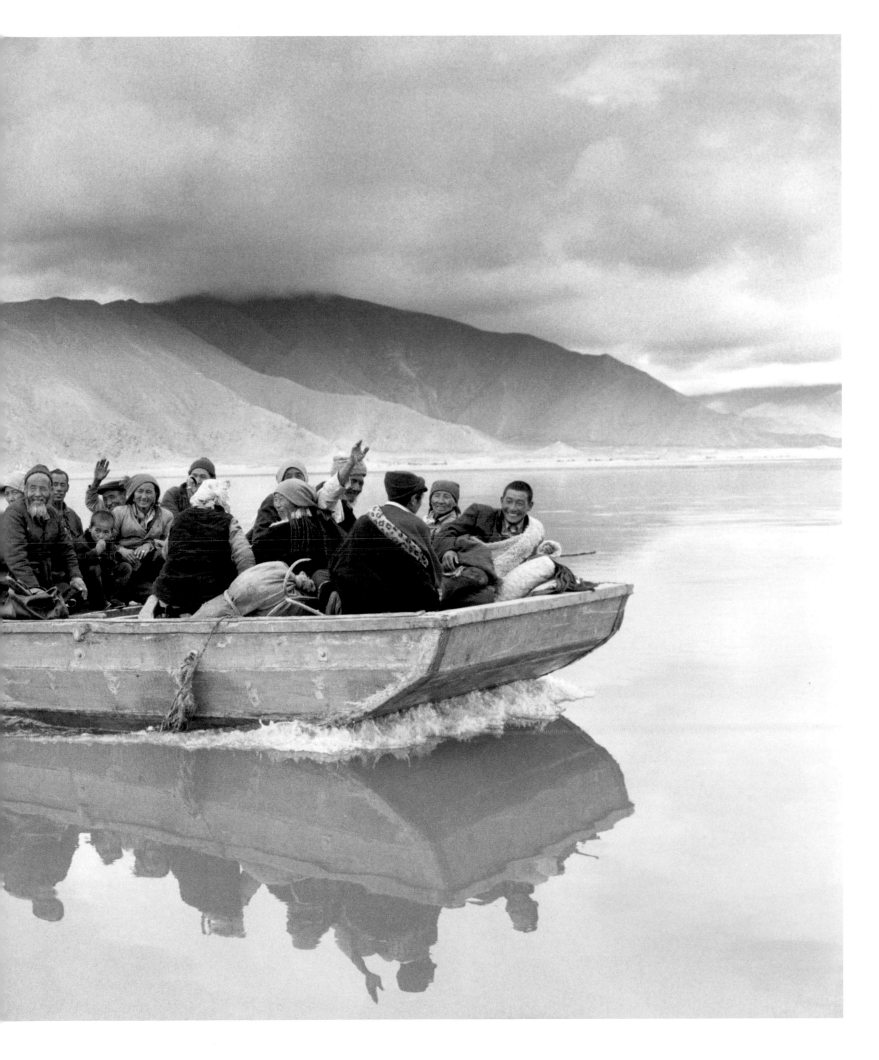

Central Tibet · 1992

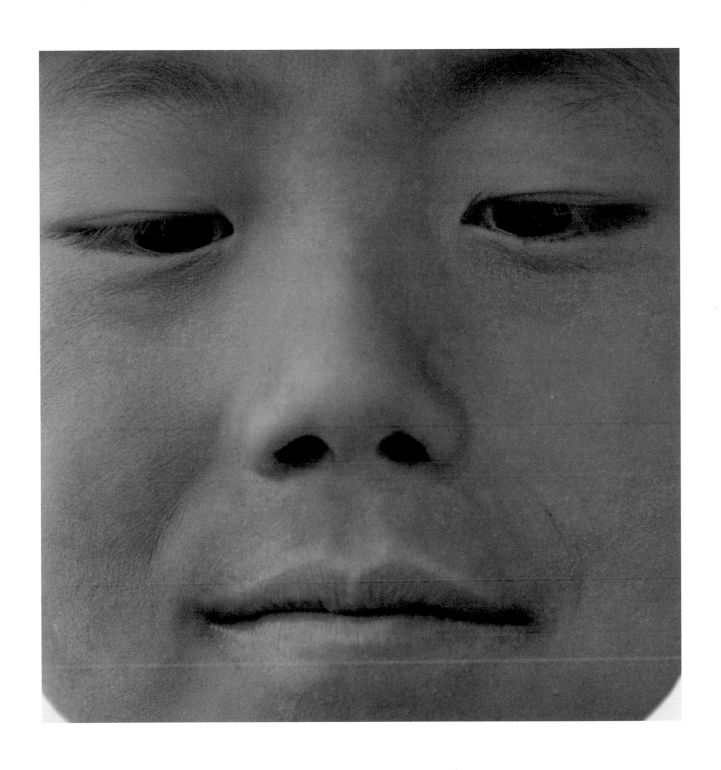

A composer does not remember
his lost fatherland,
but he remains all his life
unconsciously attuned to it,
delirious with joy
when he sings in harmony
with his native land . . .
which proves the permanence
of the elements
that compose his soul

PROUST

The only true voyage

would be not

to visit strange lands

but to possess other eyes,

to see the universe

through the eyes of another,

of a hundred others,

to see the hundred universes

that each of them sees,

that each of them is

PROUST

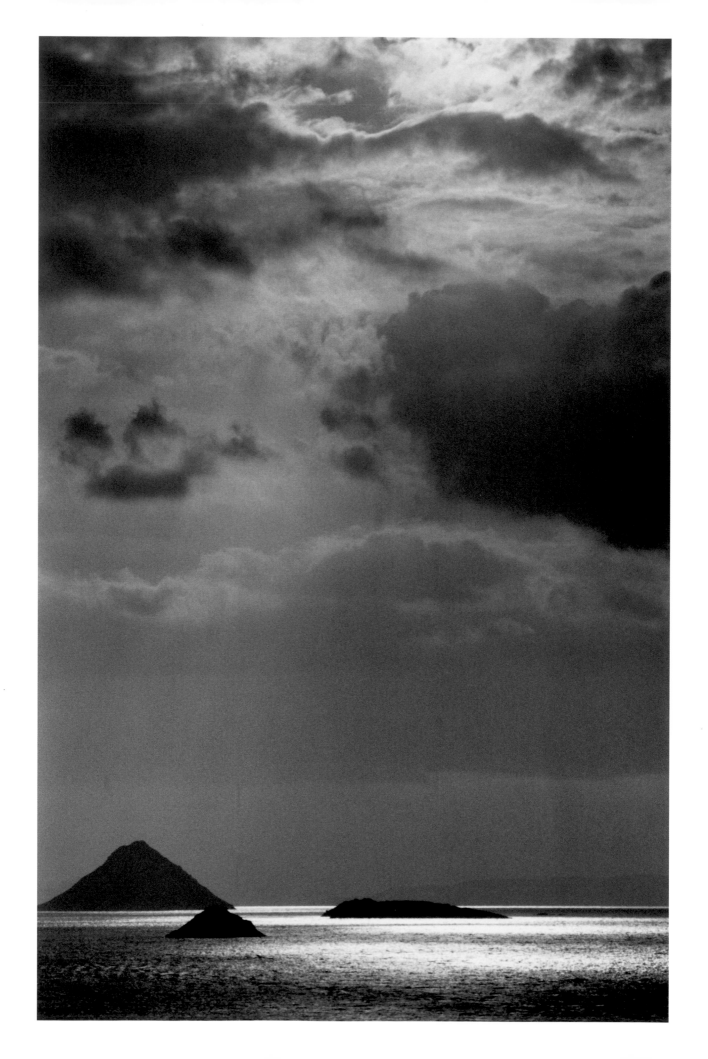

Re-Union

My eastward odyssey ended symbolically on a flight across the Pacific from India to San Francisco in 1982. Whereas Columbus had traveled west trying to reach the East, I had gone eastward in stages, a process that eventually returned me to the West.

I had visited many peoples, many places. Looking beyond time and tribe, I found that a sense of the unseen, behind the seen, lies at the heart of many traditions. "The things which are seen are temporal; but the things which are not seen are eternal," says Second Corinthians.

A feeling for the numinous pervades civilizations and their arts. The highly rational Greeks used shimmering myths to dramatize Homer's voyages, to narrate their plays, to name their temples and their sculptures. Elaborate cosmologies framed the ancient civilizations of India, Egypt, Mesopotamia, Persia, China, Tibet. For the North American hunter-gatherer, as for the medieval Christian monk, nature was an endless reservoir of symbols.

Every civilization has its creation myth. I found the Hindu story compelling and repeatable: a big bang of energy devolves into matter; a spark of that primal energy remains accessible within everyone.

The arts of our own time focus more on everyday life than on ancient gods. Science has transformed our relationships, our travels, our understandings. Today, we are inspired less by tribal narratives, more by crosscultural revelations. The poetry of the thirteenth-century Afghan mystic, Rumi, sells hundreds of thousands of books worldwide. Our vocabularies may have changed, but our thirst for the unseen cannot be quenched.

The world is far from flat. The physical environment is coming to be felt as sacred. The arts of the past century have been marked by varying degrees of abstraction: sounds, shapes, patterns, forms, harmonies, textures, and colors are emphasized for their own sake: they are felt as analogs to emotional meaning, and sometimes seen as universal building blocks.

To all this, the young art of expressive photography adds its own palette of possibility: for instance, photographs' special ability to address issues of time and spontaneity. Since the inception of the medium, many photographers have believed their work has the potential to go beyond "naive realism"—holding implications beyond the literal. "A symbol expresses itself completely and points beyond itself," said Goethe, in one translation.

An ardent believer in this kind of photo-transcendence was Alfred Stieglitz. He called his cloud pictures, taken in the 1920s and '30s, "equivalents." Stieglitz' theory of equivalence had often been discussed by artists of various genres who convened at Stieglitz' "Gallery 291." These included Wassily Kandinsky, who believed that "colors, shapes, and lines reflect the inner, often emotive 'vibrations of the soul.'"

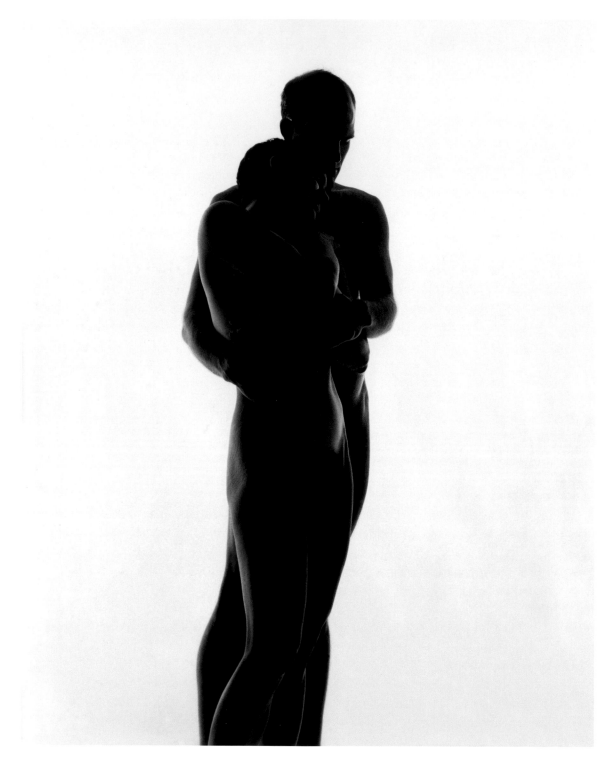

Palo Alto, California · 1991

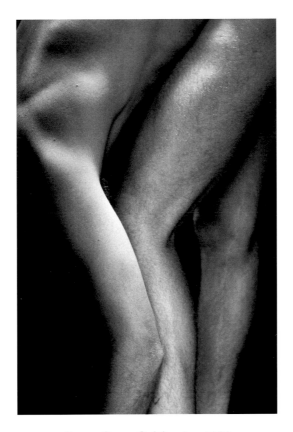

Santa Cruz, California · 1983

Certain photo pundits eventually fought back. Writing from within the chic-ironic hothouse that was the 1970s and '80s art world, the New York Times announced, with evident relief, that Minor White, having died a few years earlier, was "the last of the line" of those believing that photographs could see beyond the "factual." That brand of naive realism was soon invalidated by photographers like Sally Mann, her work pervaded with mysterious overtones, and by Latin Americans such as Graciela Iturbide, her pictures saturated with the imaginative mysticism of Mexican culture.

In the 1950s, The Family of Man, a widely shown exhibition of people worldwide, including prominent wall texts, first inspired me to appreciate the expressive power of the medium that later became my profession. Predictably, perhaps, the huge show, created by Edward Steichen, curator at New York's Museum of Modern Art, was soon panned by highbrows for being too lowbrow, and attacked by revolutionaries for pushing universal values and ignoring socio-economic injustice. But I loved The Family of Man and still do. The show and the book introduced me to great photographers whose oeuvres I later explored in depth—Edward Weston, Henri Cartier-Bresson, August Sanders, W. Eugene

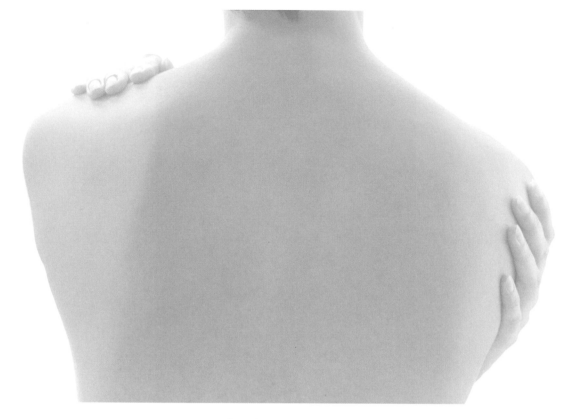

San Francisco · 2002

Smith, Roy deCarava, and many more. Plus, The Family of Man had planted a seed: its celebratory captions expressed the kind of common human denominator I would find in my own way.

Half a century later, having roamed a world full of pain and joy and so much in between, I would return to the land of my birthplace—the westernmost edge of the westernmost continent—with the words of the Rg Veda resounding in my ears: "To whom are we to direct the song of praise?"

Decades of exposure to gritty photojournalism, and to Hindu and Buddhist understandings, had proved to me that the "real" world never really changes. Bombs continue to fall, politicians to feed on territorial instincts, people to clamber over each other's bodies in the eternal rat race. Is it a particularly Asian gift to be able to span these seeming opposites—God and Caesar? I felt that possibility in the pictures and words of the American photographer Gene Smith, who had struggled with the realities of life at LIFE before quitting and later being beaten nearly to death by industrial criminals for shooting a very tough story in Japan. Asked about his photographic education, Smith seemed to sum up a lifetime of courage when he replied, "I learned it all from Beethoven."

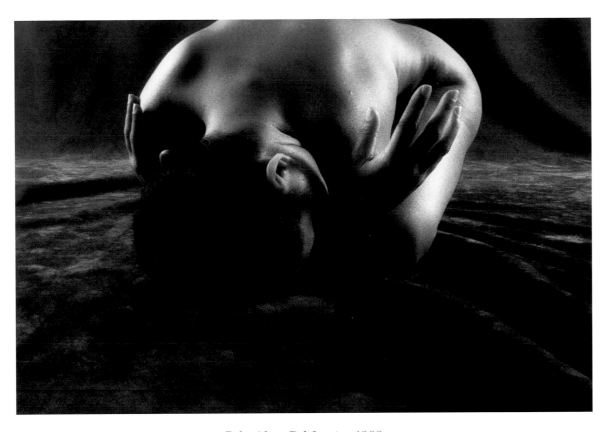

Palo Alto, California · 1992

From San Francisco I journeyed south to visit Los Angeles. Since my boyhood there, the city had changed almost beyond recognition. In the decades which I, the L.A. boy, had spent going out to discover the wider world, that world had been coming to L.A.

My mother had passed away. My father had retired. (I was alone with him when he passed away in 1996.) The far-flung department store empire Dad had created had disappeared—a victim of changing markets. Yet L.A.'s museum world, which he had done so much to establish, was thriving. The Los Angeles County Museum of Art was anchored in its original building by Dad's superb collection of seventeenth-century Dutch still lifes, landscapes and cityscapes; a projected new wing was to be filled with postmodern movements like Pop Art, which seemed to match the vibe of this still chrome-plated town. The sprawling megopolis was a far cry from the spotty outpost of '40s movie sets, reclaimed orange groves, beach clubs, obscure prophets, postwar tycoons, and modern Medicis among whom I had grown up. Despite being planted on thin soil, L.A. had blossomed into a vast, exhausting, extremely complex, and diversified metropolis, bursting with traffic jams and creative energies.

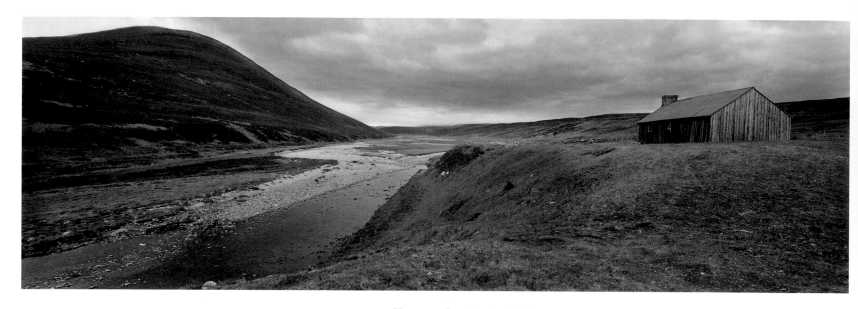

Kinrara, Scotland · 2001

Tucked between all the big results of top-down planning—the financial institutions and high-rise apartment complexes and soaring downtown buildings—were strip malls and cracked weedy side-walks and thousands of out of the way places and seldom seen neighborhoods transient and perma-nent, jumbled among scattered rows of funky small stores and gas stations. Had I been in a photodocumentary mood, I might have wandered among the ethnic enclaves of Latinos and Asians and Blacks and many others where the city's—and the nation's—life blood was surging and bubbling from the bottom up. Bigger than most nations, California had been transformed into a collection of minorities, threaded together by freeways and overlain with a vast checkerboard of technology, en-tertainment, and thousands of other businesses. Globalization—interconnectedness—was here and now and living in L.A.

But I was in a quiet mood. I replanted myself near San Francisco—where I had started as a pho-tographer. I explored the form and beauty of classic nudes, landscapes, and seascapes. I opened a studio. There I made black-and-white prints in limited editions. I joined the non-profit Friends of Pho-tography, founded in Carmel by Ansel Adams, Brett Weston, and others. I donated prints to one of the Friends' fundraising auctions in San Francisco—only to see the organization collapse two years later, in 1991. I conducted photo workshops on the nude in California and Europe. I attended events such as the Houston FotoFest, where I made contacts and found gallery representation. While keep-ing a foot in the door of these mini-worlds, I was never really of them—a lifelong stance.

Years of travel and meditation had transformed my relationship to photography, to life. Having roamed the world, I was grateful now to tend my own inner garden. No longer searching for myself, I could just be.

I ignored art world taboos—starting with that big one in a society obsessed with novelty and progress: the fear of appearing "derivative." I believed in building on the work of one's predecessors, wherever that might lead. "All art comes from other art" was a truism I believed in, if not slavishly.

I was skeptical of dealers pushing art photographers to be "edgy." So much of what was "hot" and "happening" was about style rather than substance—Mad Avenue more than intrinsic value. Navigating between all that on one side, and the "culture of complaint" on the other, I tried not to complain about the complainers or the marketers. I watched the trends from a distance, and continued to look at the world through my own lens.

Readers of this book may notice that the dates on some captions appear out of sequence with the overall narrative. The written story has been compressed of necessity: yes, I did pay return visits to certain areas in succeeding years, not forgetting to take my camera.

Places do change, however—and not just Los Angeles. Soon after I left New York City's shtetl-like Lower East Side, it began to gentrify into the East Village. Eventually, my own East Sixth Street was lined with Asian restaurants. Half a century of war and strife entirely transformed places like Beirut, Yemen and Iraq. In an Iran gripped by hardliners, one could nonetheless spot white running shoes under the hems of black burkas.

It is also true that, when revisiting a place, one can never be certain what has changed: the visitor, the visited, or the chemistry between the two. London's Number 24 double-decker bus still comes down from Hampstead, past my old flat by Piccadilly and on to Chelsea; but riding it today feels quite different than when I, the covert witness, was so intensely attuned to "eyes in the street."

A voyage of discovery cannot be replicated.

Attitude is everything.

An ancient text—from the Upanishads—reminds us: "That which is the subtle essence, this whole world has for its self. That is the true. That is the self. That art Thou."

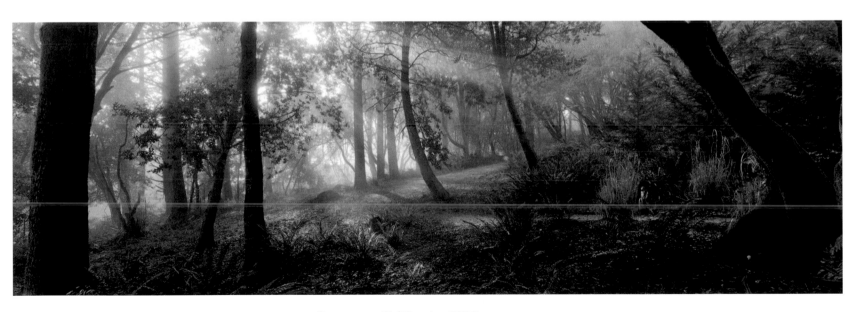

Inverness, California · 2002

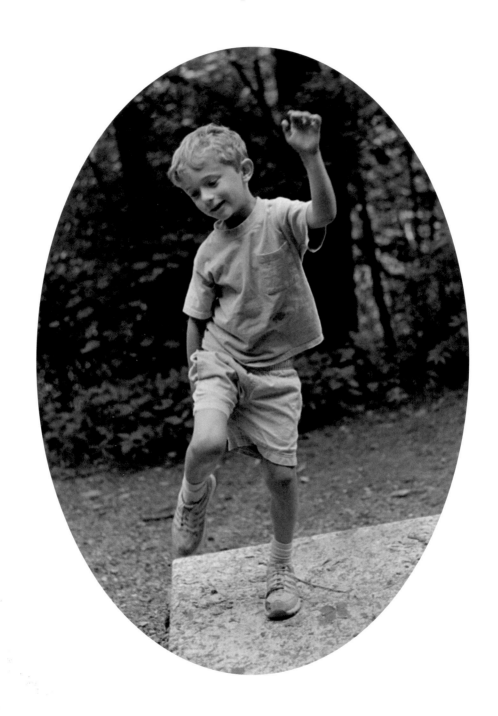

Amena (Lake Orta) Italy · 2005

Thanks to

Weston Naef, whose vision enhances civilization

Julia Morris, graphic designer, for her great eye and steady help

Rose Marie Tuohy, talented general assistant, for important help during a critical phase

Marianne Hinckle, for her expert contributions during pre-production

The many publishers and dealers who, for half a century, have seen fit to expose my work

Gerhard Steidl, premier publisher of photographic books

Ulla, my wife, constant companion in the deep background and endless foreground

Mystics of all times and places: pointing us beyond surfaces toward:

Causes and Spirits

First edition published in 2011
© 2011 William Carter for the images
© 2011 Steidl Publishers for this edition

All rights reserved. No part of this publication may be reproduced or
transmitted in any form or by any means, electronic or mechanical,
including photocopy, recording or any other storage and retrieval system,
without prior permission in writing from the publisher.

Book design: Steidl Design
Scans by Steidl's digital darkroom
Production and printing: Steidl, Göttingen

Steidl
Düstere Str. 4 / 37073 Göttingen, Germany
Phone +49 551-49 60 60 / Fax +49 551-49 60 649
mail@steidl.de
www.steidlville.com / www.steidl.de
ISBN 978-3-86930-123-5
Printed in Germany

endsheets: The Palm of My Hand, California, 2001–2010

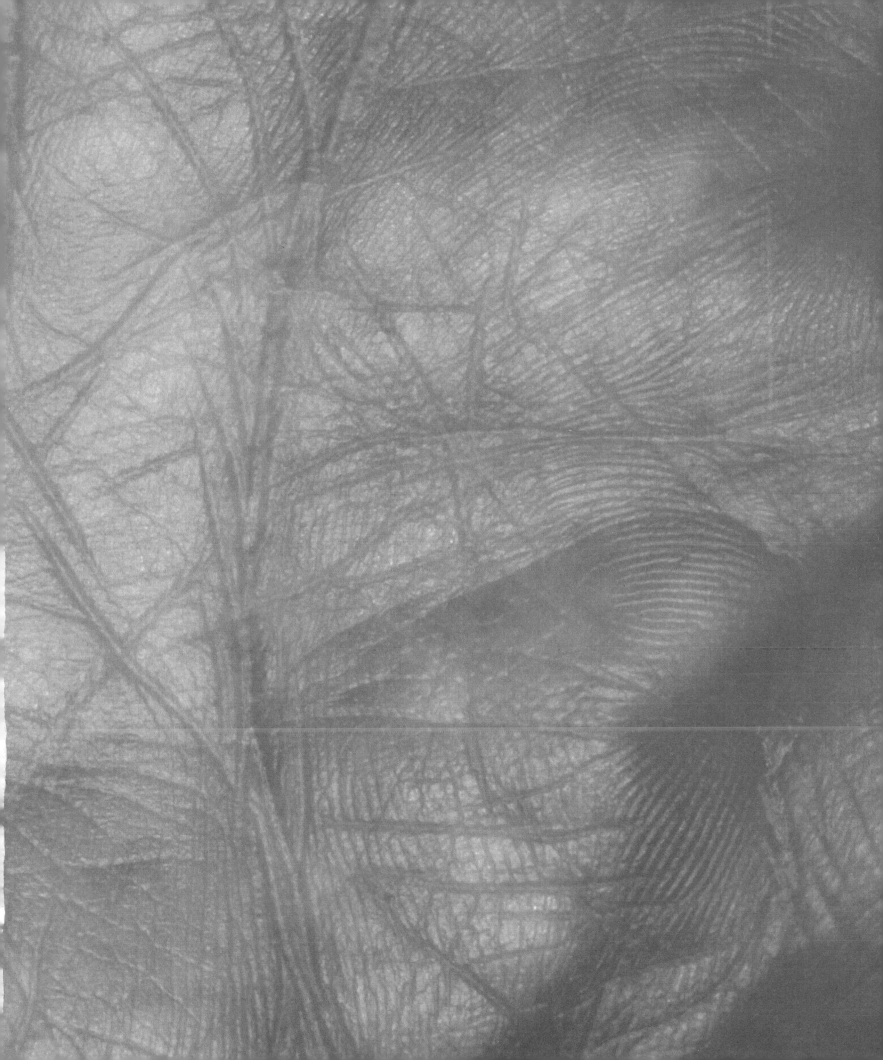

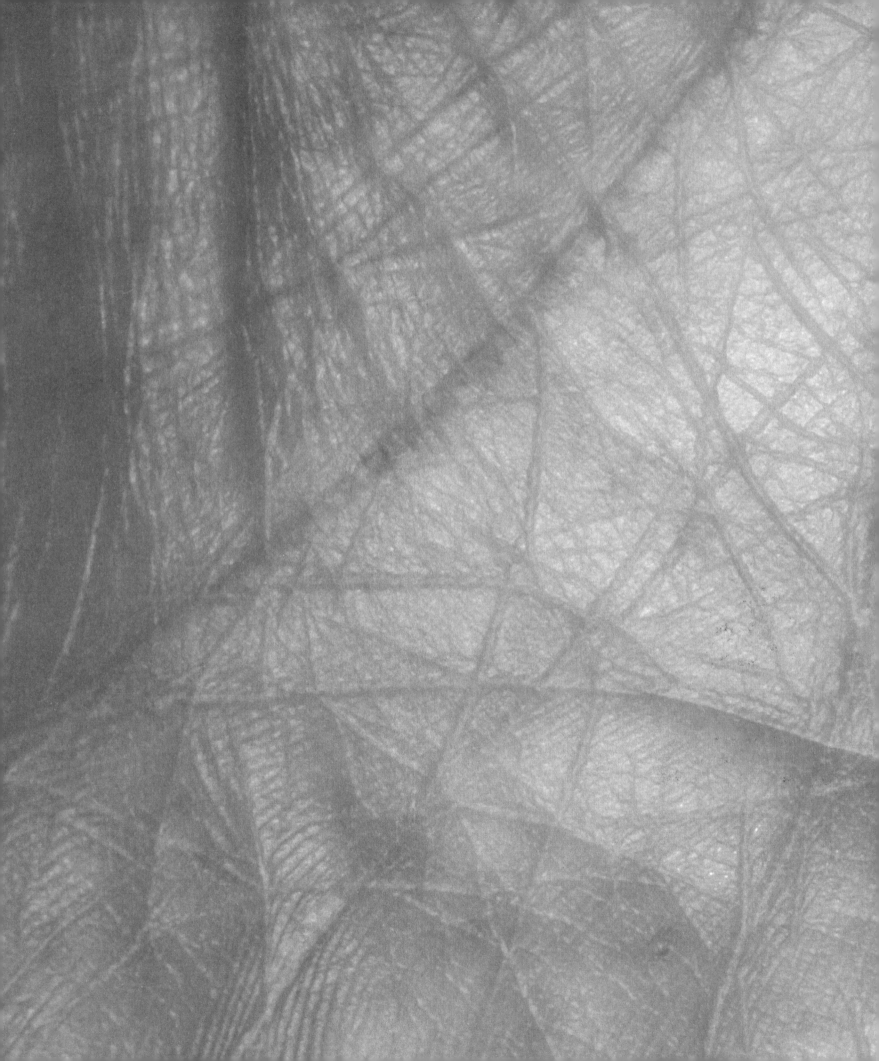